1994

THE ORIGINS OF
PHOTOJOURNALISM
IN AMERICA

THE ORIGINS OF
PHOTOJOURNALISM
IN AMERICA

MICHAEL L. CARLEBACH

SMITHSONIAN INSTITUTION PRESS
Washington and London

Editor: Catherine F. McKenzie
Production Editor: Jack Kirshbaum
Designer: Janice Wheeler

Library of Congress Cataloging-in-Publication Data
Carlebach, Michael L.
 The origins of photojournalism in America /
Michael L. Carlebach
 p. cm.
 Includes bibliographical references and index.
 ISBN 1–56098–159–8
 1. Photojournalism—United States—History.
 I. Title.
TR820.C357 1992
070.4′9′097309034—dc20 91–40145
 CIP

British Library Cataloging-in-Publication data
available

Manufactured in the United States of America
96 95 94 93 92 5 4 3 2 1

⊗The paper used in this publication meets the mini-
mum requirements of the American National Stan-
dard for Permanence of Paper for Printed Library
Materials Z39.48–1

Cover photo: Original daguerreotype by L. Wright
of the train wreck on the Providence-Worcester Rail-
road. Courtesy of the International Museum of Pho-
tography at George Eastman House.

For my parents,
William and Priscilla

CONTENTS

ACKNOWLEDGMENTS

THIS STUDY HAS BENEFITED significantly from the assistance of archivists, historians, and librarians from around the country who shared their considerable knowledge and made available the resources of their institutions. I owe a special debt to John Hench, associate director, to Georgia Barnhill, curator of graphics, and to Nancy Burkett, curator of newspapers, at the American Antiquarian Society in Worcester, Massachusetts. Under the auspices of a Peterson Fellowship, I spent a good portion of the summer of 1986 perusing the society's extraordinary collection of nineteenth-century publications and photographs. The visual and written materials gathered during that period form the core of this study.

I am grateful also for the help provided by the following persons: Joan Metzger, photographic historian at the Arizona Historical Society; Sally Pierce, curator of prints and photographs at the Boston Athenaeum; Anne-Marie Shaaf at the Historical Society of Pennsylvania; Rachel Stuhlman, librarian at the International Museum of Photography at the George Eastman House in Rochester, New York; Ken Finkel at the Library Company of Philadelphia; Greg K. Curtis, photography curator at the Maine Historical Society; Marcy Silver, curator of prints and photographs at the Maryland Historical Society; Ross Urquhart, curator of photography at the Massachusetts Historical Society; Bonnie Wilson, curator of photographs at the Minnesota Historical Society; Rebecca Kohl and Dave Walter at the Montana Historical Society; Jonathan Heller, archivist in the Still Pictures Branch of the National Archives. I am also grateful to Nina Rutenberg Gray, assistant curator of prints at the New-York Historical Society; Terrance Richardson at the Oswego County Historical Society in New York; Joyce Botelho of the Rhode Island Historical Society; Lawrence Hibpshman, archivist at the South Dakota State Historical Society; George Talbot and Myrna Williamson of the visual

and sound archives of the State Historical Society of Wisconsin; and John Grabowski of the Western Reserve Historical Society in Cleveland, Ohio.

Several persons at the Smithsonian Institution were especially generous with their time. I wish to thank William Stapp, curator of photographs, and Wendy Wickes Reaves, curator of prints, at the National Portrait Gallery; Paula Fleming, curator of photographs at the National Anthropological Archives; Mary Grassick, curator in the Photographic History Archives of the National Museum of American History, and Diane Cooke, formerly of the Office of Rights and Reproductions at the National Portrait Gallery, now an editor at the Smithsonian Institution Press. I wish also to thank Daniel Goodwin, editorial director, and Jack Kirshbaum, editor, at Smithsonian Institution Press, and Catherine McKenzie, copy editor.

David Kent, my friend and colleague in the School of Communication at the University of Miami, contributed significantly to this project. He carefully read various drafts of this study and provided many of the illustrations from his superb collection.

Edward Pfister, dean of the School of Communication, and University of Miami provost Luis Glaser also helped in many ways, notably by providing funds for study at several major collections and research institutions in the Northeast. Also, throughout the long process of compiling the research for and the writing of this work, Brown University professors Bruce Rosenberg, William McLoughlin, and Patrick Malone offered advice and criticism that helped me to focus my thoughts and ideas.

I am indebted to Robert Carr, official archaeologist of Dade County, Florida, and Robert Cauthen of Leesburg, Florida, for the loan of photographs; to John Loengard, former picture editor of *Life* magazine, for his advice and support; and to historian and editor Stefan Lorant for the willingness to share his considerable knowledge of nineteenth-century photographic practices; and to Jerry Taksier and Bill and Fred Karrenberg at Pyramid Photographics in Coral Gables, Florida. Most important, Margot Ammidown, my wife, helped to edit much of this work; her expertise and encouragement were invaluable.

THE ORIGINS OF
PHOTOJOURNALISM
IN AMERICA

LONG BEFORE THE ESTABLISHMENT of mass-circulation picture magazines like *Life, Look,* and *Colliers* in the 1930s, even before the invention of the halftone process and rotogravure printing press in the 1880s, photographs were used to inform the public about events, people, and places in the news. To be sure, the pictures were often presented crudely. In some instances photographs were pasted directly onto the pages of magazines or books. Most often, however, artists copied photographs, and they were printed in magazines, books, and newspapers as woodcuts or steel engravings; often, only the caption suggested their photographic origin. In addition, early photographic methods made it difficult to record fast-moving events or unposed human activity. Until hand-held cameras and roll film revolutionized photography late in the century, photographers in America performed most camera work indoors, in studios, under conditions they rigidly controlled.

Regardless of the difficulties, a surprising number of photographers did make pictures intended for publication prior to 1880. Their work and the complementary efforts of editors and publishers paved the way for the great flowering of photojournalism in the twentieth century and are the subject of this book.

The idea that photographs could be printed with words, even crudely printed with words, was epochal and led to fundamental changes in the way information was gathered and disseminated to the public. The combination of text and photographs is, indeed, the guiding principle and single most important characteristic of photojournalism. Wilson Hicks, the redoubtable editor of *Life* magazine from 1937 to 1950, said as much in his classic study, *Words and Pictures,* published in 1952. He rightly contends that the basic unit of photojournalism is not the gritty hard-news picture standing alone, but photographs and text printed together. In this informational mix, picture

INTRODUCTION

content matters less than the manner in which the picture is used. Photojournalism does not consist exclusively of those familiar, powerful, and persuasive images of accident and mayhem, death and destruction; its content is really as varied as journalism itself. In photojournalism, words that provide a context for the photograph are vital; so, too, is the publication of the picture.[1]

The ability of photographs to inform and persuade a mass audience is based upon the public's belief in their infallibility and objectivity. In mid-nineteenth-century America, the photographic process was understood to rely less upon the imagination of the photographer than on the mute precision of solar energy. Photography was a more perfect art not because photographers were more artistic, but because their product was created by light itself. "No man quarrels with his shadow," wrote Ralph Waldo Emerson more than a century ago, "nor will he with his miniature when the sun was the painter. Here is no interference, and the distortions are not the blunders of an artist."[2]

Most early descriptions of photography contain similar declarations, for it seemed that at last a way had been found to capture the world, then transfer it mechanically to an immutable two-dimensional surface. In a speech delivered at the annual dinner of the National Academy of Design in 1840, less than a year after the first public demonstration of photography in Paris, Edward Anthony, a photographer who in partnership with his brother Henry amassed a fortune as a manufacturer and distributor of photographic supplies, predicted that the daguerreotype was "destined to produce a great revolution in art." Using a simple and portable apparatus, he said, an artist could now "furnish his studio with facsimile sketches of nature, landscapes, buildings, groups of figures, [and] scenes selected in accordance with his own peculiarities of taste" without being subject to the inherent imperfections of drawings.

Equally important, photographs were produced quickly, thus obviating the efforts of artists who took days or even weeks to complete work that in any event could not compete with those "painted by nature's self with a minuteness of detail."[3]

Though the invention of photography and its enthusiastic acceptance by the public led to important changes in the way visual information was transmitted, it does not follow that the modern press photographer had an exact counterpart in the nineteenth century. There is a world of difference between nineteenth- and twentieth-century photographic techniques and equipment. Indeed, the profession of news photographer is a modern one. With few exceptions, photographers from 1839 to 1880 spent their careers making studio portraits and scenic views. Most were village photographers engaged in the routine documentation of small-town life and times. Photographers were not known as "photojournalists" until the proliferation of photographically illustrated newspapers and the development of small cameras and gelatin-based roll film created a national market for news pictures after 1900.

While photojournalism may not have existed as a definable enterprise in the nineteenth century, it did not spring full blown to life during the first decades of the twentieth century either. Even in the 1840s and 1850s, when bulky equipment, long exposure times, and primitive printing methods made it difficult to make and publish news pictures, there were some who saw the journalistic potential of photographs. "For our own part," wrote the editor of the *Christian Watchman* in 1846, "we are unable to conceive any limits to the progress of this art." Already, he noted, daguerreotypists avidly sought pictures of the news: "A man cannot make a proposal or a lady decline one—a steam boiler cannot explode, or an ambitious river overflow its banks—a gardener cannot elope with an heiress, or a reverend bishop commit an indiscretion,

but straightway, an officious daguerreotype will proclaim the whole affair to the world."[4]

Some historians consider the adoption, during the first decades of the twentieth century, of the halftone process of reproducing photographs to mark the real beginning of photojournalism in America. Halftones duplicated the continuous tones of photographs mechanically, and made the painstaking, expensive, and occasionally inexact work of engravers obsolete. Long before the process was introduced in 1880, however, American periodicals had adopted several methods of printing photographs with type. When time permitted, they produced fine steel engravings, etchings, and mezzotints, which some thought to be perfect copies of the original images. Popular publications such as *Frank Leslie's Illustrated Newspaper* and *Harper's Weekly* ran photographs as wood engravings in nearly every edition. In books and some magazines, actual photographs were used as illustrations. And photomechanical gravure processes such as the Woodburytype and Albertype were used to create editions of nonsilver prints of extraordinary detail and tonal range.

The fact that until late in the century photographs were printed as steel engravings or woodcuts did not lessen their news value, because editors almost always identified these pictures as photographs. Readers were thus encouraged to discriminate between the products of a camera and those of an artist's hand. If the caption indicated a photographic origin, the illustration assumed an aura of authenticity, no matter how crude the engraving. "It will readily be seen," wrote Marcus Aurelius Root, a Philadelphia daguerreotypist and author of the first thorough history of photography published in America, how useful photography "must be for illustrating books, periodicals, etc., supplying them with reliable sketches of machinery, of architecture, of scenes of disaster or of jubilee, of portraits," or any-thing else that "is suited to interest or instruct the public."[5] Root wrote this in 1864, more than fifteen years before the first halftone was used, and nearly half a century before the process gained widespread use.

The mass appeal of nineteenth-century photographs is demonstrated by the long-lived popularity of the stereograph, a composite of two nearly identical views taken by a camera with lenses placed two and a half inches apart (the approximate distance between human eyes, measured from their centers). Stereos gave the illusion of depth when placed in a viewing device appropriately called a stereoscope.[6] Their content varied from the purely pictorial to carefully choreographed dramas and situation comedies, to scenes of accident and happenstance. For many Americans, knowledge of the world and current events was strongly influenced by those curious twin photographs mounted on five-by-eight inch cards. In Victorian America the stereoscope accompanied by sets of views was as ubiquitous as the family television in modern times.

No one was more euphoric about the possibilities of stereoscopy than Dr. Oliver Wendell Holmes, writer, teacher of anatomy, and father of the distinguished jurist. He praised stereoscopic photography in two memorable articles for the *Atlantic Monthly* in 1859 and 1861. He also designed the most popular and effective stereoscope, which he steadfastly refused to patent, offering it instead as a gift to the American people. Stereographs, he wrote, duplicate events with impeccable clarity, producing the "appearance of reality which cheats the senses with its seeming truth." These are neither toys nor gimmicks, he said, but the initial stage of "a new epoch in the history of human progress."[7]

The mass production of stereo views afforded the public a cheap and reliable source of news pictures for more than half a century. Cards were made and distributed by individual photographers around the

country and by huge photographic equipment and supplies companies such as that run by the Anthony brothers in New York City. Photographers often recorded noteworthy scenes and events with two cameras, one for making oversized prints for display purposes, the other for making stereos. And the purpose of the latter was always the same: to inform or entertain the public through the medium of photography. Views of Civil War battlefields, of the exploration and settlement of the western territories, and of the burgeoning cities of the East educated Americans about events and places they could not see for themselves. William Henry Jackson, for instance, gained fame as a pioneer photographer largely through the sale of stereographs of western landscapes and activities associated with the building of the transcontinental railroad, though he is best known today for the huge negatives (up to twenty by twenty-four inches) he made of Rocky Mountain scenery. According to his son, Charles Jackson, "A whole generation viewed his camera studies through the stereoscope—and then came to know and appreciate a West which most of them never visited."[8]

Often photographers recorded events and activities in series of views. One could purchase, for example, the photographic narrative of a whaling voyage, or the construction of a great bridge, or the terrible effects of a man-made or natural disaster. Sets of stereos that combined pictures and words in sequential form (printed captions usually appeared under the images or on the reverse side of the cards) familiarized the public with the possibility of using several pictures to tell a story. Moreover, because they consisted of actual photographs, not engraved replicas, they avoided being confused with the more imaginative creations of sketch artists.

Many nineteenth-century photographs, both stereo and full sized, are now treated as fine works of art and are prized by art collectors. They grace the walls of museums and galleries and appear in large, expensive books as slick duotone reproductions. In addition, the value of photographs as historical documents is universally acknowledged. Neither the aesthetic nor the documentary aspect of photography is at issue herein. Rather, the focus of this study is the additional capability of photographs to report and comment upon the news.

That they now function in this way, as an essential element of journalism, is obvious. We maintain our faith in the silent authority of photographs and recognize their value as reportage despite the omnipresent blare of video news. For now as in the nineteenth century, photographs are, as Susan Sontag notes, "experience captured." The camera appears to be an impersonal witness, and the pictures it produces elicit trust. "A photograph passes for incontrovertible proof that a given thing happened," writes Sontag. "The picture may distort, but there is always a presumption that something exists, or did exist, which is like what's in the picture."[9]

We know, of course, that photographs do not always tell the whole truth. We know that they are sometimes doctored and that published images do not reproduce reality exactly. The extensive use of photographs in modern advertising, where pictures are combined with words on the printed page to sell products, further confuses the issue. Some purely commercial images look journalistic, whereas the occasional news picture seems more commercial than informational. Recent developments in digital imaging and electronic scanning make it easier to manipulate and alter images, but much harder to detect what is false.

Though relevant to any contemporary discussion, concern about the accuracy of photographs was seldom expressed by the first generation of practitioners. The occasional complaints and disparagements most often concerned the obnoxious behavior of photographers or the apparent inability of

the camera to flatter. The public's reaction to photography in general, and to the spate of inventions at mid-century that made photographs more accessible, was uniformly enthusiastic.

My own enthusiasm about photography and photojournalism stems from more than two decades of professional practice. I believe that cameras can produce realistic images, some of which have great emotional impact. But cameras, it seems to me, are mind guided, and as a result, photographs made by people are never objective. Decisions made by photographers about the inclusion or exclusion of visual elements and about precisely when to take pictures are critical. However, these acts of selection do little to impair the accuracy and extraordi-nary detail of photographs, so they remain an essential component of journalism. That will change only if journalists begin using computers routinely to transform photographs of the real world into factoids on floppy disks.[10]

The publication and mass production of still pictures from 1839 to 1880 accustomed Americans to a new kind of journalism, one that relied on photographs to transmit information. While mechanical and technological developments in the last years of the nineteenth century stimulated the growth of photojournalism, the effort to use photographs as a medium of mass communication really began when the daguerreotype was king.

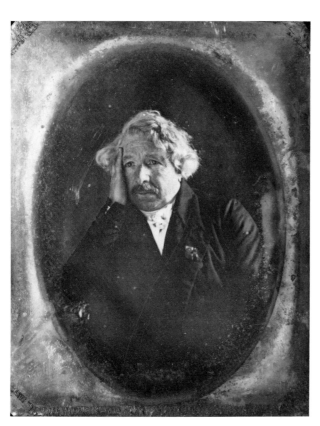

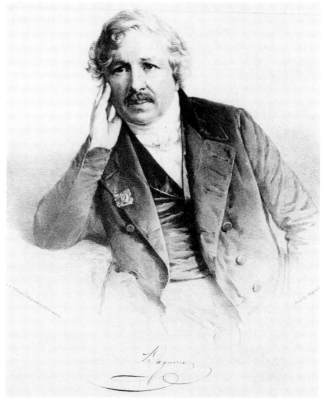

Daguerreotype of
Louis-Jacques-Mandé
Daguerre, made by
Charles Meade in 1848.
Division of Photo-
graphic History, Na-
tional Museum of
American History,
Smithsonian Institution.

Lithographic copy by
Francis D'Avignon and
Abram J. Hoffman of
Charles Meade's da-
guerreotype portrait of
Daguerre. National Por-
trait Gallery, Smithso-
nian Institution.

ON JANUARY 7, 1839, Louis-Jacques-Mandé Daguerre, proprietor of the popular Diorama in Paris, announced to the prestigious Académie des Sciences that he and his late partner, Joseph-Nicéphore Niepce,[1] had succeeded in preserving the theretofore fleeting images seen in the camera obscura. At first it seemed that daguerreotypes were more art than anything else. However, it soon became apparent that they could be used to make realistic illustrations for the periodical press. Engravings made from daguerreotypes, especially those of famous people, were a staple of the publishing industry in America as early as 1840. And by 1844, a few American daguerreotypists made pictures of news events and found ways to make these images available to the public.

That daguerreotypes were used at all by the press is remarkable and testimony to the public's faith in the new images, for there was no easy way to mass produce or print them. Their use is even more surprising, given the existence of a competing process for producing photographic images—one that was much better suited to mass production. On January 31, 1839, an Englishman, William Henry Fox Talbot, announced that he, too, had caught and made permanent the camera's ephemeral images, adding that his discovery predated that of Daguerre.

Apart from profound technical differences, the purposes of the English and French processes were identical: to produce pictures of the natural world, unspoiled by the inevitable failure of human vision and craftsmanship. Images were made mechanically, automatically, by Talbot and Daguerre, the sun itself substituting for the shaky hand of man. It was, wrote Gaston Tissandier, author of one of the first complete histories of photography, a discovery that "at once stamped itself as something grand, extraordinary, as a work full of vitality and vigor."[2]

Ironically, Talbot's calotype process,

DAGUERREOTYPES AND THE PRINTED PAGE

A photograph is simpler than most memories, its range more limited. Yet with the invention of photography we acquired a new means of expression more closely associated with memory than any other. The Muse of photography is not one of Memory's daughters, but Memory herself. Both the photograph and the remembered depend upon and equally oppose the passage of time. Both preserve moments, and propose their own form of simultaneity, in which all their images can coexist.

JOHN BERGER
Another Way of Seeing

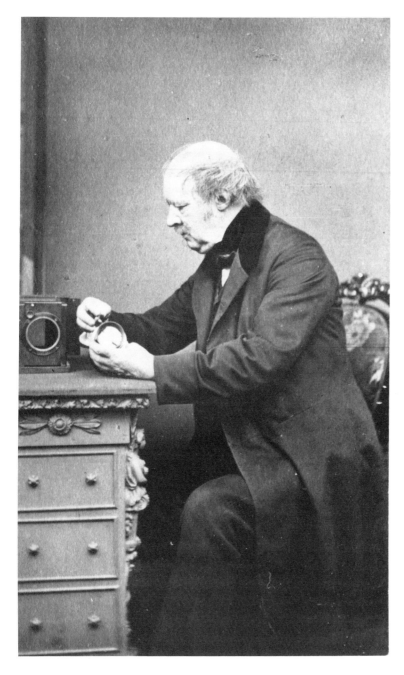

Carte de visite of William Henry Fox Talbot, made by J. Moffat in Edinburgh, Scotland, 1864. Division of Photographic History, National Museum of American History, Smithsonian Institution.

which is the forerunner of modern photography, languished in America and in Europe after 1839, while the daguerreotype, a photographic dead end, reigned supreme. Daguerreotypes, one-of-a-kind positive pictures printed on thin, shiny, silver-plated sheets of copper, took America by storm. They were relatively inexpensive (most cost between one and five dollars, including a leather or gutta-percha case) and amazingly accurate; their bright mirrored surfaces seemed to catch and hold each subtle detail and nuance of light. But they could not be easily duplicated. Making copies of daguerreotypes was as complicated and time consuming as making the original, and the second-generation images often lacked the bite and sparkle of the first. Moreover, in order to be printed with text, daguerreotypes had to be first made into engravings or woodcuts and then transferred by hand onto materials that could be inked and used in standard printing presses.

On the other hand, the process introduced by Talbot in England yielded a positive print on paper that was made from a paper negative. Original prints made by Talbot's process could be mass produced as long as the original negative held out. The use of a paper negative, however, led to a final product that seemed less sharp and crisp than a daguerreotype. The fibers present in even the finest printing papers diffused and softened the image. The minutely detailed daguerreotype, enclosed in an embossed case, gold toned and hand tinted, seemed the perfect keepsake. Talbot's paper prints, however rich in chiaroscuro, were widely considered to be inferior.

But it was not simply the look of the finished product that gave daguerreotypes a competitive edge in America. A more significant reason lay in the fact that Talbot's process was encumbered by patent restrictions whereas daguerreotypes could be made without charge by anyone, practically anywhere. The only country in which Daguerre's process was patented was Great

Britain. Daguerre applied for and was granted an English patent early in the summer of 1839. Historians Helmut and Alison Gernsheim contend that Daguerre was motivated only partly by a desire to protect his process. A more compelling reason, they suggest, was nationalist pride. The message was clear: The "true" invention of photography belonged to France, and any Englishman wanting to use the superior French product would have to pay the price.[3]

Led by the prodding of François Arago, astronomer and president of the Académie des Sciences, the French government decided to give Daguerre's discovery to the world. Daguerre and Isidore Niepce, the son and heir of Daguerre's first partner and collaborator, were awarded generous annuities for life in return for their efforts. In America, the decision to allow the free use of daguerreotypes was viewed favorably by the press. One writer saw it as an act of consummate governmental altruism. Arago, imbued "with that ardent devotion to science and to the interest of its cultivator which so often characterize scholars, . . . resolved that while France had the honor of so great a discovery, it should also have the higher glory of . . . making the discovery a present to the entire world."[4] It is more probable that Daguerre and Arago were motivated by practical rather than idealistic considerations. They wanted to assure the quick spread of the French process and knew that an invention rigidly controlled by patents would not easily be assimilated. Once the government agreed to pay the inventors directly for their work, the process was revealed in its entirety, and France and Daguerre reaped the publicity benefits of what appeared to be an act of pure unselfishness.

Such was definitely not the case with Talbot's process. Talbot published his pictures in a work entitled *The Pencil of Nature,* issued in six parts between 1844 and 1846, with the avowed purpose of demonstrating the superiority of his process over Da-

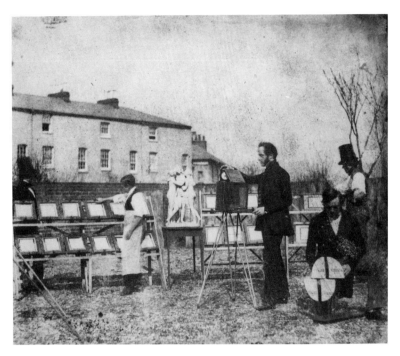

Mass-producing Talbot's paper prints at Reading, England. Division of Photographic History, National Museum of American History, Smithsonian Institution.

guerre's. And in advertisements in the British press, he pointed out with considerable prescience and justification that his pictures, not Daguerre's, would effect a revolution in the graphic arts. "Authors and Publishers will find the Photographic process in many cases far preferable to engraving for illustrating their works," he wrote in 1846, "especially when faithful representations of Nature are sought."[5]

Talbot's considerable efforts notwithstanding, in America few photographers chose to purchase the right to make paper prints. The comparatively poor quality of the finished product and its expense virtually assured the success of its rival. The photographic press did little to enhance the cause of paper photography, for the idea of restricting photography in any way appalled most photographers. In contrast to what seemed to Americans as French magnanimity, Talbot's patents were considered mean spirited and small. Restrictions on the use of photography, wrote Nathan Burgess in 1862, render the responsible parties "odious in the eyes of the fraternity, . . . as

grasping and over-reaching in their endeavors to gain a few dollars and cents out of this beautiful process." He added that photography belonged "to a higher race of discoveries than most others"; it was "almost of the things spiritual" and thus ought not be degraded by crass efforts to make money.[6]

The result of the machinations of the photographic press in America against the calotype patents can be seen in the utter failure of the process to elicit the support of photographers or publishers. Frederick and William Langenheim, who owned a successful studio in Philadelphia, purchased the American rights, but in spite of their efforts to popularize the process, it remained essentially unused.[7] American photographers were determined not to pay for the right to make paper photographs (calotypes) when for nothing at all they could make daguerreotypes. An article in *Humphrey's Journal,* one of the first and most influential photographic periodicals printed in the United States, summarized the American point of view. While Talbot's pioneering work was laudable, wrote editor Samuel Humphrey, he had to be given full credit also "for restraining or hoarding his improvement." The price for using Talbot's process was exorbitant, and as a result the calotype was justifiably "prevented a popularity which might have proved at least a source of little satisfaction." It was to be forever regretted "that this gentleman should continue to clog the improvement of an art, of which we must in justice allow him to be the chief originator."[8]

Most photographers in America were probably aware of the competition between the French and English processes; the controversy was made to order for American photographic journals. There is little evidence, however, to suggest that the general public participated in the debate. Daguerre's process was available and Talbot's was not, so from 1839 to approximately 1855, photography meant daguerreotypy in America.

The new pictures soon became an important part of popular culture. The daguerreotype's "superiority in portraits, over miniature or oil painting," wrote Henry Hunt Snelling in 1849, "has been tacitly acknowledged by the thousands who employ it to secure their own or a friends [*sic*] likeness, and by the steady increase in the number of artists who are weekly, aye daily springing up in every town and village in the land."[9] Not only were daguerreotypes amazingly accurate, they were inexpensive, especially in comparison to hand-painted portraits. Some cost as little as twenty-five cents, though the average price was between two and three dollars, an affordable sum for middle-class Americans.[10] "The bright and beautiful sun . . . shines alike upon the rich and poor," wrote William Strickland, a Methodist minister and associate editor of the *Christian Advocate*. The sun has come to the relief of the common man, he wrote, "becoming the poor man's artist, [and] paints, as no human hand can paint, lifelike portraits for a sum within the reach of all."[11]

John Werge, an Englishman who compiled an early history of photography, described a studio in New York City that produced inexpensive daguerreotypes as a "portrait factory." All the work was done in assembly-line fashion. Each employee had a specific job to do, and the sitter passed from the waiting room to the operating room (where the images were taken) and finally to the finishing room as if on a conveyor belt. Once exposed, the plate was developed, fixed, tinted, and encased by different persons. Werge was pleased with the results, noting that "three of the four portraits were as fine Daguerreotypes as could be produced anywhere."[12]

It may be that those employed as laboratory workers in large urban photographic studios, who spent their days developing

the images over baths of hot mercury, did not last long in the profession, or anywhere else for that matter. Mercury is a pernicious and ultimately lethal poison, and it must have done considerable damage to those who regularly came into contact with it. "Barometer makers, looking glass manufacturers, and, indeed, all who have to handle mercury in large quantities, are subject to diseases of a very distressing character," wrote Samuel Humphrey in the *Daguerreian Journal*. A year later, a report in the *Photographic Art-Journal* gave graphic evidence of what mercury could do. "Mr. Gurney, of New York, is said to be lying ill from the effects of mercury poisoning, the fourth case which has come under our observation in two years."[13]

In September 1839, a complete English translation of Daguerre's process was published in the *Journal of the Franklin Institute*; a similar version, published in the August issue of the *London Literary Gazette,* arrived in America the same month.[14] Spurred by the promise of a facile, mechanical method of creating portraits and other views—a method that demanded neither special artistic training nor usurious payments to the inventor—thousands rushed to learn the new art and begin making money with it. And the public, especially the middle class, was delighted at last to be able to own accurate, detailed pictures.

Daguerreotypy was, as one female enthusiast remarked late in the century, a democratic art, an art for the masses. "To realize today what the discovery meant, one must recall the means of portraiture then in existence." Few could afford to have fine portraits painted of themselves and their families, and the work done by itinerant artists and miniaturists sometimes rendered their subjects barely recognizable. Photography changed all that. "The daguerreotype was comparatively inexpensive," Mrs. D. T. Davis wrote, "and any one could use the process who would give it attention. The

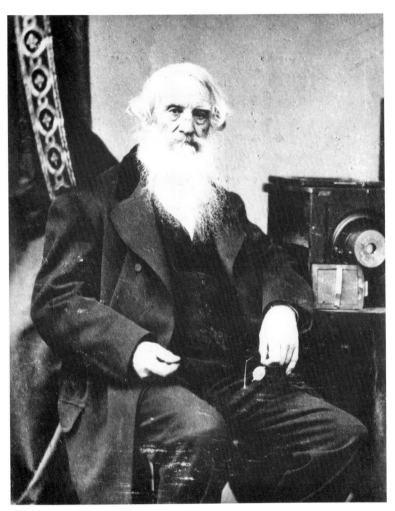

Daguerreotype of Samuel F. B. Morse with daguerreotype camera, made by Abraham Bogardus. Division of Photographic History, National Museum of American History, Smithsonian Institution.

simplicity of the operation, the mystery as well as the beauty of the result, the endless opportunity it offered—all this appealed to young Americans, . . . and far and near they fell to daguerreotyping."[15]

In her article for *McClure's Magazine,* Davis stressed the mass appeal of daguerreotypy, especially the notion that it was a process easily learned and inexpensive to operate. Certainly it was both, but there is more to the story than that. In late 1839 and 1840, when the daguerreotype was introduced in America, the country had not yet recovered from the disastrous panic of 1837. Unemployment remained high, and prices for farm products and manufactured

goods were depressed. Many public works projects such as turnpikes and canals, begun during the heyday of the Jackson years, were canceled by fiscally strapped state governments; others were curtailed. Banks that had fueled the speculative fever over western land were particularly hard hit, and in many towns and villages they were the first businesses to go under. Nor was there much hope that the federal government would come to the rescue. Martin Van Buren, elected in a landslide in 1836, was opposed to federal intervention in the economy and, like his predecessor, loathe to accept the idea of a national bank. The economy, it seemed, would have to heal itself.[16]

Given the gloomy and uncertain economic climate, it is not surprising that enterprising persons turned to the new and much heralded field of daguerreotypy. It was, after all, a business requiring little in the way of formal artistic or scientific training, and the initial capital outlay was comparatively slight.[17] As a result, as soon as the details of Daguerre's process were made available, there was a rush to begin making pictures. Albert Sands Southworth, one of Boston's best-known daguerreotypists, whose long association with Josiah Johnson Hawes produced some of the finest examples of the art, remembered the frenetic activity of the early days.:

Into the practice of no other business or art was there ever such an absurd, blind, and pell-mell rush. From the accustomed labours of agriculture and machine shop, from the factory and counter, from the restaurant, coachbox, and forecastle, representatives have appeared to perform the work for which a life apprenticeship could hardly be sufficient for a preparation for duties to be performed of a character to deserve honorable mention.[18]

Hard times gave the art and business of daguerreotypy the impetus it needed to spread quickly through the land. Regardless of the complaints of men like Southworth who were appalled at the pedestrian quality of so many of the early operators, photography continued to be practiced by those with little formal education or training and nothing at all to lose. In 1843, the *Daily National Intelligencer* reported that in New York "in these Jeremiad times" there were but two kinds of people making money: beggars and daguerreotypists. "Daguerreotyping, which is now done for two dollars and a half, is the next most profitable profession" to begging. And since all the necessary daguerreotype supplies could now be purchased from shops on Fulton Street, "any peddlar can take up the trade."[19]

In Nathaniel Hawthorne's *The House of the Seven Gables,* Holgrave, a twenty-two-year-old daguerreotypist, offered contemporary readers a somewhat unflattering glimpse into the motivations of young American photographers. Holgrave's "present phase, as a daguerreotypist," wrote Hawthorne, "was of no more importance in his own view, nor likely to be more permanent, than any of the preceding ones." Prior to taking up the camera, he had worked as a dentist, schoolmaster, salesman, and political editor of a country newspaper. There was something decidedly unsettled about Holgrave, a sense that his law was different from those around him. He made Phoebe and Hepzibah Pyncheon uneasy, not because he was immoral or untrustworthy, but because he seemed "responsible neither to public opinion nor to individuals."[20] It is a description of photographers that is curiously apt even today.

Within a few years of its invention, the daguerreotype was fully assimilated into American culture. Storefront displays of daguerreotypes were certain to attract crowds of spectators and to lure many of them up to the photographers' top floor, skylit studios. The daguerreotype in its molded case became a kind of instant status symbol as families vied with one another to procure collections of "the most finely executed and elaborately finished portraits."[21]

By 1853, not much more than a decade after the introduction of daguerreotypy in America, the *New York Daily Tribune* reported that there were between thirteen thousand and seventeen thousand persons engaged in the business of making daguerreotypes and that they produced and sold no less than three million images each year. In Manhattan and Brooklyn alone some one hundred daguerrean galleries employed nearly 250 men, women and boys.[22] The rural areas of the country were hardly less affected. In Maine, for instance, the commercial census reported that in one eighteen-month period during the early 1840s more than a million and a half daguerreotypes were made in the state.[23] "Daguerreotyping . . . has done much to advance her cause with the people," enthused the editors of the *Cosmopolitan Art Journal*. "There is scarcely the humblest cottage but has some beautiful and correct image of friend or relative."[24]

The public's acceptance of the daguerreotype was encouraged by the press, which was delighted with the accuracy of daguerreotypes and their potential to be used as the basis for illustrations on the printed page. Unfortunately, there appeared to be no convenient method of reproducing the continuous lines and delicate halftones of daguerreotypes. "From the origins of photography, even in Daguerre's time," wrote Tissandier, "it has been a matter of regret that the beautiful picture produced by light at the focus of the camera was condemned to remain as an unique type."[25] His complaint was well taken. But the problem was not unsolvable, and images copied from daguerreotypes were issued by the press in America as early as 1840.

Engravings of American celebrities made from daguerreotypes were popular consumer items. They had the ring of truth about them. The *Connecticut Courant* reported in 1849 that "scarcely a cottage or hamlet can be found, however obscure or isolated, but what displays on its walls more or less specimens of this art."[26] Publishers and printers were eager to use daguerreotype originals as a way of enhancing the public's approval of their products. One printer in New York City even announced that his "facilities are such that he is enabled to execute all orders promptly and in every style of the Art, upon the most reasonable terms," paying particular attention "to the Drawing and Engraving of Subjects from Daguerreotypes."[27] Talbot's patents and the uniqueness of daguerreotypes probably delayed the full use of photographs by the press in America, but there was nonetheless a natural and generally recognized connection between the images caught and preserved by the camera and the printed page.

Historian Beaumont Newhall rightly points out, for instance, that a great many early daguerreotypes, especially those of famous or newsworthy people, "were published in the form of engraved or lithographed copies." It is likely, he adds, that "more daguerreotypes were seen in the form of these copies, than in the originals."[28] What is most significant is that these copies were almost always identified as facsimile copies of daguerreotypes in order that they be differentiated from work originally created by sketch artists, engravers, or painters. Illustrations derived from the camera were labeled as such and so were regarded by the public as being more truthful than other printed pictures. Even crude, single-line woodcuts or engravings, if credited as daguerreotypes, seemed more realistic. The reference to a photographic origin, writes Edward Earle, "lent a sense of veracity to the engraving's low definition and almost schematic-like quality."[29]

Daguerreotypes disclosed "a more absolute truth, a more perfect identity with the thing represented," wrote Edgar Allan Poe, no stranger to daguerreian studios and an enthusiastic supporter of the new art.[30] Late in the century, author and photographer John Fortune Nott concurred in an article on the use of photographs by the press. "It

Engraving of Daniel Webster by John Sartain from a daguerreotype by John Adams Whipple. Used in *The Camera and the Pencil* by Marcus Aurelius Root. American Antiquarian Society.

Engraving by John C. Buttre from a daguerreotype of President James Buchanan by Mathew Brady. Otto Richter Library, University of Miami.

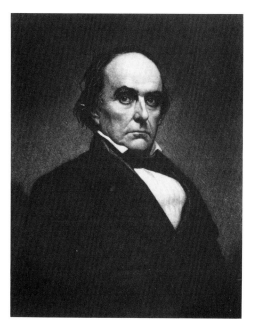

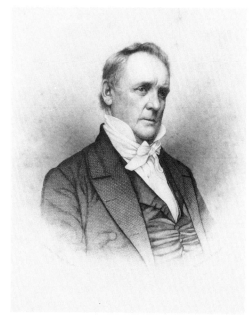

Engraving by J. B. Forrest from a daguerreotype of James Fenimore Cooper by James R. Chilton. Published in the *United States Magazine and Democratic Review* no. 15 (July 1844). Cooper is said to have disliked this portrait. American Antiquarian Society.

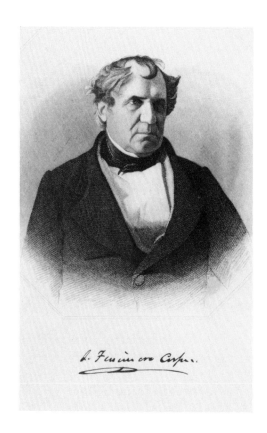

must be patent to those who give the matter any attention," he wrote, "that the public demand is for truth rather than for work which only shows this or that artist's treatment of the various scenes, highly artistic though they may be."[31]

Copies of daguerreotypes, whether produced by engraving or by redaguerreotyping the original, abounded in the 1840s and 1850s. Enterprising daguerreotypists realized the potential for profit in pictures of men and women in the news. Booksellers and newsstand proprietors sold lithographed and engraved copies of daguerreotypes, and photographic studios churned out daguerreotyped copies of their own celebrity clients. Photographers often invited people in the news to have their portraits made free of charge, and then simply kept one or more of the pictures from which to make reproductions later.

A ledger book from the Broadway studio of Mathew Brady, one of the best known and most prolific daguerreotypists in America, demonstrates his careful attention to the potential news value of his various clients. Those identified as congressmen, senators, or judges invariably had "complimentary" written after their names.[32]

Before long, complaints began to be heard about photographers who pestered the famous for a chance to take their pictures. One unhappy gentleman wished "there was no such discovery as Daguerre's for it is so annoying that it is impossible to go to New York, Boston, or Philadelphia, without being tormented by a dozen invitations to sit for a daguerreotype likeness." He recalled that during one twenty-four-hour stay in New York he received no less than twenty-one "very polite invitations" to allow one artist or another "the gratifying pleasure of adding a portrait of his most humble [self] to their collection." Such behavior appalled those who felt the daguerreotype could be a high and noble art. Samuel Humphrey wrote that the aggressive importunings of photographers would

but "lower the art you profess to follow" and cause "those very persons [to] think little of you, and but a trifle more of the art that causes him so much trouble."[33]

Such complaints did little to deter daguerreotypists. Advertisements in photographic journals and daily newspapers kept the public apprised of the pictures that major urban galleries had for sale, and they continually extolled the value of their daguerreotypes in paid announcements. In Providence, Rhode Island, for instance, daguerreotypist Henry N. Manchester bragged in 1853 about the superiority of daguerreotypes over hand-painted portraits. "No one who has the least appreciation of the beautiful and really valuable in a picture, can for one moment hesitate between a truly faithful, brilliant and deep-toned portrait . . . and a mere daub or caricature. . . . [Even] a poor Daguerreotype is dear at any price." Marcus Aurelius Root was evidently similarly disposed to advertising his own wares. "My extra-liberal use of printer's ink coupled with my repeated success in producing good pictures," he wrote, "not only augmented largely my own business, but induced hundreds beside to adopt the same vocation."[34]

In February 1851, the *Daguerreian Journal* announced that the Clark brothers' gallery in New York City was planning to publish a twenty-six-by-thirty-inch lithograph "containing correct likenesses of nearly fifty grand officers and distinguished invited guests in their appropriate regalia, as they appeared at the recent great Masonic Union Celebration at Tripler Hall." Later the same year, the Albany daguerreotypist S. L. Walker announced that he, too, was publishing a lithograph and that his would contain "correct likenesses" of all the members of the New York state senate.[35]

This style of combination print, a large picture made up of engraved copies of single daguerreotypes, was a common way of illustrating important events that could not easily be daguerreotyped. In the years

Engraving by Robert Whitechurch after Peter Frederick Rothermel of Henry Clay addressing the Senate. Made from daguerreotypes and published by William Smith in 1855. National Portrait Gallery, Smithsonian Institution.

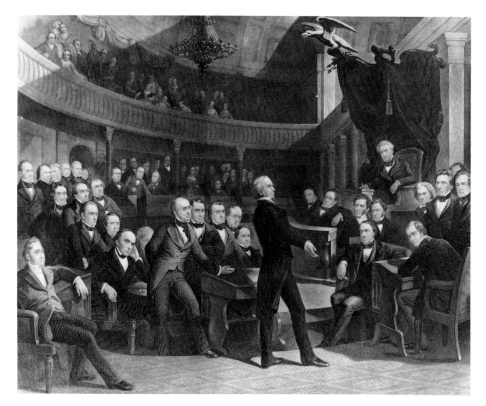

Daniel Webster Addressing the United States Senate in the Great Debate on the Compromise Measures of 1850, lithograph made from daguerreotypes by Eliphalet M. Brown, Jr. National Portrait Gallery, Smithsonian Institution.

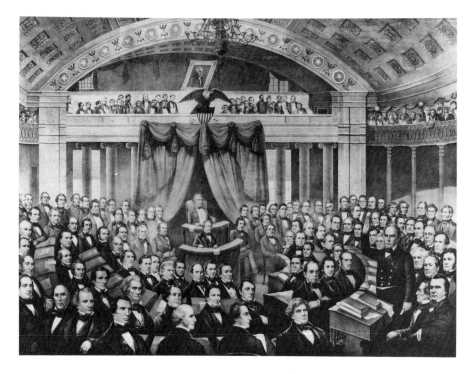

DANIEL WEBSTER ADDRESSING THE UNITED STATES SENATE

IN THE GREAT DEBATE ON THE COMPROMISE MEASURES 1850

prior to the Civil War, when great debates in Congress over slavery and its extension into the western territories electrified the nation, several firms published large prints made from daguerreotypes. One of the most popular of these was an engraving of the Senate chamber made from daguerreotypes taken of individual senators by Edward Anthony and his assistant, Victor Piard, in an unused committee room of the United States Capitol in 1842. The print was engraved by Thomas Doney and published in 1846.[36]

As photographers augmented their portfolios in the 1840s, portraits based upon their daguerreotypes began replacing the work of traditional artists in the periodical press. By August of 1842, for instance, steel engravings in the *United States Magazine and Democratic Review* were almost always copied from daguerreotypes. In the November 1842, edition, the editors explained the reasons for making the switch to daguerreotypes. That month they published a portrait of the president, John Tyler, made from a "remarkably fine daguerreotype likeness" by Augustus Morand from New York City. "A 'counterfeit presentment' of any human countenance, prince or peasant, needs no endorsement to its accuracy of resemblance," wrote the editors. Compared to the painted miniatures of Tyler then in circulation, which were described as the "veriest daubs of caricature," Morand's work demonstrated the "unflattering fidelity" of the daguerreotype process. Unflattering indeed: Tyler's nose had been rumored to be on the large size; Morand's portrait proved it to be of majestic proportions. The editors noted in this issue that in order to appease their Democratic subscribers, a future issue would contain a daguerreotype portrait of Roger B. Taney, a "Chief Magistrate of their own choice and election."[37]

Henry Hunt Snelling, editor of the *Photographic Art-Journal,* announced in his first issue, published in January 1851, that he, too, would regularly use daguerreotypes as illustration. He planned to publish a series of portraits of America's great daguerreotypists as well as "beautiful steel engravings" of well-known persons such as Jenny Lind, Henry Clay, Zachary Taylor, and others. Each portrait would be accompanied by a biographical essay. Snelling encouraged American photographers to submit their best images for possible inclusion in the magazine. Each winner would receive a new Voigtländer camera, the most sophisticated in the world, in addition to having his or her portrait printed in the magazine.[38]

Even in the early years of daguerreotypy in America, from 1839 to 1845, there was no shortage of portraits of the famous and infamous, for photographers rushed to obtain celebrity likenesses as a way of increasing their own income and notoriety. The daguerreotype came into vogue at a time when the country was in the thrall of men like Andrew Jackson, Daniel Webster, Henry Clay, and John C. Calhoun. One writer recalled in 1869 that publishers and photographers considered it imperative "to preserve their faces for posterity by the aid

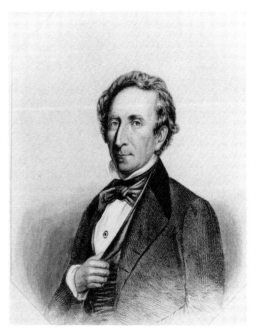

Engraving from a daguerreotype by Augustus Morand of President John Tyler. Published in the *United States Magazine and Democratic Review,* August 1842. American Antiquarian Society.

of the new process." And though these political leaders might have considered it an imposition to sit for "long and weary hours and days" while a painter painstakingly worked, they "made no objection to giving a flitting moment of their valuable time" to a daguerreotypist.[39]

While one may reasonably question whether a politician or anyone else for that matter would always be willing to sit for a photographer, there is evidence of a collective appreciation for the historical, documentary, and reportorial value of daguerreotypes. "If our children and children's children to the third and fourth generation are not in possession of portraits of their ancestors," wrote temperance advocate Timothy Shay Arthur in 1849, "it will be no fault of the Daguerreotypists of the present day."[40] Joel Whitney, the first na-

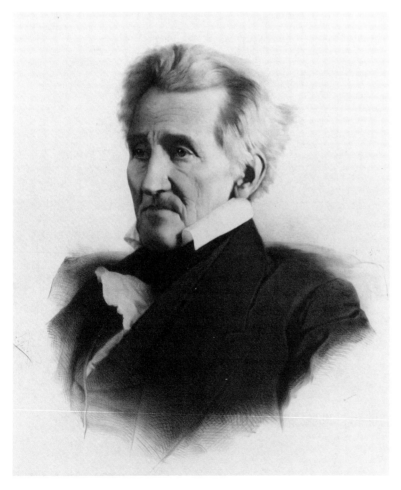

Lithograph by Adolphe Lafosse from a daguerreotype of Andrew Jackson, made by Mathew Brady shortly before Jackson's death at the Hermitage in Tennessee. National Portrait Gallery, Smithsonian Institution.

tionally known photographer in Minnesota, adopted a similar theme in a series of newspaper ads in the early 1850s. "There is a Reaper," he reminded his customers, "whose name is Death. And since no one can tell when he will thrust in his sickle and cut us off from life, NOW is the time to get your Picture taken."[41]

One of the those whose portrait was most desired was Andrew Jackson, who by the early 1840s had returned to his home in Tennessee, where he lived as a virtual invalid. He was daily besieged by persons seeking some small favor: his signature on a petition, a job recommendation, a well-placed word for some pet project. "I am dying as fast as I can," he complained, "and they all know it, but they will keep swarming upon me in crowds, seeking for office, intriguing for office."[42] Yet according to T. B. Thorpe, author of an article published in *Harper's Monthly* in 1869 that described how daguerreotypists had managed to secure likenesses of political leaders, Jackson remained solicitous of photographers who wished to procure one last portrait. Ignoring the wishes of his household staff, the former president inquired about the purpose of his visitors, "and against the positive advice of his attending physicians he persisted in gratifying those who had 'come so far' by having his picture taken."[43]

It should come as no surprise that nineteenth-century photographers were sometimes relentless in their quest for pictures of the rich and famous. In 1848, Charles Meade, an Albany, New York, daguerreotypist, sailed to Europe with his brother and partner, Henry, for the purpose of augmenting their collection of saleable images. While in France, Charles succeeded in obtaining several portraits of Daguerre, which was no small feat; the inventor of it all was notoriously camera shy. The *Photographic Art-Journal* reported enthusiastically that the brothers Meade "now possess the only Daguerreotypes of Daguerre in this country." Evidently, it was only with the great-

est difficulty, "and through the influence of Madame Daguerre," that Meade was able to persuade the great man to sit still for a moment.[44]

Several studios in Washington, D.C., New York, and other eastern cities compiled impressive portfolios of daguerreian portraits. These were often presented to the public in the form of photographic museums. The National Daguerreotype Miniature Gallery, owned by Edward Anthony, Howard Chilton, James R. Clark and Jonas Edwards, opened in New York in 1845 to favorable reviews. Among the portraits on display, reported the *New York Morning News,* were those of "the lamented Inman, the artist Weir, [and] Cassius M. Clay." As proof of the success of the gallery, the paper

Woodcut illustration of Josiah Gurney's Daguerrean Saloon, *New York Illustrated News,* June 11, 1853. American Antiquarian Society.

Woodcut illustration of Mathew Brady's New Daguerreotype Saloon. *New York Illustrated News,* June 11, 1853. American Antiquarian Society.

noted "the large and increasing patronage they are receiving, not only in this city, but from distinguished visitors to our city from all sections of the Union."[45] The success of the gallery was soon followed by that of John Plumbe's National Daguerreian Gallery and Mathew Brady's gallery on lower Broadway in New York. In each case, the gallery served as both exhibition hall and publishing concern. Daguerreotypes such as Anthony's fine portrait of Daniel Webster or Plumbe's of Washington Irving were printed as engravings and sold at the gallery.

Early in 1846 an article in the *New York Morning News* described Plumbe's collection of "exquisitely finished" portraits of the nation's leaders. Noting that the photographer had succeeded in obtaining likenesses of John Quincy Adams, Senator Dixon Lewis of Alabama, and Supreme Court justice Levi Woodbury, among others, the writer concluded that both "lovers of the arts" and "those who have the curiosity to look upon the lineaments of the great men who participate in the honors and responsibilities of the National Government, will derive an unalloyed gratification by visiting the room in which these pictures are now deposited."[46]

Plumbe, born in Wales in 1809, arrived in the United States with his family in 1821. His career in photography was in some ways typical of the careers of others who gravitated to the new medium in the 1840s. Originally trained as a civil engineer, Plumbe worked on railroad surveys in western Pennsylvania, Virginia, and North Carolina in the early 1830s. In 1838, he published a short treatise extolling the virtues of the western territories; his purpose was to spur emigration to Iowa and Wisconsin.[47] At the same time, Plumbe began lobbying for the construction of a transcontinental railroad. He moved to Washington, D.C., in 1840, ostensibly to continue his activities on behalf of the railroad and the western territories. But the prospects for federal sponsorship of public works projects was slim in 1840, for the economy had not recovered from the panic of 1837. His career as an engineer and publicist at a low ebb, Plumbe turned to daguerreotypy as a way to make a living. He learned the process from John G. Stevenson, a daguerreotypist and fellow boarder at Mrs. Cummings's house on Pennsylvania Avenue. Within a few years, Plumbe had his own gallery and was well on his way to becoming what Robert Taft called "America's first nationally known photographer."[48]

By 1846, Plumbe had branch studios (he called them "depots") in Baltimore, New York, Boston, Philadelphia, Dubuque, Cincinnati, St. Louis, Saratoga Springs, Newport, Albany, Louisville, and Harrodsburg Springs, Kentucky. Not content with the relatively simple and profitable business of making portraits, Plumbe began experimenting with methods of mass producing his pictures, especially those of political leaders. Many were copied onto lithographic stones and sold to the public as "Plumbeotypes." Plumbe also sold various of his daguerreotypes to magazines and journals.

Thomas Doney, one of the best-known engravers in the country, produced several fine mezzotint facsimiles of Plumbe's portraits for periodicals such as the *United States Magazine and Democratic Review* and the *American Whig Review*. In addition to his portrait work, Plumbe moved his camera outside the studio to take advantage of the public's interest in views of the nation's capital. "We are glad to learn that this artist is now engaged in taking views . . . which are executed in a style of elegance, that far surpasses any that we have ever seen," enthused the editors of the *United States Journal* in 1846. "It is [Plumbe's] intention to dispose of copies of these beautiful pictures, either in sets or singly, thus affording to all, an opportunity of securing perfect representations of the government buildings."[49]

Late in 1846, Plumbe announced the for-

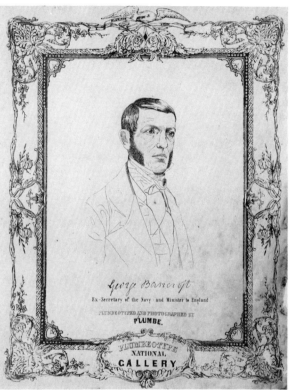

Daguerreotype (ca. 1844) of former secretary of the navy and ambassador to Great Britain George Bancroft, made by John Plumbe. National Portrait Gallery, Smithsonian Institution.

Plumbeotype of George Bancroft from a daguerreotype by John Plumbe. National Portrait Gallery, Smithsonian Institution.

mation of a new publishing enterprise called the National Plumbeotype Gallery, which would operate out of his Philadelphia studio. Plumbe promised prospective subscribers that he had "discovered a method of transferring beautiful copies of Daguerreotypes to paper," and he proposed to issue for fifteen dollars a year a "daily Portrait of some interesting public character on fine quarto paper, constituting an appropriate ornament to the centre table." At the end of each six months, subscribers would receive a free title page and index so that the entire work could be bound. The portraits, said Plumbe, would be exact duplicates of daguerreotypes of "Presidents of the United States, Vice Presidents, Heads of Departments, Members of Congress, Statesmen, Judges, Lawyers, Divines, Officers of the Army and Navy, Actors, Authors, Editors, Physicians, Poets, Artists, Musicians, [and] Distinguished Strangers."[50] Anyone with even a modicum of fame was considered fair game for his camera. Even more important, Plumbe was determined to mass produce his images, never for a moment accepting the uniqueness of the daguerreian image. He was thus one of the first to recognize the potential of photographs to be used as a medium of mass communication.

Plumbe's grand plan for publishing his pictures never came close to succeeding. In 1847, twenty-seven Plumbeotypes were produced, but besides varying considerably in quality, they bore little resemblance to the daguerreotypes on which they were based. Some, in fact, were little better than the crudest woodcuts or lithographs in line, and as a result, they attracted few subscribers.[51] At the same time that his National Plumbeotype Gallery was foundering, another of Plumbe's publishing projects, a general interest magazine called *Plumbe's Popular Magazine,* was also going under. By the end of 1847, Plumbe was destitute. Neither his lithographed Plumbeotypes nor his magazine caught the imagination of the public, but it was the greedy machinations of several of his far-flung gallery operators that triggered the final financial collapse. He was forced to sell all of his work as well as his equipment and studios.[52] After his financial demise, he headed west, to California, where he hoped to recoup his fortune in the gold fields along the American River. But he failed there, too, and died by his own hand in Dubuque, Iowa, in 1857, destitute, alone, and forgotten.

Plumbe's significance lies not so much in any of his photographs but in his comprehension of the ways that photographs could be used. He was one of the first American photographers to recognize the importance of the camera as a means of recording and storing information, and he began to systematically collect pictures of political leaders and the places in which they worked. At the same time, he was determined to make his images available to the general public via the printing press. Not satisfied with occasional sales of his work to monthly journals, Plumbe conceived the novel idea of producing pictures on a daily basis. But in 1847 the available printing technologies could not supply enough low-cost copies of daguerreotypes with sufficient detail to satisfy the public. Fine steel or copper engravings, mezzotints, and aquatints were both expensive and time consuming to produce. It was one thing to have Thomas Doney take a week or two to copy a daguerreotype for the *Democratic Review* with its limited circulation; such finesse was impractical and inefficient on a daily publication. Plumbe's only alternative was to have his pictures copied quickly and crudely, leaving out the minute photographic details that so captivated the public.

Mathew Brady, whose early fame as a photographer was due at least in part to his success at marketing his photographs of American celebrities, also ventured into the publishing business. Like Plumbe's attempt, however, Brady's *Gallery of Illustrious Americans* met with little success, a

victim of the high cost of producing fac-simile copies of daguerreotypes. Charles Edwards Lester, one of Brady's financial backers and the editor of the publication, noted in an article in the *Photographic Art-Journal* that "there had been National Galleries undertaken before this, but they had either failed for lack of encouragement, or been abandoned mid-way in their progress." Brady's effort, regarded initially as an "enterprise too formidable to excite the interest of any American publishers," would succeed, according to Lester, because of Brady himself, an artist whom he described as having a "reputation which belongs to no other man." With studios in Washington, D.C., and New York City, Brady had been assiduously adding to his collection since 1845 and had been able to obtain the daguerreotyped likeness of "almost every man of distinction among our countrymen, and those of ambassadors and celebrated men from foreign nations."[53]

To secure the best possible copies of his daguerreotypes, Brady hired Francis D'Av-ignon, whose lithographic work was highly regarded in America and Europe. Born in France and raised in Russia, D'Avignon came to the United States in 1842 at the height of the public's excitement over the new art of daguerreotyping. By 1850, he had established an unexcelled reputation for producing exquisitely detailed lithographic copies of daguerreotypes, though some printers complained that his stones were exceedingly difficult to use.[54] D'Avignon was well paid for his work on Brady's *Gallery*; he is said to have received one hundred dollars for each stone produced in addition to a share in the profits.

The original plan was for a run of twenty-four portraits, issued at regular intervals beginning early in 1850. Apparently, Brady and Lester also planned to market the *Gallery* in England. An article in the *London Illustrated News* indicated that the portraits were available at a printing establishment in Cheapside. By the end of 1850, however, after only twelve portraits were printed, the enterprise failed. The high

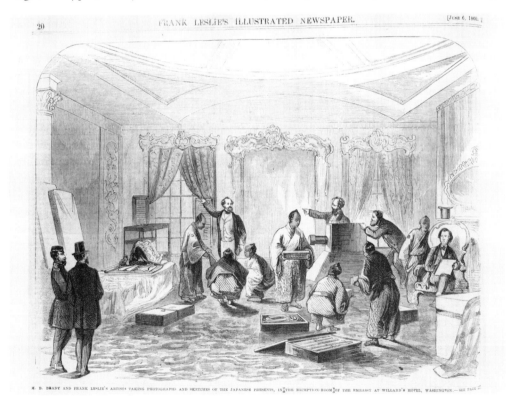

Woodcut illustration of Mathew Brady and a sketch artist making photographs and drawings in a reception room of Willard's Hotel in Washington, D.C., of presents brought by the first Japanese envoys to the United States. *Frank Leslie's Illustrated Newspaper,* June 6, 1880. American Antiquarian Society.

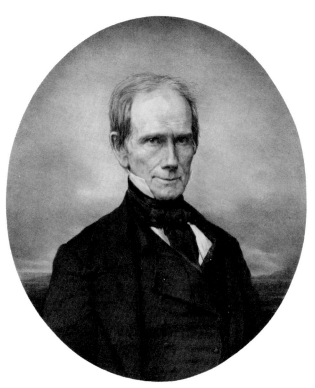

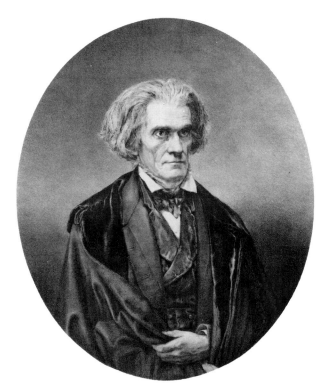

Lithograph of Henry
Clay made by Francis
D'Avignon from a da-
guerreotype by Mathew
Brady. Published in
*Gallery of Illustrious
Americans,* 1850. Na-
tional Portrait Gallery,
Smithsonian Institution.

Lithograph of John C.
Calhoun made by Fran-
cis D'Avignon from a
daguerreotype by Ma-
thew Brady. Published
in C. Edwards Lester,
ed. (New York: M. B.
Brady, F. D'Avignon,
and C. Edwards Lester,
Publishers, 1850). Na-
tional Portrait Gallery,
Smithsonian Institution.

costs of production were simply not offset by the number of paid subscribers. Nonetheless, Brady's effort is noteworthy if only as a precursor of contemporary magazines that furnish an avid public with endless pictures of men and women in the news. As historian William Stapp rightly contends, Brady's attempt to publish high quality copies of his daguerreotypes is testimony to his understanding of the potential of photographs to inform and entertain the general public.

In spite of its failure, *The Gallery* was a monumental concept, and enough examples of it have survived to make its plates of famous Americans, such as John J. Audubon, the best known of D'Avignon's lithographs. Although Brady, D'Avignon and Company did not survive the year, the partnership produced one of the great moments in the history of American portrait prints and . . . American photography.[55]

Unlike Plumbe, whose photographic empire crumbled when his publishing operations failed, Brady hardly slowed down at all. He continued to photograph political, theatrical, and artistic celebrities and to make his work available to the periodical press in this country and in Europe.[56] By the mid–1850s, the credit "From a daguerreotype by Brady" was an expected addition to printed portraits of the famous, and Brady himself became something of a celebrity. The luster of his subjects seemed to rub off on him, and he became America's unofficial, self-appointed court photographer. In 1856, Frank Leslie said as much in an article explaining the use of pictures on the pages of his new illustrated newspaper.

We have established a rule in the management of our pictorial columns of letting our illustrations speak for themselves. Without regard to trouble or expense we endeavor to produce the best things possible for a great American newspaper. Our success in one of our illustrated departments has been marked, and has called forth much admiration—we allude to the production of portraits of eminent men. In accomplishing this, we are greatly indebted to the enthusiasm and untiring efforts of Mr. M. B. Brady, whose National Gallery of Daguerreotypes has been of signal importance to publishers throughout the Union.[57]

The author of the article added that the engraving on the cover, a portrait of lawyer and diplomat Andrew Jackson Donelson, had been copied from a daguerreotype "taken by Mr. Brady from life, especially for this paper, and which has been so faithfully transferred to the wood that all who see it may rest assured that it is life-like."[58] Encouraged by the success of Brady and a few of his colleagues in the major cities of the East, daguerreotypists began making their work available to publishers. And the press in turn began giving out photographic assignments, thus assuring the exclusivity of their illustrations.

When impresario P. T. Barnum finally persuaded Jenny Lind, the "Swedish Nightingale," to come to America in 1850—a transaction sweetened considerably by his promise to pay her a thousand dollars for each performance—Brady was one of a number of photographers who made and distributed her portrait. In this he had to circumvent Barnum, who was determined to keep for himself the proceeds of sales of all Jenny Lind mementoes. To promote Lind, who was little known in America, Barnum mounted an enormous advertising campaign. Among other things, he supplied free portraits of her to any magazine or newspaper that expressed even the slightest interest in running a story about her.[59] Barnum was thus in direct competition with photographers who were similarly anxious to sell views of Miss Lind.

Brady managed to elude Barnum, however, and made a picture of Lind that some in the press called "unrivalled."[60] In an interview with George Alfred Townsend, a noted war correspondent with Joseph Pulitzer's *New York World,* Brady recalled, just

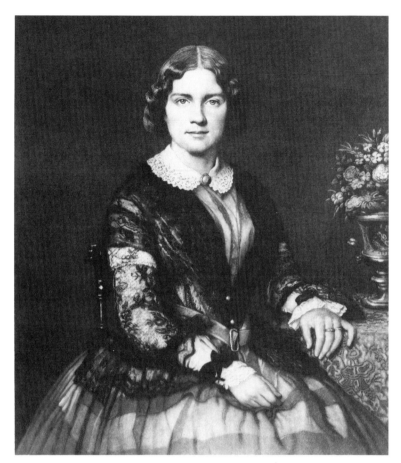

Mezzotint of Jenny Lind, "The Swedish Nightingale," made by John Sartain from a daguerreotype by Frederick DeBourg Richards. Published in *Eclectic Magazine,* June 1857. Library of Congress.

five years before he died, how he managed to avoid Barnum. When the great showman kept deferring his frequent requests for a private picture session, Brady "found an old schoolmate of [Lind's] . . . who lived in Chicago, and he got the sitting."[61]

Lind's 1850 tour of America was an enormous success, due in no small measure to Barnum's ability to capture the attention of the public. By the time the singer arrived in New York on Sunday, September 1, the American public was fully primed to make her American tour a triumphant success. "Never, in the history of music or in the history of entertainment in America, [had] the advent of a foreign artist been hailed with so much enthusiasm," wrote Joel Benton, Barnum's biographer.[62] Photographers clamored for her picture, though few managed to secure a good likeness. The price paid for daguerreotyped and engraved copies rose steadily. "There has been a great demand among our Artists and others for Daguerreotype likenesses of Jenny Lind," reported the *Daguerreian Journal* in November. "Each seems desirous of adding a metallic immortality of this gifted songstress" to his collection. Single images, which were often duplicated and issued without credit given to the original photographer, "readily sold for from five to twenty-five dollars."[63]

Frederick DeBourg Richards, a young daguerreotypist from Philadelphia, managed to make something of a name for himself not only by photographing Lind successfully but also for entertaining her for the better part of a day. At its annual fairs, the Franklin Institute regularly exhibited the work of Richards, who began photographing in 1848 at the age of twenty-six. When Lind's tour reached Philadelphia, she was persuaded to visit Richard's gallery and studio, located in rooms formerly occupied by Montgomery Simmons, a daguerreotypist best known for hand-tinting his pictures. The *Daguerreian Journal* noted with some pride that Richards's portraits of Lind

were judged "to be fully equal, if not superior, to any ever taken of this lady," and added that she was "so well pleased with either Mr. R or his pictures, that she spent nearly a whole day at his rooms."[64] Richards advertised his portraits in both the local and photographic press. "Thinking that perhaps Daguerreotypists . . . would like to have a copy of Jenny Lind, and as it is allowed by all that my picture of her is the best in America," he wrote, "I will sell copies at the following prices—one sixth, $2; one fourth, $4; one half, $6."[65]

Brady, Richards, Plumbe, and others in the business of photography relied heavily on the press to run their pictures and so to keep their names before the public. "In those days a photographer ran his career upon the celebrities who came to him," Brady told Townsend, "and . . . most of the pictures I see floating about this country are from my ill-protected portraits." Brady, like Plumbe before him, never accepted the idea that the daguerreotype was one of a kind; he saw that its true value was in its reproduction on the printed page. "My gallery has been the magazine to illustrate all the publications in the land," he said. "The illustrated papers got nearly all their portraits and war scenes from my camera."[66] Daguerreotype portraits, whether published as engravings, woodcuts, aquatints, lithographs, or mezzotints; copied for distribution as daguerreotypes; or kept and treasured as unique and personal mementoes, were a staple of the photographic business in America in the 1840s and 1850s. "What a happy consolation!" exclaimed H. J. Rogers, who spent more than two decades making portraits and other pictures in Connecticut. "We are not aware," he said, "of the immeasurable extent and degree to which our domestic and social affections, and sentiments, are perpetuated and purified as we solitarily look upon the shadows of the departed, absent friends."[67]

Not that every person was delighted with the results of his or her sitting. John Quincy Adams felt that the portraits made of him during a stopover in Utica, New York, were "all hideous"; Ralph Waldo Emerson told a friend that he was "no subject for art, but looked like a pirate"; Washington Irving refused nearly all requests to sit for photographers after 1854 (he was especially displeased with a set of portraits made by Brady); and Horace Greeley told New York photographer George Rockwood that he was "always aversed [sic] to being photographed."[68] Photographers did not take these and other complaints too seriously. After all, there was seldom any shortage of willing, enthusiastic subjects. The most common retort to unhappy customers was a quick reference to the mechanical exactitude of the art. In a daguerreotype, said photographers, you are what you look like. "If people when sitting for pictures *will* look dull, void, vacant, cross, staring, meaningless, statuelike," said Rogers, "they cannot expect by this means to reproduce the individuality of the soul."[69] "Indifference," warned the *Daguerreian Journal,* "is the best expression for a Daguerreotype." As for photographers, they were reminded that their most formidable enemy was "incontestably human vanity."[70]

By the early 1850s, photography in the daguerreian form was firmly established in America, not only as a new and democratic art, but as an indispensable arm of the press. Various methods of duplicating daguerreotypes had been perfected, making the photographic portrait an item for mass consumption. As art historian Beatrice Farwell contends, "Never before in history had the products of highly skilled draftsmen been translated with such fidelity into mass produced form as with the invention of lithography and wood engraving." She notes further that between 1820 and 1850 the "printing and publishing industries were transformed by the new availability of pictures . . . for the new mass market."[71]

In America, several well-publicized innovations in the process of making da-

Wood engraving of the aftermath of a fire that destroyed the Pemberton Mills in Lawrence, Massachusetts, in January 1860, made from a daguerreotype by John Adams Whipple. American Antiquarian Society.

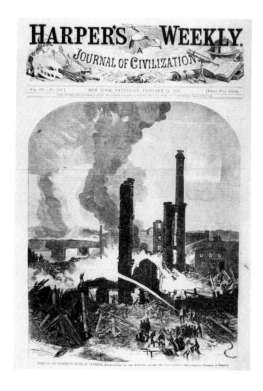

guerreotypes improved both their quality and popularity, and European daguerreotypists soon began advertising that they employed the "American Process." Electroplating and steam-driven, high-speed buffing of the silver-coated copper plates; the use of chemicals known as "quickstuff" (principally bromine and chlorine) that significantly increased the light sensitivity of the plate; and improvements in cameras and lenses made portrait sessions relatively quick and painless.[72] "By modifications," wrote an enthusiast in 1855, "these processes have been greatly increased in sensibility; the result which formerly required twenty minutes being now obtained in as many seconds."[73] By the mid–1840s, most portraits were made with exposures of under ten seconds and occasionally faster. *Dwight's American Magazine* reported in 1847 that the daguerreotype "has been brought to such high perfection that pictures are obtained in the very short space of half a second and thus very transient objects are represented."[74]

When Horace Greeley traveled to Europe in the summer of 1851 to see, among other things, the Crystal Palace exhibition in London, he was unprepared for the paucity of the American display. Our manufacturing exhibits were "grossly deficient," he wrote, or "inferior to the best rival productions in Europe." In only one area did the American efforts vanquish the competition. "In Daguerreotypes, it seems to be conceded that we beat the world," wrote Greeley, "when excellence and cheapness are both considered. At all events, England is no where in comparison."[75] At the fair, Mathew Brady and Martin Lawrence of New York were awarded medals for their portraits, and Bostonian John Adams Whipple won a Council Medal for his daguerreotypes of the moon.

Although it was certainly easier for photographers to confine their work to the studio or gallery, where they made routine, standardized images of clients with all the necessary materials for development and presentation close at hand, photographers like Whipple and Plumbe slowly expanded the ways in which photography was practiced in the 1840s. If daguerreotypes could record the subtle contours of the human face, capturing in the process a sense of the character and personality of the sitter, then it was fair to assume that the camera could also describe the world outside the artist's cozy nook. And if daguerreotypes could be used to record for posterity the countenances of men and women in the news, it might also be used to depict actual news events. Doing so would not be easy, however, principally because the process was still slow and cumbersome.

From 1839 to the time of the introduction of the wet-plate process in 1851, the emphasis was on stillness. Subjects were advised to remain motionless during the exposure, and as a precaution, wrought iron clamps were used to hold one's head firmly in place.[76] The need to remain perfectly rigid for several seconds, staring with fixed expression into the lens, made por-

trait sessions something of an ordeal. "In the earlier days, when only iodine was used as a sensitizer," wrote James Ryder, "a long time was required to impress the plate. The poor martyr who sat for an hour in direct sunlight was paying dearly for his likeness."[77] Children were a particular problem. Unless asleep, or dead (postmortem portraits of children were common), they sometimes appeared as little more than indistinct blurs on the finished plate. The family portrait, at times, was not a pretty sight.

The camera was not destined to remain long inside four walls, however, its single lens permanently pointed at the stationary, skylit faces of innumerable clients. Itinerant daguerreotypists early emerged as an alternative to photographers in the staid city studios. They worked in floating galleries on streams and rivers or traveled by horse from town to town, setting up crude, temporary studios for a few days and then moving on, demonstrating the mobile possibilities of daguerreotypy. Regardless of the formidable chemical and mechanical requirements of the process, the operator was not compelled to work in some urban photo factory wherein nothing was left to chance. Itinerants "form no inconsiderable portion of the fraternity," wrote A. B. Fenton in 1851. "They are environed by obstacles which present themselves in various and particular ways," he wrote, adding that the photographer "will find it next to impossible to pursue his profession with the same success when compelled to change his rooms thrice, twice, or even once a month."[78] Still, it could be done. It was done.

As early as 1841, daguerreotypes made in the open air, miles from any studio or gallery, were used to settle a pernicious boundary dispute between Great Britain and the United States. The territory in question lay along the border between Maine and New Brunswick, Canada. The United States claimed that American territory included

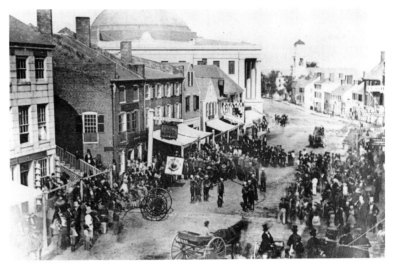

Daguerreotype of muster of Engine Company Casco Number 1, Middle Street, Portland, Maine, made by Marcus Ormsbee, ca. 1847. Maine Historical Society.

some prominent headlands on the banks of the St. John River, headlands the existence of which the British denied altogether. Secretary of State Daniel Webster sent James Renwick, a civil engineer and professor at Columbia College, to the territory in question with instructions to return with scientific evidence to bolster the American position. Renwick asked that his former student, Edward Anthony, accompany the expedition with whatever equipment was necessary to make daguerreotypes. Anthony agreed to go, and Renwick submitted copies of the resulting images to the boundary commission. In the Webster-Ashburton Treaty, signed on August 9, 1842, the United States settled for about seven-tenths of the disputed land, including the headlands photographed by Anthony.[79]

Years later, Anthony spoke of his stint as a photographer for the government at a meeting of the Photographic Section of the American Institute.

The boundary was described as running along the highlands between the rivers emptying into the Atlantic Ocean and those emptying into the St. Lawrence. On the land claimed by the United States, Great Britain asserted there were no highlands. . . . [T]hough the facilities for making views in the wilderness were very poor at that time, yet I succeeded in taking a number

of the objects required, which were copied in water colors, and deposited in the archives of the State Department at Washington. [80]

What was merely difficult for Anthony was practically impossible for Solomon Nunes Carvalho, a daguerreotypist and painter from Charleston, South Carolina. He accompanied Colonel John Charles Frémont on his fifth and last expedition across the Rocky Mountains to California and the Pacific in 1853, the purpose of which was to establish the most viable route for the first transcontinental railroad. On a sudden impulse, without consulting with his family, Carvalho, then thirty-eight years old, agreed to join Frémont's party as the official artist-photographer "with the full expectation of being exposed to all the inclemencies of an arctic winter." For Carvalho, city born and bred, the expedition was one long adventure. He was given an Indian pony said to be a "first-rate buffalo horse," but he knew nothing at all about horses. "My sedentary employment in a city," he wrote, had not "required me to do such offices; and now I was to become my own ostler, and ride him to water twice a day, besides running after him on the prairie for an hour sometimes before I could catch him." [81]

Eventually Carvalho learned enough to be able to cope with his pony and keep up with the others. But photographing on the plains of Kansas and in the deep snows of the high Rockies was another matter altogether. As Frémont knew, the unsettled West was a difficult place in which to make pictures. He had attempted to take daguerreotypes of his own on his first expedition on the Oregon Trail in 1842 but had failed decisively. Charles Preuss, that expedition's German cartographer, commented acidly in his diary about Frémont's photographic experiments:

Yesterday afternoon and this morning, Frémont set up with daguerreotype to photograph the rocks; he spoiled five plates that way. Not a

thing was to be seen on them. That's the way it is with these Americans. They know everything, they can do everything, and when they are put to a test, they fail miserably. [82]

Apparently, none of Frémont's efforts on that or any of his subsequent trips were successful—thus his decision to take along a professional on his last trip.

Carvalho also had problems making pictures, though he ultimately succeeded. It took him nearly two hours to complete each exposure, since in every instance his equipment had to be unpacked, a plate or two prepared, exposed, developed, and fixed, and then the whole lot carefully repacked and loaded onto a cantankerous mule. [83] He found that the turbid water on the flat plains of Kansas was "quite unfit for daguerreotype purposes," and in the high country, freezing temperatures and snow made everything, even staying alive, difficult.

To make daguerreotypes in the open air, in a temperature varying from freezing point to thirty degrees below zero, requires different

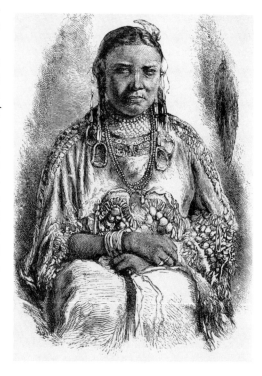

Wood engraving of a Cheyenne woman from a daguerreotype by Solomon N. Carvalho. Published in John Charles Frémont's *Memoirs of My Life*. Otto Richter Library, University of Miami.

manipulation from the processes by which pictures are made in a warm room. My professional friends were all of the opinion that the elements would be against my success. Buffing and coating plates, and mercurializing them, on the summit of the Rocky Mountains, standing at times up to one's middle in snow, with no covering above save the arched vault of heaven, seemed to our city friends one of the impossibilities. . . . I encountered many difficulties, but I was well prepared to meet them by having acquired a scientific and practical knowledge of the chemicals I used, as well as of the theory of light: a fine determination to succeed also aided me in producing results which, to my knowledge, have never been accomplished under similar circumstances.[84]

Carvalho left the expedition in Parowan, Utah, too ill with scurvy, dysentery, and frostbite to continue. He stashed his daguerreotypes and equipment high in the mountains. Frémont eventually retrieved them and sent the images to New York to be prepared for publication. The pictures made by Carvalho were considered the property of Frémont, who had paid for the expedition himself. Nothing in Carvalho's or Frémont's later writings suggests that Frémont somehow absconded with the work of his photographer, and in 1856 Carvalho campaigned for Frémont after he was nominated as the first presidential candidate of the Republican party.

In any event, the question of ownership is moot, since the original images were lost. In the introduction to her husband's memoirs, Jessie Benton Frémont provided both the rationale for their use and a possible explanation for their disappearance. Carvalho's plates had been taken by Frémont to California and then sent by ship to New York. "Their long journeying by mule through storms and snows across the Sierras," wrote Mrs. Frémont, "then the searching tropical damp of the sea voyage back across the Isthmus, left them unharmed and remarkably clear, and, so far as is known, give the first connected series of

views by daguerre of an unknown country, in pictures as truthful as they are beautiful."[85]

In New York during the winter of 1855–1856, Frémont had the views meticulously copied by Mathew Brady, who used the newly perfected paper processes. Then, in a small studio in Frémont's home, James Hamilton, an artist well-known for his book illustrations, and John Ross Key, grandson of the composer of the national anthem, made wood engravings and oil copies of the images. What became of Carvalho's original plates or Brady's paper copies after this is a mystery. Jessie Frémont said that all the materials for her husband's book were placed in a fireproof warehouse in Washington, D.C., in 1878, but the place burned to the ground in October 1881. Though the steel plates and wood engravings made by Hamilton and Key survived intact, shielded from the flames by being placed in underground safes, "choice books, pictures, and other treasured things" were reduced to ashes.[86] It is possible that the Carvalho plates and Brady copies were among the objects lost in that fire.

At about the same time that Carvalho struggled through the mountains on an unpredictable Indian pony, a daguerreotypist named Eliphalet Brown, Jr., traveled halfway around the world to compile a photographic record of Commodore Matthew Perry's official voyage to the Orient. When news of Perry's plans to steam to Japan reached the public in 1851, the commodore was inundated with requests "from all quarters of the civilized world" to go along. "Literary and scientific men, European as well as native, and travellers by profession" eagerly sought an opportunity to accompany Perry, according to Francis Hawks, author of the official narrative of the expedition. Perry, however, "resolutely persisted" in giving unqualified refusals to such requests, though he did make room for Brown as well as for an artist named

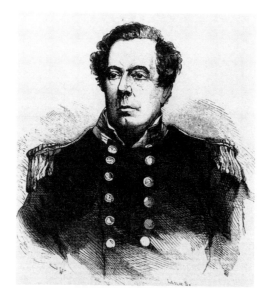

Wilhelm Heine in order that precise visual records be made of the opening of the Orient.[87]

Brown had achieved some success as an artist and photographer in New York City and Washington, D.C., prior to signing on with Perry. He produced several lithographs for Currier and Ives, and like Edward Anthony, he made daguerreotypes of each United States senator during the great debates of 1850. Brown's portraits were used in a composite print, *Daniel Webster Addressing the Senate,* published by James Edney in 1860.

An engraving of Perry copied from a daguerreotype made by Brown in the early 1850s was published in the *New York Illustrated News* in 1853. It is possible that the commodore admired the portrait and the demeanor of the photographer who made it, and thus invited Brown to join him on his Pacific trip. Both Brown and Heine enlisted at the rank of acting master's mate before leaving the United States, for Perry was loathe to have his ships populated by civilians. Upon his return in 1854, Brown supervised the publication by Sarony and Company of lithographs made from his daguerreotypes (he had produced over four hundred), though he did not immediately leave the navy.[88] During the Civil War he earned the rank of ensign. After the war, he was appointed admiral's secretary in the Mediterranean Squadron, a position he held until his retirement from the service in 1875.[89]

Perry's expedition to the Orient and the subsequent decision by the Japanese to return the favor by sending a delegation of

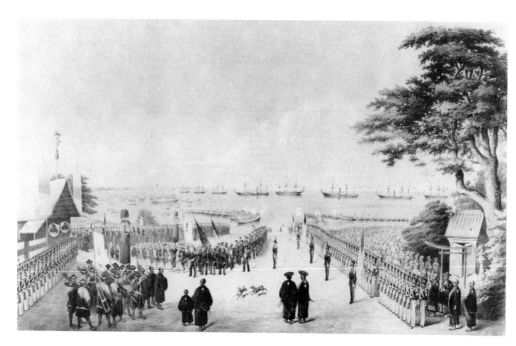

their own to America were major news stories. Brady, the Meade brothers, and several other photographers made pictures of the Japanese when they toured America in 1853. Their images were copied onto woodblocks by engravers and published in the popular illustrated press.

When gold was discovered in 1848 at Captain John August Sutter's sawmill on the American River in California, there was a stampede not just to get out to the diggings but to memorialize the adventure with a daguerreotype or two. Views of the gold fields, the ramshackle mining towns, the dusty tent cities of prospectors, and the extraordinary contraptions used to pry from the earth the flecks and nuggets of precious metal were made by Robert H. Vance and others from San Francisco and exhibited widely in the East. James Ryder remembered the gold-rush days as being especially good for business. "Before leaving on this desperate enterprise," he wrote, "daguerreotypes were wanted to leave with friends, and it gave me work. Many who came for likenesses brought with them outfits to be shown in their pictures . . . [such as] tents, blankets, frying pans in which to cook bear meat, buffalo steaks and smaller game by the way, and to wash out their gold on reaching the diggings."[90]

"The daguerreotype is especially suited to reproduce all those mechanical mining devices," wrote Edward Vischer, a German visitor to California, in 1859. He was especially impressed with the panoramic views made by Robert H. Vance, whose work was shown on the West Coast as well as in New York City.[91] Samuel Humphrey was similarly enthusiastic about Vance's pictures. Upon seeing some three hundred daguerreotypes made in the gold fields, Humphrey wrote that despite the "disadvantage of operating in a tent or the open air, and in a new country," Vance produced work that "will compare with any taken with all conveniences at hand." He photographed with a reporter's eye for significant

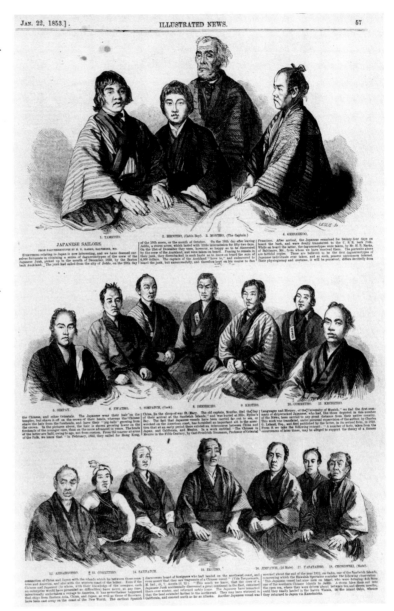

Wood engravings of shipwrecked Japanese sailors from daguerreotypes by Baltimore photographer H. K. Marks. Published in the *New York Illustrated News,* January 22, 1853. American Antiquarian Society.

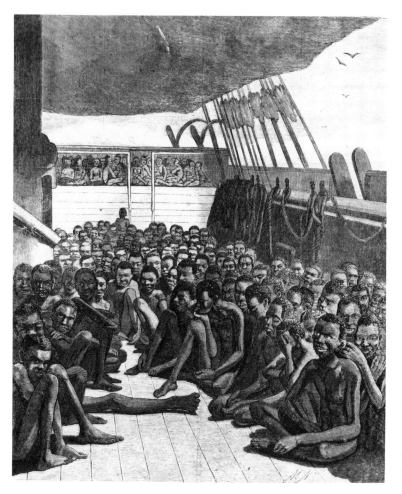

"The slave deck of the bark 'Wildfire,' brought into Key West on April 30, 1860," wood engraving from an unattributed daguerreotype. Otto Richter Library, University of Miami.

eral favorable reviews of his panoramic daguerreotypes of San Francisco and the gold fields. In McIntyre's work, the emphasis was on the human element. He had succeeded in "picturing 'all sorts' [of] men, with spade and tin pan in hand, eagerly looking after the dust," wrote Samuel Humphrey. Some examined "a lump just found," and others waded in knee-deep water; one man looked up at the camera with a grin, "exhibiting 'something' in his pan which he no doubt would try to make us believe was the metal."[93]

Images made and published or distributed by Carvalho, Brown, Vance, Anthony, and McIntyre proved that daguerreotypy could be a mobile art. There was a growing realization among photographers and publishers that daguerreotypes captured more than just faces, that events, too, and faraway places could be recorded. It seemed now that photographers could go nearly anywhere and make pictures that might be used as a kind of visual narration.

One of the most peripatetic American daguerreotypists was H. Whittemore, originally of Worcester, Massachusetts, who photographed extensively in South America in the early 1850s. At the annual fair of the American Institute of the City of New York in 1851, Whittemore exhibited work made in Barbados, Nassau, Cuba, Trinidad, Key West, New Orleans, Niagara Falls, and Apalachicola, Florida. Humphrey noted in the fall of 1851 that Whittemore had received an offer from "the publisher of a well-known illustrated newspaper in London," yet another indication that the press was beginning to pay attention to the potential of photographs as illustrations.[94]

detail. The gold rush was a news event, and Vance intended his pictures to tell the story. He made portraits of Captain Sutter and his family as well as panoramic views of Stockton, Colomu, Gold Rush, Carson's Creek, Marysville, and Sacramento. "We do not know of any mode of fixing upon the metallic plate the perfection of nature, to equal that of the Daguerreotype," wrote Humphrey. In Vance's work, every line was "faithfully portrayed" and possessed "a minuteness of detail not to be equalled by the hand of man."[92]

Vance was not the only daguerreotypist to ply his trade in California, nor was he alone in attempting a kind of journalistic coverage. S. C. McIntyre, who worked as a dentist in Tallahassee, Florida, before heading west with his camera, received sev-

As the speed and portability of photography increased, so did the prospects for recording spot news. Daguerre had originally contended that even portraits would be impossible to obtain, since no one would be willing to sit still long enough to make an impression on the sensitized plate. But as

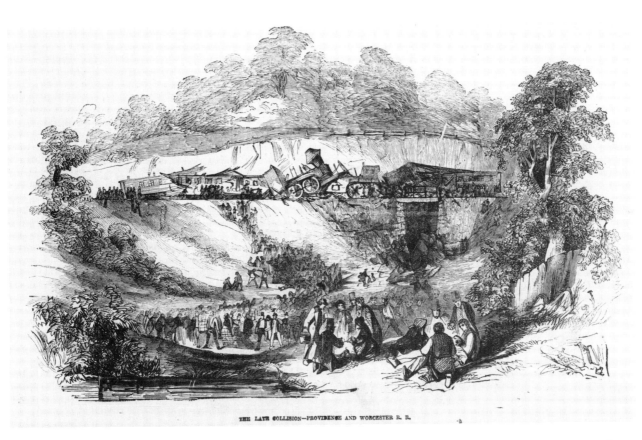

THE LATE COLLISION—PROVIDENCE AND WORCESTER R. R.

Wood engraving of a train wreck on the Providence-Worcester Railroad, August 12, 1853, from a daguerreotype by L. Wright. Published in the *New York Illustrated News* on August 27, 1853. American Antiquarian Society.

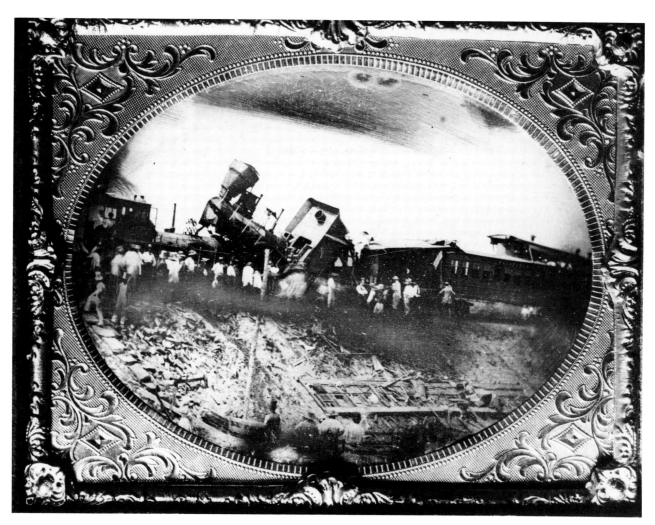

Original daguerreotype
by L. Wright of the
train wreck on the
Providence-Worcester
Railroad. International
Museum of Photogra-
phy at George Eastman
House.

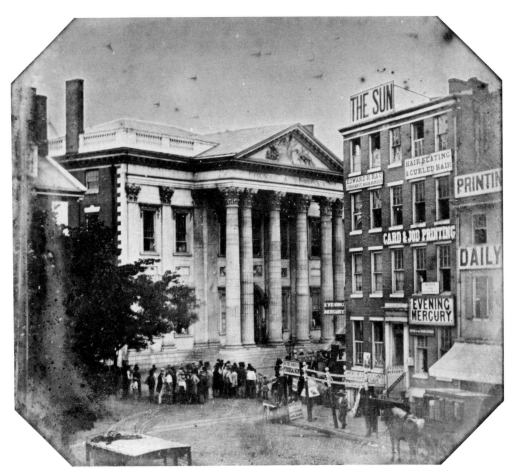

Daguerreotype made by William and Frederick Langenheim on May 9, 1844, during the military occupation of Philadelphia. Library Company of Philadelphia.

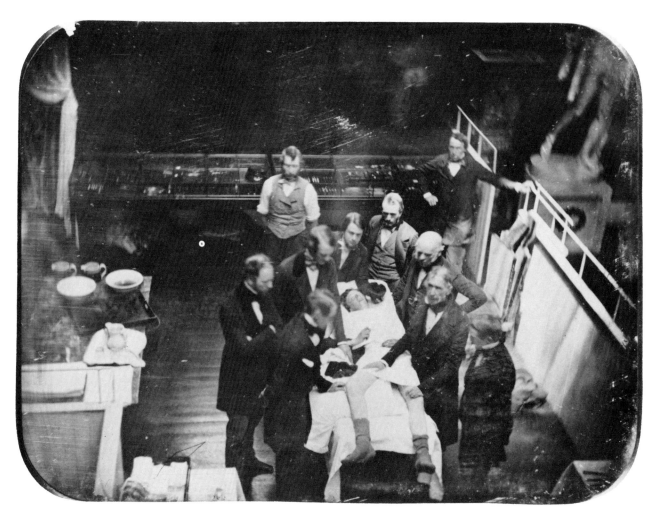

Daguerreotype made by Josiah Hawes in October 1846 showing a surgical patient under ether. The person with his hands on the patient's legs is Dr. John Collins Warren, chief surgeon and cofounder of Massachusetts General Hospital. At Dr. Warren's left is Dr. Oliver Wendell Holmes, father of the Supreme Court justice. Massachusetts General Hospital.

photographers moved away from their studios, taking their cameras outside where things moved about without warning, where light itself was unpredictable, they learned that they could produce good, clear pictures in all kinds of situations.

In May of 1844, the city of Philadelphia was the scene of bitter rioting between Protestants, most of whom were native born, and Irish Catholic immigrants. The local school board had determined in 1843 that it was permissible for Catholic children to use the Douay version of the Bible and that they might be excused from attending Protestant exercises. This decision incensed local anti-Catholics, who formed the American Republican party with an eye to taking control of city government in the spring elections. During the campaign, nativist Americans marched into the Kensington area of Philadelphia, an Irish enclave. Rioting ensued and a Protestant boy was killed. In retaliation, some thirty homes and two Catholic churches were put to the torch. The state militia was called out, and troops from the USS *Princeton* dispatched to the troubled area.

The Langenheim brothers, William and Frederick, made a daguerreotype on May 9, 1844, that must stand as one of the earliest attempts to make a spot news picture in America. The view reveals a deceptively placid urban street corner. On the right is a four-story brick building housing a variety of small businesses, and in the center stands an impressive, columned edifice outside of which stand some twenty-five or thirty men, many wearing stovepipe hats. Just barely visible, half-hidden in the shadowy gloom of the center building's portico, stands a uniformed figure. One can barely make out the white straps crossed on his breast. A penciled notation on the reverse of the original plate provides the full story. "Northeast corner of Third and Dock Street[s], Girard Bank, at the time the latter was occupied by the Military during the Riots."[95]

Boston daguerreotypist Josiah Johnson Hawes nearly recorded a more sedate news event, the first use of anesthesia on a surgical patient in America, in mid-October 1846; but the prospect of seeing blood so unnerved the photographer that he left the operating theater at Massachusetts General Hospital without making a single image. He was not forever daunted, however. Several days later, he returned and made at least two views of a young man splayed on an operating room table, surrounded by nattily dressed physicians who seem to be waiting for the photographer to make his pictures before they begin cutting. The mask containing ether can be seen lying by the patient's head. This was actually the third operation performed with anesthesia, and so it lacked some of the news value of the first. Usually, however, the caption of this picture indicated that it was, indeed, the first operation of its kind.[96]

George N. Barnard, who would achieve a measure of fame as the official photographer on General William Tecumseh Sherman's long march through the heart of the Confederacy during the Civil War, manifested an early appreciation of the camera's capacity to record news events. Born in Coventry, Connecticut, Barnard became a photographer in 1842 and for five years worked as an itinerant in New England and New York. In 1847, he settled in Oswego, New York, where he became an active member of the daguerreian community. In 1853, he was elected secretary of the New York Daguerreian Association. A year later he was awarded an honorable mention in Anthony's Prize Competition for a whole-plate daguerreotype entitled *Woodsawyer's Nooning*. Although made in the studio, the image was meant to depict an actual scene. "It represents an aged Canadian Woodsawyer and his son," wrote Barnard, "sur-

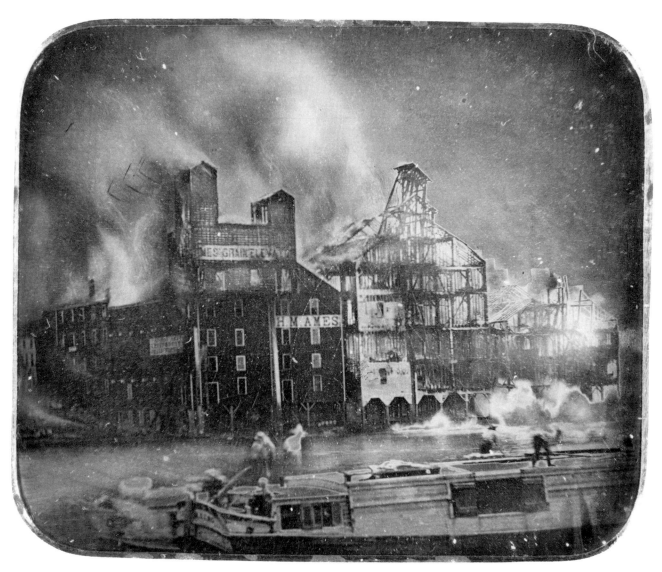

One of the copies made
by George N. Barnard
from his original da-
guerreotype of burning
mills, Oswego, New
York, July 5, 1853. In-
ternational Museum of
Photography at George
Eastman House.

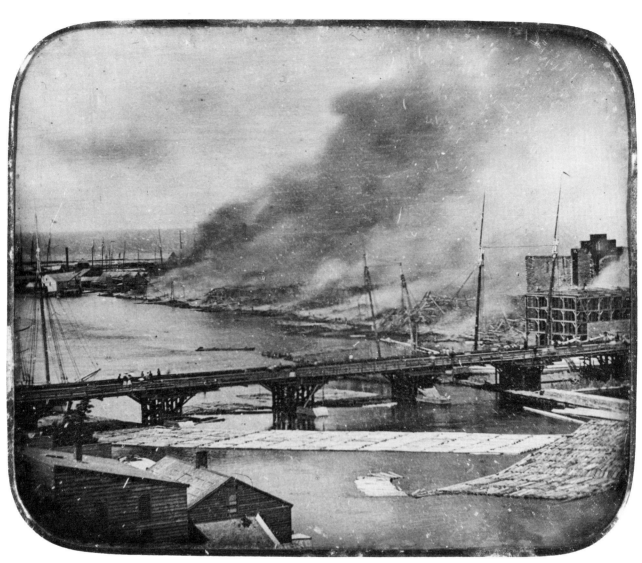

Overall view of the Os-
wego mill fire by
George N. Barnard. In-
ternational Museum of
Photography at George
Eastman House.

rounded by the instruments and objects of their labor."[97]

On July 5, 1853, Barnard made at least two views of a great fire in Oswego. This was no small affair, but a major urban conflagration. Fanned by strong westerly winds, the fire spread "with astonishing rapidity" until nearly an entire ward of the city was reduced to "a mass of ashes."[98] The *New York Times* reported losses of between five hundred thousand and eight hundred thousand dollars. Some two thousand persons were left homeless and "immense amounts of grain, flour and merchandise . . . consumed in the mills and warehouses."[99]

Barnard's pictures offer contrasting views of the fire. One, taken at what appears to be the height of the conflagration, shows a grain elevator enveloped in flames, its skeletal structure limned by fire. Beside it stands another grainery, owned by one H. M. Ames, its topmost floors already wreathed in smoke. It will not survive. On the lower portion of the image is an empty barge, on the deck of which stand two figures, one half-lost in a blur of motion.

The other view, made from considerably farther away, shows the full extent of the devastation. Smoke rises from the remains of several blocks of buildings. One brick facade on the far right of the frame remains standing, and smoke rises from the wooden superstructure of a nearby building. The bridge across the Oswego River is intact,

and on it are some spectators who peer out at what is left of their town. Like any good news photographer, Barnard made both close-up and overall views of the fire. The cumbersome and comparatively slow process of daguerreotypy notwithstanding, Barnard's work manifests a thoroughly modern approach. His images depict an unplanned news event. Since he made copies of his daguerreotypes and advertised their sale in local newspapers for several months after the fire, it is clear that he also understood the public dimension of photography.

In 1857, Barnard invented a process for transferring photographs directly onto the woodblocks used for engraving. He also began an association with the Anthony brothers in New York City. Shortly thereafter, he joined Mathew Brady's staff in Washington, D.C., and began covering the Civil War. From itinerant to war photographer, Barnard's career offers convincing evidence of the growing commitment to use photographs journalistically. In 1871, he photographed the smokey aftermath of the great Chicago fire, and four years later he produced a stunning series of stereographs of former slaves in and around Charleston, South Carolina.[100] Many of his pictures told the story of his times. If by the 1860s he was not known as a photojournalist, it is because the word had not yet been invented.

THE PUBLICATION AND DISSEMINATION of photographs was a goal of the men who invented and worked with the first processes, but in America the mass production of the camera's images was stalled by the early hegemony of the daguerreotype. "I have proposed to myself an important problem for the arts of design and engraving," Joseph Niepce, Daguerre's partner and inventor of the heliotype, wrote in a letter to the Royal Society in 1827.[1] His experiments were intended not just to find a method of preserving the images produced by the camera but also, and more important, to find a mechanical means of reproducing those images on the printed page.

In 1826, Niepce succeeded in producing a copy of an engraving of Georges d'Amboise, archbishop of Rouen whom Pope Alexander VI made a cardinal in 1499. For Beaumont Newhall, Niepce's heliograph of the good cardinal was momentous. "It was the first of those photomechanical techniques that was soon to revolutionize the graphic arts by eliminating the hand of man in the reproduction of pictures of all kinds." Niepce demonstrated the crucial link between photography and the mass production of the camera's images. It was his most important contribution, according to Newhall, "for it involved a principle that became basic to future techniques: the differential hardening by light of a ground that would control the etching in exact counterpart of the image."[2]

Daguerreotypes could be published, as we have seen, but it was never easy. They had first to be transformed by hand into engravings, etchings, or woodcuts. What photographers and publishers wanted was a method of mass producing and disseminating the camera's images that yielded a final product that looked photographic, a paper print that retained the original's details and delicate halftones. Talbot had invented such a process, but outside of England, calotypes were little used, since they could not effectively compete with daguerreotypes in

T W O

PAPER PRINTS FOR THE MASSES

*The ability to publish and disseminate
photographic views was both
necessary and desired; it had to wait
for the practical advent of paper
photographs, printed from negatives,
to allow for such dissemination.*

ROBERT A. SOBIESZAK
San Francisco in the 1850s

43

Crystalotype of an exhibit at the 1853 Crystal Palace exhibition in New York, made by John Adams Whipple. Published in *The Crystalotype World of Art* (New York: George Putnam, 1854). American Antiquarian Society.

terms of cost or delineation of detail. Throughout the history of printmaking, as historian William Crawford notes, the most successful processes have been those that present the most visual information at competitive prices. In the early days of photography the daguerreotype prevailed on both counts. The principle underlying Talbot's process, the unlimited production of identical positives from a single negative, however, was recognized as sound. What was needed in order to mass produce and disseminate photographs was a "process that combined the optical precision of the daguerreotype with the reproducibility of the calotype."[3]

By the late 1840s, dissatisfaction with Talbot's paper-negative process and with the continuing difficulty of copying daguerreotypes was widespread. The solution adopted by photographers was the use of glass as a base for the negative. As with the invention of photography itself, there is some dispute as to whose process takes precedence. Apparently, several inventors arrived at the solution at roughly the same time. The first to publish an alternative method was the nephew of Joseph Niepce, Claude-Félix-Abel Niepce de Saint-Victor. In 1848, he announced that glass plates coated with albumen and sensitized with salts of silver produced fine negatives that yielded clear and detailed prints.

John Adams Whipple, one of Boston's most prominent and successful photographers, was taken aback by Niepce de Saint-Victor's announcement, for he, too, had been experimenting with glass plate negatives and sensitized albumen emulsion. Whipple's process differed in several crucial aspects from that of his French counterpart, however, and in 1850 he was awarded a patent for the production of what he called crystalotypes. Whipple coated his glass plates with a mixture of albumen and pure, crystalline honey (thus the name). The plates were then sensitized in a solution of silver bromide. They could be used when

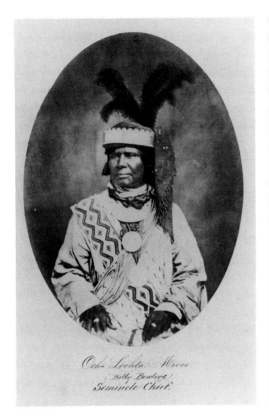

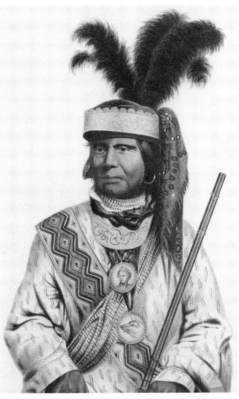

Paper photographic print of Seminole leader Och-Lochta Micco, "Billy Bowlegs," made by Julian Vannerson. National Portrait Gallery, Smithsonian Institution.

Unattributed lithograph of Julian Vannerson's portrait of Och-Lochta Micco, with a rifle added for effect. Published in Thomas Lorraine McKenney's *History of the Indian Tribes of North America*. (Philadelphia: Rice, Rutter and Co., 1865–1870). National Portrait Gallery, Smithsonian Institution.

either slightly damp or dry, though the exposure times increased significantly when the plates were completely dry.[4]

Whipple marketed his process aggressively, and by 1852 it was receiving rave reviews from American photographic publications. Samuel Humphrey complimented the inventor for three "very fine specimens of Photography on paper": a large view of Boston's new atheneum and two portraits. "We have seen many of the paper pictures taken on the other side of the Atlantic," Humphrey wrote, but "for richness in tone and . . . delineation we never have seen anything superior to these specimens before us."[5]

As increasing numbers of American photographers purchased the rights to Whipple's process (the price for a license was a relatively inexpensive fifty dollars, with another fifty thrown in for instructions, if desired), the usefulness of paper photography

began to be appreciated. Suddenly, photographers were able to produce perfect copies of their work with little fuss and at low cost. "Hitherto the photographists of this country have confined themselves exclusively to the practice of their art upon the silvered plate," wrote an observer in 1852, "but, if we are to judge from the constantly increasing demand for photogenic paper and paper chemicals—it will not be long before photography on paper will be as extensively practiced as the daguerreian art."[6] This prediction appeared in Henry Hunt Snelling's *Photographic Art-Journal,* an early advocate of the new process. In December 1852, Snelling praised Marcus Root's crystalotypes of New York City. The new paper prints, he wrote, combined the "beauty of an actual painting with the unerring accuracy of the daguerreotype." Most important for Snelling was the production of a negative from which "hundreds of copies

may be taken—thus in a measure rivalling the steel plate press."[7]

Horace Greeley's *New York Daily Tribune* was also enthusiastic about Whipple's process, though the editors had some reservations. The fact that a single negative could now be used to produce thousands of identical copies and the "rapidity and cheapness" of the process promised to "make it a popular method of illustration for books." But the actual prints still left something to be desired. In comparison to the crisp highlights and deep shadows of daguerreotypes, crystalotype portraits seemed curiously lacking in contrast, and landscapes were "without an atmosphere."[8] Within a year, this criticism of paper prints was obviated as photographers learned how to deepen the contrast, gloss, and brilliance of their prints.

The first paper prints were made by sensitizing ordinary writing paper in baths of silver nitrate. Since this process permitted the solution to be absorbed into the fibers of the paper, the final product was often flat and dull-looking. As a remedy, photographers and photographic suppliers began coating photographic paper before it was sensitized. The image thus remained more on the surface of the paper, enhancing both the contrast and luster of the final print.

The various albumen processes for making glass-plate negatives and prints were messy and required extremely delicate handling. The English photographer John Mayall noted the necessity of exercising "every precaution . . . to avoid dust." He also argued that the albumen collected from ducks' eggs was more suited to use in photography than that of hens, and that goose egg albumen was probably the best of all.[9] Problems of dust and albumen sensitivity notwithstanding, the switch to a negative-positive process revolutionized photography.

As if to demonstrate the applicability of his process to the world of publishing, Whipple supplied the prints used in *The Crystalotype World of Art,* published in a limited edition by George Putnam in 1854. The book was designed as a catalogue of several of the most impressive works of art at the New York world's fair of 1853, housed in an American version of London's spectacular Crystal Palace. Whipple's crystalotypes of sculptures, each carefully pasted onto a page, constitute the first significant use of photographs (as opposed to engravings or woodcuts of photographs) in a published book in America.

It was not, however, Putnam's original intention to use actual photographs in his book on the New York exhibition. Early in 1854, Putnam published his first guide to the wonders of the New York fair, entitled *The World of Science, Art, and Industry,* which was edited by Professor Benjamin Silliman and Charles Rush Goodrich. It included a great many engravings made under the supervision of C. E. Dopler from daguerreotypes made by H. Whittemore of the various exhibitions.[10] Later in the year Putnam saw Whipple's paper prints of the moon (they received a first-place award) and was clearly impressed with their potential to be used in the publishing industry. He reissued his original book on the Crystal Palace show with the addition of several of Whipple's crystalotypes.[11]

While Whipple was experimenting with albumen coatings on glass, others were working with a substance called collodion, a clear, viscous solution made by dissolving an explosive substance called guncotton in a solution of alcohol and ether. Collodion was destined to transform photography. By 1855, it had replaced all the albumen processes. Known familiarly as the "wet-plate process," collodion photography was used for some three decades to produce millions of negatives on glass or metal. Though volatile and extremely flammable, collodion poured onto glass plates formed an ideal base for light-sensitive silver salts.

Guncotton, or cellulose nitrate, is made by soaking natural cotton in a hot mixture

of nitric and sulphuric acids. It was discovered in 1846 by Swiss and German chemists and was initially intended to be used in the military. Its extreme volatility made it far too dangerous and unmanageable, however. The British Board of Ordinance actually considered using guncotton in artillery shells, but because of its tendency to explode at lower temperatures than gunpowder, they abandoned the idea in 1847.[12] Later the same year, Flores Domonte and Louis Menard, a brilliant and eccentric chemist, painter, and philosopher, discovered the use of guncotton to make collodion.[13] For several years its main use was in medicine; applied to burns and abrasions, collodion forms a tough, leathery second skin.

In 1851, an English sculptor, Frederick Scott Archer, suggested in an article in the *Chemist* that collodion was far superior to albumen as a base for light-sensitive silver. To maximize the speed of exposure, both collodion and albumen were best used while slightly damp. But according to Archer, albumen-coated plates were virtually impossible to handle except when completely dry, whereas collodion "is admirably adapted for photographic purposes. . . . It presents a perfectly transparent and even surface when poured on glass, and being in some measure tough and elastic, will, when damp, bear handling in several stages of the operation."[14]

John Towler, author of *The Silver Sunbeam,* one of the first studies of photography published in America, wrote in 1864 that he found it "impossible to calculate the impetus given to photography by this discovery, or its value to society."[15] Archer refused to patent the wet-plate process, and photographers eagerly adopted his method of making glass-plate negatives. After the process was introduced in America in 1853, great strides were made "in many parts of [the] country in the making of guncotton for use in collodion," recalled S. Rush Seibert, a portrait photographer who worked

Wood engraving of English heavyweight boxer Tom Sayers from a photograph by J. E. Mayall. Published in *Frank Leslie's Illustrated Weekly,* March 24, 1860. American Antiquarian Society.

for many years in Washington, D.C. The pristine daguerreotype was doomed. The wet-plate process "was immediately made a success," Seibert wrote, "and Daguerreotypes were laid aside in many establishments, although I continued to make them at intervals between 1840 and 1874."[16]

Gustave Le Gray, who pioneered the use of albumen plates in France, saw the proliferation of paper prints as a boon to education and a further argument for realism in art. "The popularity that daguerreotypes have obtained," he wrote in 1852, "will soon be surpassed by that of photographs on paper, and their great number scattered among the masses, will form an artistic taste and education, while art itself will no longer be permitted to deviate from the only true path, that of nature."[17] Le Gray's countryman, Gaston Tissandier, was just as enthusiastic. He saw the paper print as a means to broaden the distribution of photographs. "The printing processes of photography are destined to follow an ever-widening sphere," he predicted. "The permanent sun-print must be regarded as one of the greatest discoveries of modern science, fitted as it is to supply faithful impressions of almost anything that may be brought within the field of the astronomical telescope, the microscope, or the camera."[18]

Photographers used collodion almost exclusively from 1855 to the early 1880s, when the commercial production of dry plates again transformed the market. Collodion enabled photographers to make countless copies of their most important and sought-after pictures. Moreover, it made possible several new kinds of photographs: ambrotype, tintype (ferrotype), carte de visite, and stereograph. Sensitized and applied directly to the blocks of end-grain boxwood used in engraving, collodion was also discovered to be a boon to draftsmen. Photographs could be printed directly onto the wood blocks, forming perfect templates for engravers. Finally,

collodion was portable. Photographers thought little of traveling long distances with their entire darkrooms packed into rugged backpacks or horse-drawn buggies.

Their methods now may seem hopelessly complicated and arcane, but the necessity of preparing, sensitizing, exposing, and developing each plate while the collodion base was still moist was actually considered an improvement over the baths of hot mercury used in the daguerreotype process. Collodion could be used on a variety of surfaces (wood, glass, and metal) and was easily adapted for use outside the studio or darkroom. Its tough, pliable nature made it possible for the photographer to peel the finished collodion negative from its glass support; it could then be rolled in blotter paper for easy storage and the glass plate used to make another negative. Thus, the photographer did not have to carry large numbers of heavy and fragile glass plates when working outside the studio.

George Mary Searle, an astronomer, Paulist priest, and "photographer of considerable skill,"[19] reminisced about the wet-plate process in an article published in *Anthony's Photographic Bulletin* in 1882. He did not recall the process with particular fondness, though it is clear that the collodion scenario he described was typical. What is important about his account is the emphasis on the portability of wet-plate photography. It may not have been easy to move about the countryside lugging one's entire darkroom, but it was commonly, even routinely, done. "Perhaps a few years ago you may have met . . . an adherent of the old school, a wet-plate man," wrote Searle, "wheeling about or laboriously carrying on his back, besides his camera and plates, a small cart-load of fixtures of various kinds."

When he arrives at a suitable spot for his view he has to set up his tent, and in the orange colored light which it gives prepare his plate and set it all dripping in the shield; then put it in the camera, which also he had to unpack and set up.

If meanwhile the circumstances of light, etc., have not changed so much as to make the view of comparatively little value, he secures it; but then again he has to repair to his tent and develop his picture on the spot. Then carefully putting up his baths and bottles and replacing his heavy load, he has to trudge along again with it on his back, and so on through the day.[20]

Backpacking one's darkroom was not the only obstacle associated with collodion photography. From 1853 to 1855, before the photographic supply houses began marketing ready-to-use collodion, photographers had to make their own. Getting the guncotton just right without having it explode was never easy. "The making of soluble cotton . . . was attended with much difficulty and uncertainty," wrote photographer I. B. Webster in 1873, "and became a great stumbling block to the progress of the art. For three long years it was a sore trial and vexatious job." After 1855, though, firms in New York and Boston began stocking enough collodion to keep American photographers amply supplied.[21]

A more serious obstacle to the free use of the wet-plate process arose in 1854, when James Ambrose Cutting, a Boston-based photographer, inventor, and entrepreneur, applied for and was granted three patents relating to the use of collodion. One of them concerned a particular method of producing ambrotypes; the others, the process of sensitizing the coated plate. Cutting's patents nearly did to wet-plate photography in America what Talbot's patents did to calotypes.

Introduced in America in 1854, the ambrotype was described by some as a daguerreotype on glass. A slightly underexposed negative was made on a glass plate by the collodion process. When the glass was coated with dark varnish or backed with black felt, cardboard, or even another plate of dark glass (called "ruby glass"), the negative appeared as a positive. Ambrotypes, like daguerreotypes, were unique, one-of-a-kind items, and were usually presented in filigreed gutta-percha or pressed-leather cases. They were almost always portraits, intended to be kept as personal mementoes, though some, of celebrities, were copied and printed as engravings in the illustrated journals. Cutting's ambrotype patent dealt with a particular method of cementing the glass plates together (he used balsam of fir). He was vigorous in protecting the patent and charged high fees for its use (one hundred dollars in towns of five thousand inhabitants), but other photographers easily circumvented the patent by using alternative methods of backing the glass negative.

Cutting's other patents were more problematic. On both sides of the Atlantic, photographers routinely mixed collodion with potassium bromide, which reacted with silver to form light-sensitive silver bromide. The process was widely used and unprotected by patent, at least until Cutting came along. There was nothing new or unusual in Cutting's request for a patent on the bromide process, but because of a dearth of documentary evidence of previous usage or invention, he was awarded all rights. Many photographers in America simply ignored it; others switched to potassium chloride as the sensitizing agent.[22] When Cutting began prosecuting those he suspected of infringing upon his patents, however, American photographers howled in protest. Charles A. Seeley, editor of the *American Journal of Photography,* spoke for many when he said that he was "adamantly opposed to patents restricting the freedom of photographers to ply their trade. . . . Nine tenths of the letters received by the *Journal* support the anti-patent stand." Both Seeley and Henry Hunt Snelling of the *Photographic and Fine Art Journal* encouraged their readers to ignore the ambrotype patent and stand united against the bromide patent.[23]

Encouraged by the photographic press, photographers fought Cutting's patents in

the courts, and many, especially those far from the cities of the East, ignored it altogether. "That the so-called 'Cutting Patents' are a fraud upon the community throughout the United States, no one can doubt," commented Samuel Humphrey in April 1860. He went on to enumerate the various methods used by American photographers to resist the patents.[24] The bromide patent was finally voided in 1868, though by that time few photographers in America paid any attention to it. Cutting had died, quite mad, a year earlier in an asylum in Worcester, Massachusetts.

One other patent was associated with the collodion process, but it had none of the stultifying effects of those of Cutting. In early 1856, Hamilton Lamphere Smith, a Yale-educated professor of natural philosophy and astronomy at Kenyon College in Gambier, Ohio, patented the ferrotype method of making pictures. Like the daguerreotype and ambrotype, the ferrotype, or tintype as it was commonly called, was a one-of-a-kind process in which a positive image was produced with no intervening negative. In Smith's process, a thin sheet of blackened, japanned iron was coated with collodion, sensitized, exposed, and developed. As in the ambrotype, the light areas of the subject contained the most silver on the plate and thus appeared light, while the dark and shadow areas were virtually transparent and thus revealed the blackened metal underneath the collodion.

Smith assigned his patent to his friend and colleague at Kenyon, Peter Neff, and his father, William Neff, in return for their assistance in his early experiments.[25] The charge for using the tintype process was only twenty dollars. Since the materials were inexpensive and easy to use, tintypes became enormously popular and were still being produced long after dry plates were introduced in the 1880s.[26]

The impact of tintypes and ambrotypes upon the press was slight. They were the staple of small town and village studios that specialized in recording the faces of the citizenry. Photographers interested in making pictures for wider distribution turned to one of the negative-positive processes that used collodion. Now for the first time it was possible for photographers to build libraries of negatives that could be used to produce countless positive copies. They could vary print size and style according to the wishes and budgets of clients, and they could supply newspapers, magazines, and book publishers with low-cost paper prints. "That the delicate and fading images of the camera obscura should be permanently secured upon plates and metal and glass, and on paper, was, at one time beyond the dreams of science," wrote an enthusiast in 1855. "What, then, may we not expect from photography with the advent of science?"[27]

Developed by Sir David Brewster and Charles Wheatstone in England in the late 1830s, the stereograph added the illusion of a third dimension to the photograph. Two views of the same object, taken with a camera with lenses separated by a few inches, were mounted side-by-side on rectangular cardboard measuring approximately 3½ by 7 inches and were viewed in a device called a stereoscope that allowed the left eye to see only the left-hand image, and the right eye to see only the one on the right. As in normal binocular vision, the effect was to create the feeling of depth. The added third dimension, although illusory, enhanced the realism of the picture.

The principle of stereoscopy was known but little practiced during the daguerreian period, from 1839 to 1849, primarily because the highly polished, mirrored surface of daguerreotypes was difficult enough to see singly, let alone doubled up and placed in a viewing device.[28] The Langenheim brothers in Philadelphia, who always seemed to be at the forefront of photographic technology, did produce stereographs from daguerreotypes, mostly of travel scenes, and they were well received

by the press. "When they are looked at in a couple of reflectors properly arranged," wrote an observer in 1852, "the scene itself seems visible in bold relief." The stereo effect was especially noteworthy in a view by Frederick Langenheim made on the banks of the river Volga. In the twin images, one could see and "inspect the piles and works of a great unfinished bridge, forming a track partly across the tide from bank to bank, every post as round and real as though the river . . . and the great work there in progress had been modelled by the fairies."[29]

In 1850, Brewster took his stereo instruments with him to London, where they were exhibited at the Crystal Palace exhibition. They attracted the attention of the public and also of Queen Victoria, who enthusiastically approved of the new process. When Archer introduced his collodion negatives in 1851, the success of stereos was assured. Paper prints, mounted side by side on cardboard, were easy and inexpensive to produce and could be viewed without straining to find just the right angle of light. Most important, they could be multiplied at will and mass marketed by either individual photographers or publishers. By 1860, they were the most popular and widely used method of transmitting visual information. More than two hundred photographers in America were producing stereos on the eve of the Civil War, and the Anthony brothers in New York City reported that during 1861 they sold several hundred thousand cards.[30]

Prior to 1861, stereo viewers were ornate and bulky affairs in the form of consoles or large boxes with eyepieces attached to one side and a slot for stereo cards on the opposite. Oliver Wendell Holmes changed all that, however. In 1861, he introduced a new, compact, and easily operated viewer. Holmes was an avid admirer of photography in general and stereoscopy in particular; his viewer, known everywhere as the American, or Holmes, stereoscope, was

Detail of a stereograph showing Appleton's Stereoscopic Emporium on lower Broadway in New York City. Division of Photographic History, National Museum of American History, Smithsonian Institution.

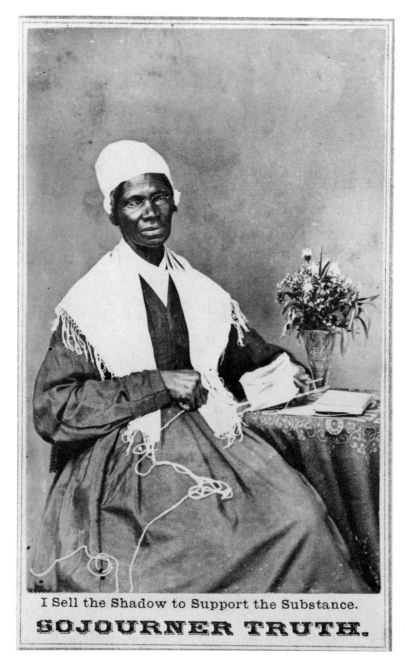

I Sell the Shadow to Support the Substance.

SOJOURNER TRUTH.

Unattributed carte de visite of abolitionist and feminist leader Sojourner Truth, ca. 1864. National Portrait Gallery, Smithsonian Institution.

lightweight and completely portable. "I believed that it would add much to the comfort and pleasure of the lover of stereoscopic pictures," he wrote. "I believed also that money could be made of it. But considering it was a quasi scientific improvement, I wished no pecuniary profit from it, and refused to make any arrangement by which I should be a gainer."[31]

The development of small, lightweight stereo cameras, with lenses placed two and one-half inches apart, soon obviated the tiresome necessity of making two separate exposures with a camera that was carefully moved to the right or left after the initial exposure. Now both exposures were made at once and on a single glass plate that when developed and dried could be used to produce thousands of paper positives. The twin-lensed stereo camera was designed to produce a picture that could be mass produced and distributed to the public. In the latter half of the nineteenth century, when a photographer intended to make pictures to sell to the public—pictures of events or scenes or persons in the news—the instrument of choice was usually the stereo camera.

For those already impressed with the descriptive detail contained in daguerreotypes, the added third dimension of stereographs seemed almost miraculous. The stereo photographer possessed a power "mightier than kings," wrote Edward L. Wilson, editor of the *Philadelphia Photographer,* who was not, admittedly, an entirely objective source. Still, his enthusiasm for stereo cards was hardly atypical; they seemed to many Americans to be the ultimate in realistic art and reporting. Apparently nothing could compete with the accuracy of stereos, not "the countless published pages of the naturalists of the world, the numberless books of travel, nor the eloquence of Agassiz."[32] Holmes spoke of the beginning of a "new epoch in the history of human progress," opened by a product that possessed "an appearance of

reality which cheats the senses with its seeming truth." [33]

For fully half a century, the stereograph was the most popular and common form of photograph. Scarcely a middle-class parlor existed in America that did not contain at least one stereoscope and a collection of views, purchased at a local bookseller's or at one of the many stereo emporiums that catered to the growing audience for photographs. "It is wonderful what becomes of countless stereoscopes that are made during a year," wrote the Anthonys in 1870. "Pile upon pile, dozen after dozen, gross after gross" were supplied, yet still the demand was unsatisfied. No matter how fast they were turned out, stereoscopes and stereo cards were "swallowed up in the vortex of popular consumption." [34]

A companion to the stereo view was the carte de visite, a small print on paper measuring roughly 2½ by 4 inches, the approximate size of a visiting card. André Adolphe Eugène Disdéri, the official court photographer of Napoléon III, introduced cartes de visite in Paris in November 1854, and they spread quickly to England and America. By 1860, cartes were by far the most popular format for the portrait photograph, far eclipsing the ambrotype and daguerreotype.

Their cheapness and the ease with which they were produced (four, six, or even eight separate views were made on a single glass negative that was then contact printed onto paper) made them, according to John Werge, "a more republican form of photography," a fact he found ironic considering their origin in an "empire not remarkable for freedom of thought." Since cartes de visite were inexpensive, and because of "their convenient size and prettiness of form," they were an immediate sensation. [35] Some referred to the public's response as "cardomania."

"The kind of pictures mostly in demand at the large galleries," reported Samuel Humphrey in 1861, "is the Carte de Visite."

He reported that in New York City many galleries had begun copying the painted and engraved likenesses of deceased persons into photographs, "as the times [had] not yet had any tendency to take away that deep affection which holds the memory of one friend to another." [36] One could purchase, for instance, card photographs of George Washington, Ben Franklin, and other heroes of the Republic.

Because they were made from glass negatives, card photographs of celebrities and other persons in the news were printed by the thousands and sold to a public eager to see and own likenesses of the rich and famous. "No picture," wrote John Towler in 1864, "has ever had so wide a sphere of action, has gratified taste so long, or has been as productive of gain to the photographer as the card picture. It is the picture of the day," he added, "and has tended considerably to simplify the photographic establishment." [37] Cards were often collected and displayed in special albums that held from fifty to one hundred images. Most often, as historian William Culp Darrah notes, card photographs were grouped in albums according to subject matter. Family albums were the most common, as one would expect, but others contained portraits of celebrities, of scenics and travel scenes, and of news events. In 1862, for example, the Anthony brothers began marketing albums of cartes de visite of Civil War scenes produced by Brady's teams of photographers. [38]

In his manual on card pictures and stereographs, published in 1862, Nathan Burgess suggested that the carte de visite was a natural outgrowth of the stereo phenomenon. Approximately the size of half a stereo picture, cartes "are in reality stereographs, only not viewed in pairs," he wrote. [39] Indeed, photographers began to print their photographs in various formats, depending on the wishes of their clientele. Stereo negatives could be made into card photographs or enlarged into display prints. The various collodion processes gave photographers the

Carte de visite of Senator Stephen Douglas by Mathew Brady studio. Collection of David Kent, Miami, Florida.

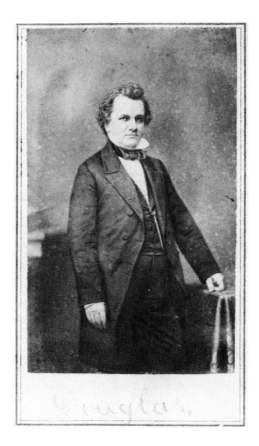

Wood engraving from the Mathew Brady portrait of Stephen Douglas. Published in *Harper's Weekly,* April 1860. American Antiquarian Society.

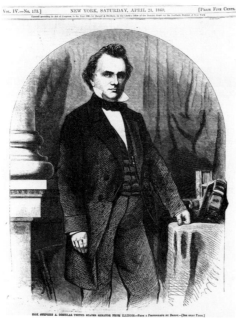

option to make a variety of print types from the same negative without losing any of the sharpness or brilliance of the original. The same negative might create a stereo card, a carte de visite, an "imperial" enlargement, and the positive template for an engraving in one of the weekly illustrated magazines.

Late in 1866, a larger version of the carte de visite, the cabinet card, was introduced in America. Measuring approximately 4½ by 6½ inches, the new print size gradually supplanted the carte de visite, the public no doubt responding to the cabinet's larger picture area and more substantial mountboard backing. Still, it was not until the late 1870s that cabinet cards began to predominate; today, it is rare to find cabinets made prior to 1876.[40]

Photographs made of Abraham Lincoln during his campaign for the presidency in 1859 and 1860 were produced in a wide variety of sizes and styles and disseminated by the Republican party as well as by individual photographers and publishers. The now famous Cooper Union portrait of Lincoln, made on February 27, 1859, by Mathew Brady on a single large glass plate, was copied and printed in carte-de-visite size and sold to the public by the thousands. Brady also supplied prints to *Harper's Illustrated Weekly* and *Frank Leslie's Illustrated Newspaper,* both of which published the print as a wood engraving. In each case the engraver made significant changes in Brady's original, though each image was captioned as a photograph.[41] Clearly, once a photograph was in the hands of an engraver or draftsman, there was no guarantee that the finished product would be a perfect match of the original. The only way to assure accuracy was to make paper copies from the original negative.

The Chicago photographer Alexander Hesler did precisely that in June 1860. He journeyed to Springfield, Illinois, where he made four separate views of the Republican nominee, over a hundred thousand copies

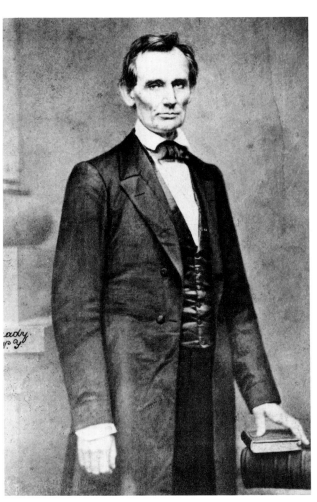

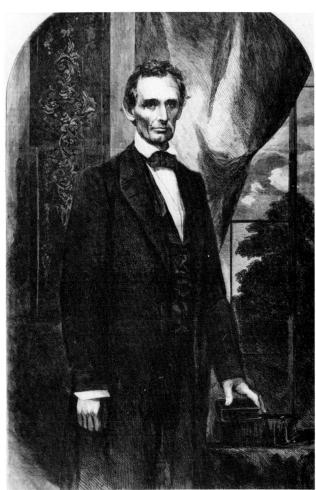

Mathew Brady's
Cooper Union portrait
of Abraham Lincoln,
made in 1859—the pic-
ture that some said got
Lincoln elected. Library
of Congress.

Engraving of Cooper
Union portrait, pub-
lished in *Frank Leslie's
Illustrated Weekly,* Octo-
ber 1860. American An-
tiquarian Society.

Engraving of Cooper Union portrait, published in *Harper's Weekly,* November 10, 1860. Otto Richter Library, University of Miami.

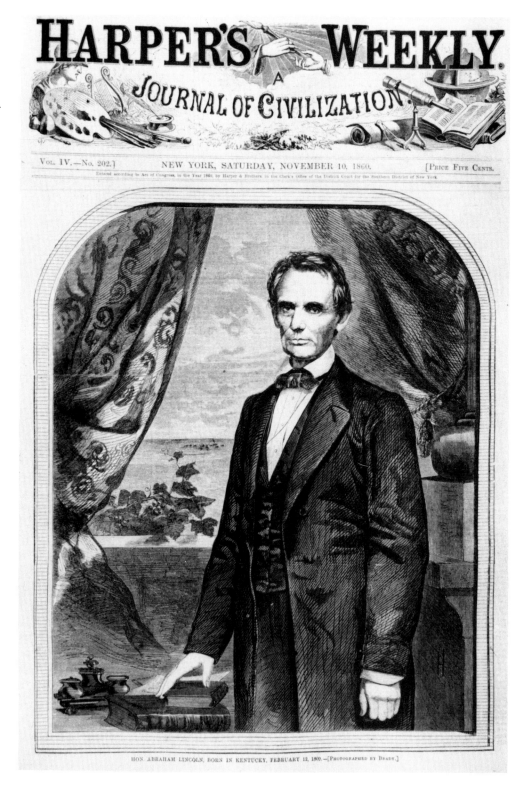

HARPER'S WEEKLY.

A JOURNAL OF CIVILIZATION.

Vol. IV.—No. 202.] NEW YORK, SATURDAY, NOVEMBER 10, 1860. [Price Five Cents.

Entered according to Act of Congress, in the Year 1860, by Harper & Brothers, in the Clerk's Office of the District Court for the Southern District of New York.

HON. ABRAHAM LINCOLN, BORN IN KENTUCKY, FEBRUARY 12, 1809.—[Photographed by Brady.]

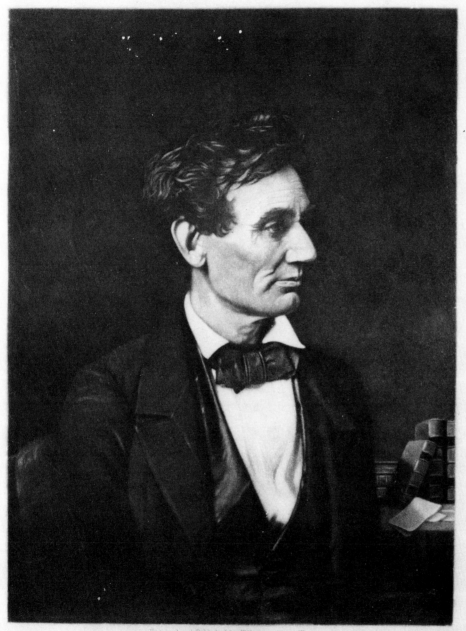

Mezzotint by Thomas Doney of Alexander Hesler's 1857 portrait of a tousled Abraham Lincoln. National Portrait Gallery, Smithsonian Institution.

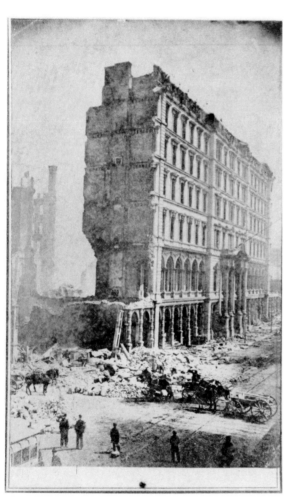

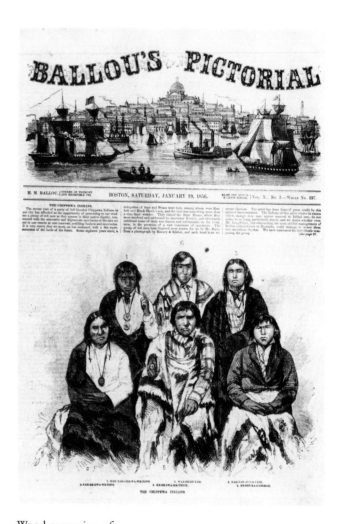

Unattributed carte de
visite of the ruins of the
Lindell House hotel, St.
Louis, Missouri, de-
stroyed by fire on
March 31, 1867. Collec-
tion of Robert Cauthen,
Leesburg, Florida.

Wood engraving of a
delegation of Chippewa
Indians from photo-
graphs by Boston pho-
tographers Samuel
Masury and George
Silsbee. Published in
Ballou's Pictorial, January
19, 1856. Author's col-
lection.

of which were distributed during the course of the campaign, many in the form of campaign badges.[42] Hesler had photographed Lincoln once before, in February 1857. That first sitting produced a side-view portrait of Lincoln, beardless and tousle-haired, that delighted editorial cartoonists in the East. The new portraits, especially Brady's Cooper Union image, depicted Lincoln as thoughtful, serious, perhaps even presidential. It was the new set of pictures that was used by the Republicans in 1860, the first time photographs were extensively used in a campaign for the White House.[43]

Lincoln pictures were everywhere. Silas Hawley, an agent for an original crayon portrait of the Republican nominee, wrote to a friend that "the country is flooded with the pictures of Lincoln, in all conceivable shapes and sizes, and *cheap*. The newspapers have his likeness; it is in the medal form; it is on envelopes; it is on badges; it is on cards; it is, indeed, on everything, and everywhere. And all for a *few cents!*"[44] It was becoming much harder for artists to compete with photographers who could now mass produce accurate pictures on paper cheaply and quickly. Photography was fast becoming the dominant graphic art.

By 1860, photographic coverage of major news events was becoming commonplace. City fires and train wrecks often attracted the attention of photographers who produced pictures in stereo and carte-de-visite size for mass distribution and enlarged prints from which engravings could be made. It was still rare for ongoing events to be captured on glass plate, but increasingly, photographers made and distributed pictures that showed the blackened husks of buildings after fires or the smashed and twisted remains of train wrecks. And photographers regarded people in the news for whatever reason as fair game; celebrity portraits were always best-sellers.

"Photography is now the historian of earth and animated nature, the biographer

of man," wrote British historian John Werge in 1890. The proliferation of photographs on paper had seen to that.[45] Albert Southworth, the partner of Josiah Hawes in Boston and one of the most highly regarded photographers in America, spoke of the early history of photography in America in an address delivered to the National Photographic Association in 1871. "In thirty years," he said, "from a few crude experiments in the laboratory of a private chemist and artist, [photography] has extended its various applications and uses throughout the length and breadth of . . . our globe."[46]

When in 1860 the Prince of Wales came to America, photographers recorded the entire grand tour. Stereos and card pictures of the prince flooded the market; Americans in 1860 seemed every bit as enthralled by England's royal family as they are today. The nation temporarily put aside talk of disunion and war, and united in a collective spasm of royalty worship. Photographs of

Stereograph by D. C. Reed, Charter Street, Newburyport, Massachusetts. American Antiquarian Society.

Bank note printed on "anti-photographic" paper in order to deter counterfeiters. American Antiquarian Society.

PRINCE OF WALES AND FAMILY.

Wood engraving of the Prince of Wales and his retinue in New York City, from a photograph by Mathew Brady. Published in *Harper's Weekly,* November 3, 1860. American Antiquarian Society.

Stereograph by George Stacy of the embarkation of the Prince of Wales at Portland, Maine, October 20, 1860. Collection of Robert Carr, Miami, Florida.

Unattributed carte de visite of the Prince of Wales and his family. Author's collection.

Victoria's son and heir making his way with appropriate pomp and circumstance about the former colonies were a lovely little diversion from the looming storm clouds of war. It was a news event with enormous popular appeal, and American photographers took every advantage of it, armed as they were with the new paper processes. None was more alert to the possibilities than Mathew Brady.

On the morning of the thirteenth of October 1860, the prince summoned Brady to his rooms at the Fifth Avenue Hotel and conferred upon him the high honor of making his semiofficial American portrait. When Brady asked why the prince had chosen him above all the others, he is said to have replied, "Are you not *the* Mr. Brady, who earned the prize nine years ago in London? You owe it to yourself. We had your place of business down in our notebooks before we started."[47] Edward's gracious re-

sponse may be apocryphal; Brady did occasionally embellish the truth. Yet the fact is that the prince and his retinue did visit the Brady studio and sit for several portraits and group shots. Even more important, Brady made the pictures available to the public in a variety of sizes and styles, and sold copies to the illustrated journals. He may not have been the best photographer of his day, but more than any of his peers he understood how photographs could be mass marketed. "I think Brady stands at the head as to prominence," said Ohio photographer James Ryder to his assistant. "He has taken portraits of more public and prominent people than any of his rivals. Presidents, senators, governors, congressmen, ambassadors, statesmen of all degrees, notables of all countries have sat [for] him."[48]

It is the public dimension of photography that seems to have motivated Mathew Brady, making him the first photographer in America to take full and complete advantage of the journalistic uses of photographs. It is not surprising that when war finally came in the spring of 1861, he was the first to see it as an opportunity to make and sell pictures on a vast scale.

THREE

PHOTOGRAPHS OF WAR

Artists have painted, and sketched, and engraved, with more or less fidelity to fact and detail those "scenes of trial and danger," but all of their pictures are, in a greater or less degree, imaginary conceptions of an artist. Happily our Government authorized, during the war, skilled photographers to catch with their cameras the reflection, as in a mirror, of very many of these thrilling and interesting scenes.

War Memories: Catalogue of Original Photographic War Views

THE CIVIL WAR WAS the first armed conflict to be photographed systematically from beginning to end. Photographs of war had been made before, notably by Roger Fenton, secretary of the Photographic Society of London, and James Robertson, chief engraver to the Imperial Mint in Constantinople (Istanbul), who were hired by the British government to document the Crimean campaign in 1855. Fenton and Robertson proved, among other things, that the wet-plate process could be used successfully far from the studio and even under occasional hostile fire. They spent less than four months in the arid war zone and made some 360 glass-plate negatives of natty English officers and enlisted men and a few of landscapes torn by artillery. However, most of the Crimean images reveal little about the conflict. Fenton and Robertson were working for the government, with instructions to make pictures that could be used to refute the flood of critical stories being published in the press. By and large, he and Robertson did as they were told, concentrating their attention on English successes and placid, behind-the-scenes views.

Several enterprising daguerreotypists made pictures of American troops during the war with Mexico (1846–1848), although their work was considerably circumscribed by the technical requirements of their craft. The largest and most important group of images of the Mexican-American conflict consists of twelve scratched and faded sixth-plate daguerreotypes of American troops in Saltillo, Mexico, and Fort Marion in St. Augustine, Florida. That they were made at all is extraordinary. Few practitioners ventured outdoors in the early days of photography or attempted to capture news events on their silvered plates. The unknown maker of the Mexican War pictures did both and thus must be considered the first true war photographer. "In an age when more than ninety-five percent of daguerreotypes were studio-made portraits," writes Martha

Sandweiss, historian and adjunct curator at the Amon Carter Museum in Fort Worth, Texas, "this man had worked outdoors in an occupied military zone with uncertain access to supplies, making views of military activities on silver-plated copper daguerreotype plates."[1]

On the eve of the Civil War in America, new collodion processes dominated photography, and practitioners were able to produce the style of photograph that most closely fit the needs and pocketbooks of their clients, or that would provide the greatest return on their investments. If budgetary considerations were of paramount importance, and if the image had no particular news value, the tintype was ideal; it was both inexpensive and easy to produce. If, however, the subject had a public persona or desired multiple prints, the carte de visite was a better choice, for the photographer could make additional copies from a negative. For outdoor scenes and views with either pictorial or news value, stereography was the preferred format. And if the final product was intended to be exhibited or tipped into a book, the image was made on a single, large glass plate. Photographers in 1860 were likely to own and use several cameras: one for portraits, a stereo camera for news pictures and scenics, and a third for large-format views.

As we have seen, the periodical press had used photographs as the basis for hand-drawn illustrations since the first days of photography. Two weekly newspapers that were established in America in the years just preceding the Civil War made photographs and other visual materials equal partners of the printed word in the reporting of news. These new publications would provide the public, or at least the northern public, with accurate and timely illustrations of the war. The pictures they published, many based on photographs, offered vivid, graphic, and reliable glimpses into all aspects of the conflict. For the first time, Americans would see, through the eyes of a score of photographers, exactly what was going on at the front.

The first illustrated weekly in America was established in 1855 by a transplanted Englishman, Frank Leslie, born as Henry Carter in 1821 in Ipswich. Leslie began his career in journalism as an artist and engraver at the *Illustrated London News,* the world's first pictorial tabloid. In 1848, he emigrated to America and three years later began working as an engraver at T. W. Strong's *Illustrated American News,* a short-lived attempt at pictorial journalism published in New York City. Shortly after the demise of Strong's newspaper, Leslie made contact with P. T. Barnum, for whom he designed a brochure extolling the wonders and curiosities exhibited at the American Museum.[2] Barnum was well pleased with Leslie's efforts. The new brochure was done "in a splendid manner," Barnum wrote, "and hundreds of thousands of copies were sold and distributed far and near, thus adding greatly to the renoun [*sic*] of the establishment."[3]

In 1852, Barnum agreed to invest twenty thousand dollars as a special partner in Leslie's *Illustrated News.* The initial number was issued on January 1, 1853. Although circulation figures reached an impressive fifty thousand by November of that year, there was barely enough money to meet production costs. By the end of the year the entire enterprise was sold to *Gleason's Pictorial* without a loss to the investors, but with no profit either.[4]

Late in 1855, Leslie inaugurated another pictorial newspaper, *Frank Leslie's Illustrated Newspaper,* which became a force in American journalism for half a century.[5] Leslie's new journal relied heavily on photographs to describe news events, and the public began to trust the information contained in the illustrations that filled each issue. He ran a wood engraving copied from an ambrotype by Mathew Brady on page one of the first issue; the caption credited both Brady and the draftsman.[6] "The painter's

Wood engravings from photographs of President Lincoln and Union military leaders. Published as *Frank Leslie's Portrait Pictorial,* ca. 1862. National Portrait Gallery, Smithsonian Institution.

easel is almost abolished, except as a hand-maiden to photography," Leslie wrote in 1859, adding that those "whose actions and deeds fill the world, are brought before the eye with characteristic expression." For Leslie, nothing was beyond the recording capacity of the camera. "Terrible battles with all their dreadful scenes of carnage and slaughter, are transferred to paper upon the instant, and soon go hurrying over thousands of miles to be viewed by the humble peasant in his peaceful abode."[7]

For two years, Leslie had the business of publishing an illustrated version of the news in the United States to himself. But in 1857, Fletcher Harper, the youngest of the four brothers who built one of America's great publishing empires, established his own weekly newspaper, *Harper's Weekly,* in an attempt to gain a share of what was clearly a national market for the news. The new publication was designed as a "newsy and up-to-the-moment" companion to the brothers' more staid and intellectual monthly magazine.[8] In its earliest editions, *Harper's Weekly* was run without pictures of any kind; it was all news and light literary entertainment. In the eighteenth number, however, printed in May 1857, the editors announced an important new policy: The magazine would thereafter "be happy to receive sketches or photographic pictures of striking scenes, important events, and leading men from artists in every part of the world, and to pay liberally for such as they may use."[9] As if to underscore that point, the issue contained wood engravings of photographs credited to Brady and the Meade brothers and depicting the men in charge of the construction of the trans-Atlantic telegraph cable. And on Saturday, May 30, Harper used a photograph on page one for the first time, a portrait of William Haile, governor of New Hampshire, made from a daguerreotype by F. A. Brown of Concord.

As more photographs were published in the periodical press, certain criteria were

developed for their use. Credit for the photograph was an important consideration, at least for the photographer. Editors who were aware of the public's belief in the veracity of photographs supported the inclusion of credit, at least in principle, and thus usually noted the photographic origins of their illustrations. When credit to the photographer was inadvertently omitted, an apology might be included in a subsequent edition. On May 9, 1857, for instance, the editors of *Harper's Weekly* apologized for failing to credit the Meade brothers for their view of the Old Brick Church in New York City, published as an engraving in the previous week's edition.[10]

To some extent, credit depended less on editorial policy than on the presumed sophistication of the audience. The editors of illustrated popular weeklies such as *Harper's* and *Frank Leslie's* were always more willing to credit photographers than those at the elite journals. Thus, *Harper's New Monthly Magazine* often omitted photographic credit, even when the pictures were duplicates of credited illustrations in *Harper's Weekly.*

An equally important requirement for photographers was that their pictures be properly captioned and arrive at the papers in a timely fashion. It appears that although photographers were delighted by the prospect of selling pictures to the national news media, they were not always in tune with the needs of the press. They had to be reminded that pictures of old news or those that were improperly or incompletely captioned were not of much use. "We shall be much obliged to our photographic friends if they will write in pencil the name and description on the back of each picture, together with their name and address," wrote Frank Leslie in 1860. The notice was necessary because the magazine was receiving a great many photographs from all parts of the country "without one word of explanatory matter." The photographers were giving Leslie's editors "credit for being *en rap-*

port with everything that transpires or exists in all parts of the United States."[11]

Missing deadlines was a problem for photographers who were without the luxury of an electronic system that could relay their images to the central office. Editors gave considerable leeway to photographers on this score; both the public and publishers understood that whereas pictures might be made of events and places far removed from the great metropolitan centers of the East, it sometimes took days or even weeks for the images to reach the front office. And once there, they had to be converted by hand into engravings on woodblocks that could be printed, a process that might take another week or ten days. Sometimes the presses simply could not wait, and stories ran without the intended illustrations. When photographs of the ruins of a collapsed bridge at Johnstown, Pennsylvania, arrived too late to be used in an 1866 edition of *Harper's Weekly,* for instance, the paper acknowledged the photographer's "courtesy" in sending the images (operatives from the Brady studio in Washington, D.C., made the pictures). Even the great Mathew Brady could not stop the presses.[12]

The widespread adoption by photographers of the wet-plate process for making negatives on glass, which facilitated the mass production of paper prints, together with the establishment of illustrated news magazines created an enormous market for photographers on the eve of the Civil War. In the late 1850s, photographers in all parts of the country began to take advantage of the opportunities offered by the nation's inexorable drift into rebellion and war.

John Brown's raid on the federal arsenal at Harper's Ferry, Virginia, in October 1859, designed to induce a general slave revolt in the southern states, was front-page news nationwide. Portraits copied from photographs of the wild-eyed zealot, patriarch of a sanguinary terrorism on behalf of the brotherhood of man, were run in the illustrated journals together with views of

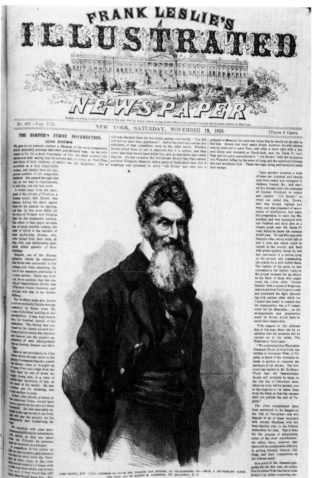

Wood engraving from photographs made on February 22, 1861, by Frederick DeBourg Richards of President Lincoln "hoisting the American flag with thirty-four stars" in Philadelphia. Published in *Harper's Weekly*, March 9, 1861. Otto Richter Library, University of Miami.

Wood engraving from a photograph of John Brown "taken one year ago" at the New York City studio of Martin M. Lawrence. Published in *Frank Leslie's Illustrated Newspaper*, November 1859, following Brown's attack at Harper's Ferry. American Antiquarian Society.

the arsenal, the rugged terrain, and portraits of his captor, Colonel Robert E. Lee. Frank Leslie published an engraving of Brown made from a photograph by Martin Lawrence, who owned one of the largest of the galleries on Broadway. Cartes de visite and stereos that described every aspect of Brown's bloody career were made and published for many years.[13]

When the war began with the shelling of Fort Sumter in Charleston harbor, photographers learned very quickly of the public's appetite for reliable pictures of the events and men of the day. Samuel Humphrey reported that the Anthony brothers' firm in New York City had bought the carte-de-visite portraits of Major Robert Anderson, the federal commander at Sumter, made by the Charleston photographer George S. Cook, and that they were printing and selling no fewer than one thousand individual cards every day.[14] Clearly, the war was going to be very good for photography.

Cook, in fact, fared exceedingly well during the war. He managed to obtain materials from the Anthonys and other firms throughout the conflict, and made and distributed pictures of soldiers and scenes in and around Charleston. In addition to obtaining and marketing a portrait of Major Anderson at Fort Sumter, Cook also attempted to secure a likeness of Jefferson Davis, who in the spring of 1861 was in the first Confederate capital at Montgomery, Alabama. A letter to Cook from a photographer named Hinton describes the rush to photograph Davis.

I am sorry I cannot oblige you with the President's Photograph at present. I have so much business to attend just now that it is almost impossible to get him to sit. There is not a portrait of him in town, small or large.

I shall wait again on him tomorrow and the first opportunity I will avail myself of some negatives and with pleasure I will send you a ¼ size negative and some photographs.[15]

JOHN BROWN'S CABIN.

"Entered according to Act of Congress, in the year 1871, by A. W. BARKER, in the office of the Librarian of Congress, at Washington."

Carte de visite of John Brown's cabin in Kansas, made by A. W. Barker. National Anthropological Archives, Smithsonian Institution.

Wood engraving of Major Robert Anderson's command at Fort Sumter, from a photograph "taken in the fort" by an unidentified photographer. Published in *Harper's Weekly,* March 23, 1861. American Antiquarian Society.

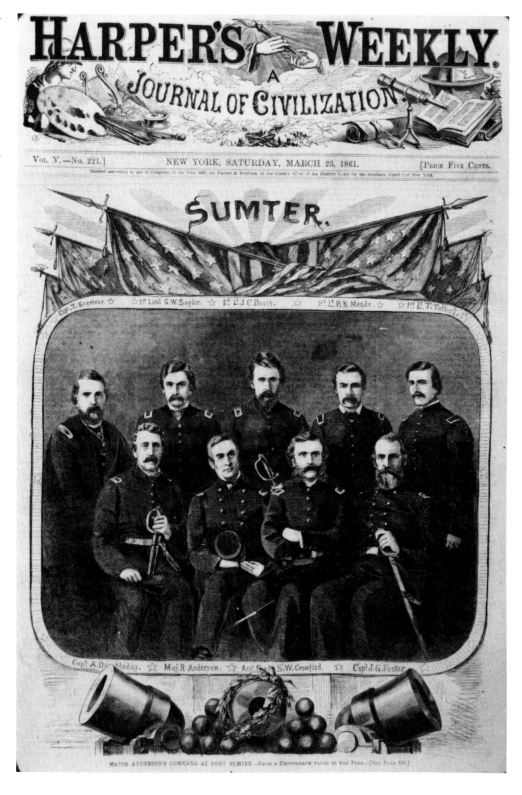

HARPER'S WEEKLY.

A JOURNAL OF CIVILIZATION.

VOL. V.—No. 221.]　　　NEW YORK, SATURDAY, MARCH 23, 1861.　　　[PRICE FIVE CENTS.

Entered according to Act of Congress, in the Year 1861, by Harper & Brothers, in the Clerk's Office of the District Court for the Southern District of New York.

SUMTER.

Capt. T. Seymour.　☆ 1st Lieut. G. W. Snyder.　☆ 1st Lt. J. C. Davis.　☆ 2d Lt. R. K. Meade.　☆ 1st Lt. T. Talbot.

Capt. A. Doubleday.　☆ Maj. R. Anderson.　☆ Asst. Surg. S. W. Crawford.　☆ Capt. J. G. Foster.

MAJOR ANDERSON'S COMMAND AT FORT SUMTER.—FROM A PHOTOGRAPH TAKEN IN THE FORT.—[SEE PAGE 190.]

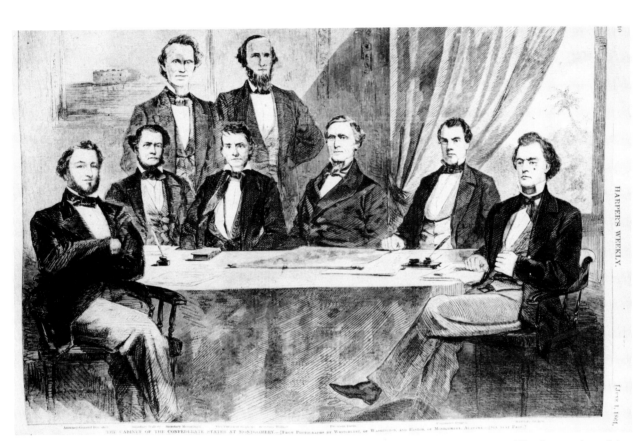

THE CABINET OF THE CONFEDERATE STATES AT MONTGOMERY.—[FROM PHOTOGRAPHS BY WHITEHURST, OF WASHINGTON, AND HINTON, OF MONTGOMERY, ALABAMA.—[SEE NEXT PAGE.]

Wood engraving of the cabinet of the Confederacy, made from photographs by Jesse H. Whitehurst of Washington, D.C., and Hinton of Montgomery, Alabama. Published in *Harper's Weekly,* June 1, 1861. Otto Richter Library, University of Miami.

Carte de visite of Major Robert Anderson at Fort Sumter, made by George Cook and published by E. and H. T. Anthony. Private collection.

Carte de visite of General Ulysses S. Grant, made and published by Mathew Brady's Washington, D.C., studio. Collection of David Kent, Miami, Florida.

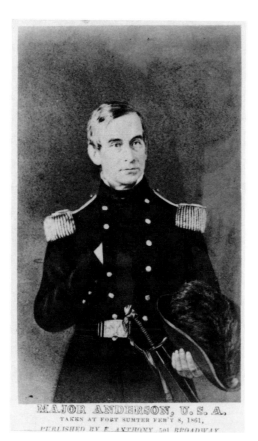

MAJOR ANDERSON, U. S. A.,
TAKEN AT FORT SUMTER FEB'Y 8, 1861,
PUBLISHED BY E. ANTHONY 501 BROADWAY

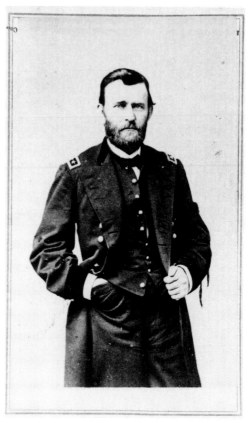

Photographers on both sides of the Mason-Dixon Line were inundated with requests for portraits of the men and boys going off to do battle.[16] For portrait studios across the land, the coming of war was a boon to business, though some photographers refused to profit from soldier pictures. In Cleveland, for instance, James Ryder was determined to do his part, and advertised that "all young men going to the front not having a photograph to leave with their mothers should come . . . and get one free of charge." For several weeks in 1861 he worked "exclusively for the soldier boys, declining to receive orders or money for other work," explaining to his regular customers that he felt "a patriotic obligation to serve the boys before all others."[17]

That these images, most of them tintypes and cartes de visite, were highly prized is

without question. As in the days of the California gold rush, the photographic portrait of a loved one far away was like a soft and subtle touch of home. For soldiers in the field as well as for their families, photographs were cherished keepsakes, instant and immutable memories. Three decades after the war ended, Confederate general John T. Morgan reminisced about the first battle at Bull Run in one of Leslie's illustrated histories of the war. He remembered seeing the body of a Union private killed during a bayonet charge. A "beautiful photograph was in the side pocket of the . . . soldier," he wrote, "near the fatal bloodspot on his shirt bosom. We thought we could readily trace his dying thoughts to that dear friend." [18]

Photographs of the commanders of the Federal armies served as more than private mementoes. Many were mass produced and sold to a public eager to support the war effort (cartes de visite produced during the war carried a special tax in the form of stamps affixed to the back of the cards), and to see the faces of the men who were leading the Union troops. Officers who achieved renown on their own or whose units were written about in the press were sure to have their likenesses distributed in the form of card photographs. The South had a similar popular interest in photographs of Confederate officers, but chronic shortages of materials, not to mention of photographers, curtailed production. [19]

Today it is common to give all the credit for documenting the Civil War to Mathew Brady. He was certainly the best-known photographer to become involved in photographing the conflict, but he was by no means the only one. Moreover, partly because by 1861 his eyesight was quite poor, it is likely that he made very few of the thousands of images that are routinely credited to him. [20]

Josephine Cobb, former archivist at the

Carte de visite composite of photographs of "Union heroes," mostly from Brady negatives. Published by E. and H. T. Anthony, ca. 1866. Author's collection.

Late portrait of Mathew
Brady, taken by his
nephew, Levin C.
Handy. Photographic
History Archive, Na-
tional Museum of
American History,
Smithsonian Institution.

Still Pictures Branch of the National Ar-
chives, compiled a list of some three hun-
dred photographers and gallery owners
who received special passes from the Fed-
eral military authorities to photograph
in and around various encampments.
Roughly one-third that many made pic-
tures in the South as long as supplies lasted.
The great majority of Civil War photogra-
phers were engaged in the routine business
of making tintype and carte-de-visite por-
traits for soldiers to send home to their
families.[21] They set up temporary studios in
tents, hung a sign on the front flap pro-
claiming pictures or photographs for sale,
and waited for the inevitable influx of
young men to show up. Occasionally, these
portrait photographers were inspired to do
more. In two separate trips to the front in
1862 and 1863, for instance, G. H. Hough-
ton, whose gallery in Brattleboro, Ver-
mont, was named Photographic Hall, pro-
duced nearly a hundred views of various
encampments of Vermont soldiers. He
made pictures of soldiers relaxing in camp
and on parade, posing with artillery pieces,
and standing over the crudely marked
graves of fallen comrades.[22] It is fair to as-
sume that Houghton was doing more than
simply recording the Green Mountain boys
for posterity. He was, after all, a commer-
cial photographer, and it is likely that he ex-
hibited and sold paper prints of his camp
views upon his return to Brattleboro.

Ben Oppenheimer, the leading photog-
rapher in Mobile, Alabama, before the war,
photographed Alabama troops in the pine
woods near Pensacola, Florida, shortly be-
fore P. G. T. Beauregard's artillery fired on
Fort Sumter. One surviving ambrotype
from that trip shows a line of backlit sol-
diers facing the camera. A carefully printed
caption on the ambrotype's leather case
identifies the troops and the photographer,
suggesting that the image was exhibited at
Oppenheimer's gallery shortly after it was
made.

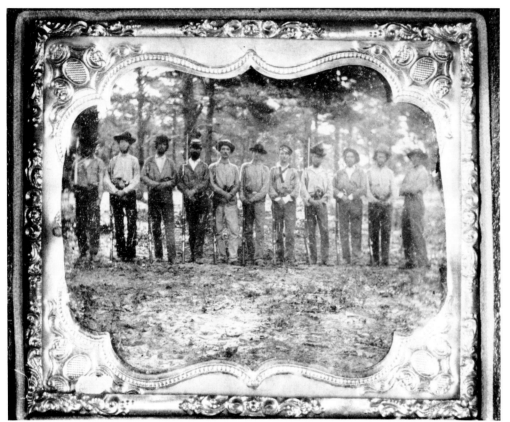

Ambrotype by Ben Oppenheimer of Alabama troops near Pensacola, Florida, ca. 1861. Collection of Robert Cauthen, Leesburg, Florida.

Carte de visite of a mass
meeting in support of
the Union, on Broad-
way, New York City,
1861. Published by E.
and H. T. Anthony.
Collection of Robert
Cauthen, Leesburg,
Florida.

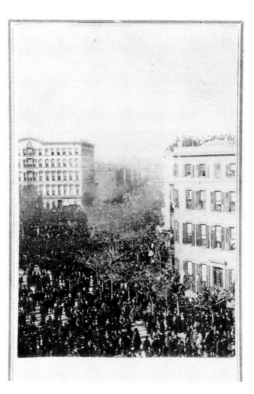

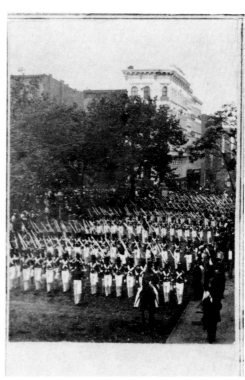

Carte de visite of troops
marching down Broad-
way, New York City,
published by E. and
H. T. Anthony. Collec-
tion of Robert Cauthen,
Leesburg, Florida.

Besides the small army of portrait photographers who vied for the soldiers' hard-earned pay, others saw in the conflict an opportunity to make pictures that could be mass produced or published in one of the illustrated weekly magazines. The Anthony brothers, whose supply house in New York City provided the Brady operation with equipment and chemicals, hired several photographers to keep the firm well supplied with images that it could publish in the form of stereos and cartes de visite and sell to the public. Thomas C. Roche, who worked for the Anthonys and Mathew Brady, gained a reputation among his fellow photographers for extreme coolness under fire. During a Union assault near the monumental but futile earth-moving experiment called the Dutch Gap Canal in 1864, for instance, Roche went about his work without the slightest regard for his own safety. The Confederates were bombarding the Union positions with mortar and artillery rounds, "throwing immense shells every few minutes, tearing up the ground and raising a small earthquake every time one of them exploded." Roche was nonplussed.

He had taken a number of views and had but one more to make to finish up the most interesting points, and this one was to be from the most exposed position. He was within a few rods of the place when down came with the roar of a whirlwind a ten-inch shell, which exploded throwing the dirt in all directions; but nothing daunted [Roche] and shaking the dust from his head and camera he quickly moved to the spot, and placing [his camera and tripod] over the pit made by the explosion, exposed his plate as coolly as if there was no danger, and as if working in a country barn-yard.

Asked if he was at all frightened, Roche is said to have replied with unfeigned bravado, "Scared? Two shots never fell in the same place."[23]

When the war drifted close enough to their studios, photographers Jesse H. Whitehurst of Washington, D.C., C. A. Johnson of Cincinnati, and William H. Tip-

ton and Charles and Isaac Tyson of Gettysburg, among many others, took the opportunity to make pictures that could be sold to the public and to the illustrated magazines. The Union military recognized the value of photographs as visual guides for mapmakers and engineers, and employed several photographers, most notably Captain Andrew J. Russell of the 141st New York Volunteers, to record the various activities of the army in the field. And in the South, a few photographers in the major cities made pictures for as long as they could, though the Union naval blockade and a general shortage of manpower effectively stifled any systematic photographic coverage.

Ascribing authorship to the profusion of Civil War pictures is difficult in part because some independent operators like the Tysons in Gettysburg omitted credit. And large-scale operations like Brady's and the Anthonys' usually did not identify the person who actually made the picture. Few, if any, of the images that were produced by the Brady studios were made by Brady himself. Like other successful photographic entrepreneurs, Brady hired talented photographers to handle the work in his studios. He supervised the various operations of his photographic enterprises, maintained cordial relations with the public, especially with individuals in positions of power, and made sure that his name and images were published regularly in the periodical press. Brady seldom actually made the exposures, and he most certainly did not rush with the exposed plate to the darkroom and there develop it and make prints.

Stereo cards and cartes de visite produced at his studios carried his name on the reverse of the card; ambrotypes and daguerreotypes had his name engraved in the copper filigree. There was nothing nefarious in the practice of taking credit for all the work produced under his auspices; it was an accepted practice in the early days of photography. Camera operators and dark-

room personnel were anonymous, and became known only if and when they set up their own operations. As long as they worked for Brady, as long as he supplied the cameras, plates, and photographic supplies, as long as he paid the salaries, he took the credit.

During the war, Brady's insistence upon this policy contributed to a major rift in his organization. It was one thing for him to take all the credit in peacetime, but when his operators in the field risked their lives to make pictures, they felt justified in demanding credit. Brady, however, was adamant about receiving what he considered to be his proper due, and as a result several of his most gifted photographers left the organization midway through the war. Alexander Gardner, who had run Brady's Washington studio before the war, left in 1863, setting up a rival photography team. He took with him several of Brady's best operators: Timothy O'Sullivan, James Gibson, George Barnard (of the Oswego fire), and David B. Woodbury.[24]

Not surprisingly, Gardner was usually meticulous about giving his photographers credit for the images they produced. A catalogue of war views available at Gardner's Gallery in Washington, D.C., printed in the early fall of 1863, gives the name of the photographer of each picture listed.[25] And after the war, when he published *Gardner's Photographic Sketch Book of the War,* he credited both the photographer and printer of each image. However, proper credit for specific images is sometimes problematic even when a photographer is listed. At Gettysburg, for instance, Gardner and O'Sullivan worked closely together, and probably collaborated on some views. One man might discover a scene with photographic potential, the second set up camera and tripod, the first coat and sensitize the plate, and the second make the actual exposure. Yet only one received credit.

Still, Gardner's policy of assigning credit to photographers was the exception in

nineteenth-century photographic practice. As a result, it is difficult to say with certainty who actually made many well-known images. The problem is compounded by the then common practice of pirating popular photographs. According to William Culp Darrah, author of several exemplary studies of nineteenth-century photography, the outright theft of "marketable portraits was so extensively practiced, even by reputable photographers, that scarcely a well-known image escaped plagiarism. Usually all that was required was an image from which a copy negative could be produced."[26] For instance, in Edmund Guilbert's *The Home of Washington Irving,* which was illustrated with George Rockwood's photographs of Sunnyside, Irving's magnificent country estate in Tarrytown, New York, the lead picture is a portrait that was actually made by John Plumbe in 1849. Not only is Plumbe not given credit, the

picture carries a notice of copyright in the name of Rockwood.[27] The identical image of Irving had been produced in the form of a carte de visite in the late 1850s and credited to the Brady studio in New York. Brady had indeed photographed Irving, but that session was not a success; the celebrated author detested the efforts of the celebrated photographer. When Plumbe's photography business failed in 1847, several of the more acquisitive members of the photographic fraternity appropriated many of his images.

The Brady collections of Civil War photographs, now housed in the Library of Congress and National Archives, thus include the work of many photographers (Brady sometimes had as many as nineteen teams of camera operators in the field), only a few of whom gained any recognition for the images they produced.[28] His staff photographers, including J. F. Coonley, George Barnard, Lewis Landy, Alexander Gardner, James Gibson, Timothy O'Sullivan, David Woodbury, Thomas Roche, and Samuel Chester, lumbered after the Federal armies in wagons loaded with photographic paraphernalia. They made pictures of fortifications and battlegrounds, of groups of soldiers relaxing in camp or posing stiffly with the implements of war, and of the human detritus of battle, the bodies of the dead lying in neat rows made by burial details or, if the photographers arrived in time, scattered haphazardly about the bloodied landscape. Gardner was right: We should know the names of the men who made those pictures.

Notwithstanding Brady's policy of crediting himself for the work of others, his effort to organize, equip, and finance teams of photographers led to the first complete photographic documentation of war.[29] "I had men in all parts of the army," Brady said, "like a rich newspaper." Brady had some thirty-five photographic bases constructed, most of them simple log structures with canvas roofs, and scattered them

Carte de visite of Washington Irving, from an original portrait by John Plumbe. Published by E. and H. T. Anthony with credit to Mathew Brady. Collection of David Kent, Miami, Florida.

about the war zones like the out-of-town bureaus of modern newspapers. Each had to be kept stocked with camera equipment and chemicals. Wagons containing portable darkrooms (called "whatsit wagons" by the troops) needed to be built and maintained, and the horses that drew them fed and cared for. It was an enormous logistical and financial undertaking. Even getting the Northern military authorities to permit him and his photographers to accompany the armies and make pictures was difficult. Brady first asked General Winfield Scott, an old friend, for authorization in the spring of 1861, but he learned that General Irvin McDowell was about to take command of the Army of the Potomac and that he would have to speak with McDowell. "I did have trouble," Brady said later, for "many objections were raised" by members of McDowell's staff.[30] Against the advice of his wife and his "most conservative" friends, Brady persisted, and just before the first battle at Bull Run, he received word he could go along.

According to his own account, Brady equipped two wagons and set out from Washington in pursuit of the Union forces with Dick McCormick, a newspaper reporter; Alfred R. Waud, *Harper's* sketch artist; and a couple of assistants.[31] His experience at Manassas was not much more successful than that of McDowell's army, though he stoutly maintained that he managed to make some spectacular images. Brady's announcement that he had returned with images of the war's first major battle attracted considerable attention in the press. Brady "has been in Virginia with his camera," wrote Samuel Humphrey, "and many and spirited are the pictures he has taken." The images, he said, would be a welcome contrast to the various written reports in the press. The pictures made by Brady and his men were "the only reliable records at Bull Run," according to Humphrey; nobody else could be trusted. "The correspondents of the rebel newspapers are sheer falsifiers; the correspondents of the

Northern journals are not to be depended upon, and the correspondents of the English press are altogether worse than either." But the camera, said Humphrey, did not, could not, lie.[32]

A reporter for the *New York Times* was even more effusive. In a story published on August 17, 1861, Brady was said to have "accompanied Heintzelman's column into the action, and was caught in the whirl and panic which accompanied the retreat of our Army." The unnamed reporter wrote that Brady was seen "at every point, before and after the fight, neglecting no opportunity and sparing no labor in the pursuit of his professional object." He concluded by saying that many of the views made by Brady would be displayed at his gallery on lower Broadway.[33]

Since no images of the battlefield taken at the time of the battle have surfaced, it is possible that these glowing testimonials were based upon Brady's account of events rather than a firsthand look at his pictures. Brady certainly went to Manassas with the intention of making pictures (he had a photograph made and distributed of himself "just returned from Bull Run"), but he was apparently not successful. At no time during the war were images from the first battle at Bull Run listed in his catalogues. Rather than admit failure, Brady contacted his friends in the press with a stirring story of his bravery under fire and the success of his mission. The legend of Brady as *the* premier Civil War photographer was born.

. In all the excitement over Brady's nonexistent images, a brief article in the August 1861 edition of the *American Journal of Photography* seems to have been overlooked. According to this report, there were indeed photographers in the van of the Union army, and one of them even managed to get "so far as the smoke of Bull's Run." The unnamed photographers, presumably Brady and his assistants, were busy "aiming the never-failing tube at friends and foes alike, when with the rest of our Grand Army they

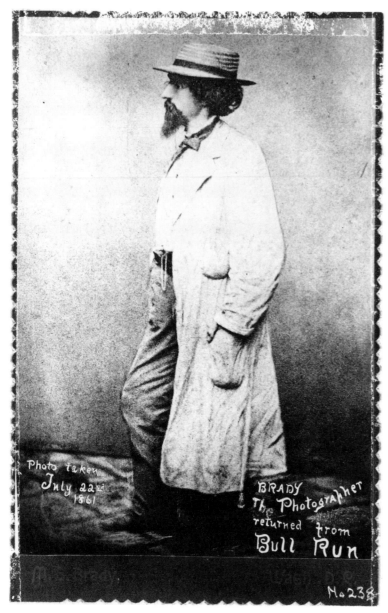

Mathew Brady "returned from Bull Run," published by Brady's Washington, D.C., studio. Photographic History Archive, National Museum of American History, Smithsonian Institution.

were completely routed and took to their heels, leaving their photographic accoutrements on the ground, which the rebels, no doubt, pounced upon as trophies of victory."[34] Perhaps Brady really did make some pictures at Bull Run, but since they have never surfaced, it is most likely the images were either left on the field or destroyed during the chaotic retreat back to Washington.

George Barnard also went to Manassas to make pictures of the first great battle of the war, but like Brady he came away without a single image. He may have been operating independently, as a member of Brady's team, or on assignment from the Anthonys. At any rate, according to a story published in *Anthony's Photographic Bulletin* in 1902, Barnard, too, got caught up in the frenzied retreat of soldiers and sightseers. "On the return," wrote the reporter, Barnard "overtook a poor fellow, sorely wounded in the leg, trying to get back to Washington." Trading places with the soldier, Barnard "shouldered his heavy instrument, and after weary walking he reached Washington, footsore and tired."[35]

Evidently, the only photographs of the first major battle were made far behind the front lines by a group of photographers from Brady's studio. They had traveled only as far as Fairfax but were "quite successful" nonetheless. Charles A. Seeley, editor of the *American Journal of Photography,* noted the "fine stereo-view of the famed Fairfax Court House," then wondered wistfully when northern photographers would "have another chance in Virginia."[36]

Historian Henry Wysham Lanier neatly summarized Brady's work in the Civil War in an essay published in 1912. It was not that Brady personally produced an extraordinary body of work, according to Lanier, but that he conceived the idea that such work could be produced, and then did what was necessary to have it accomplished. "While the war soon developed far beyond

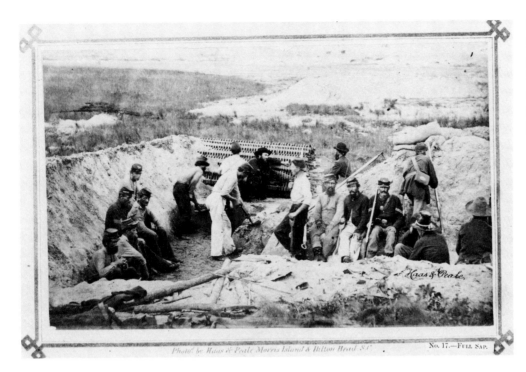

Photographic view of Union troops in coastal gun emplacement by Haas and Peale. International Museum of Photography at George Eastman House.

what [Brady] or any other one man could possibly have compassed, so that he is probably directly responsible for only a fraction of the whole vast collection of pictures," wrote Lanier, "he may fairly be said to have fathered the movement." Moreover, it was Brady's "daring and success [that] undoubtedly stimulated and inspired the small army of men all over the war region."[37]

Brady understood what photography could be; he knew that photographs could be more than sentimental keepsakes or decoration. More than any of his contemporaries, he seems to have grasped the notion that the value of photographs increases with the size of their audience. He considered himself a historian and was determined to record for posterity the great events and persons of his day. But he also understood the potential for photographs to report the news. Thus the images made during the war were sold in stereo and card form and found their way into the illustrated newspapers. Brady meant to make money on his pictures of war. What he did not count on was that the public would want more than

anything else to forget the harsh realities of war once the fighting stopped.

Photographs of the war, whether produced by Brady's or Gardner's men, by military photographers, or by one of the smaller independent operators, were made available to the public during and after the war in a variety of sizes and formats. What these images had in common was the collodion process; they were all albumen paper prints made from glass-plate negatives, and were intended to be reproduced for the public. Prints measuring eleven by fourteen inches and eight by ten inches ("imperials"), stereo cards, and cartes de visite abounded during the war years. "For the first time in history," writes Stanley Burns, an expert in the history of medical photography, "war was reported on a personal and horrific level and made available to the public almost immediately after the events occurred."[38]

Cartes de visite of the Union high command were especially popular and sold in large numbers. People collected pictures of Lincoln, McClellan, Grant, Sherman, McDowell, Burnside, Custer, Hooker, and

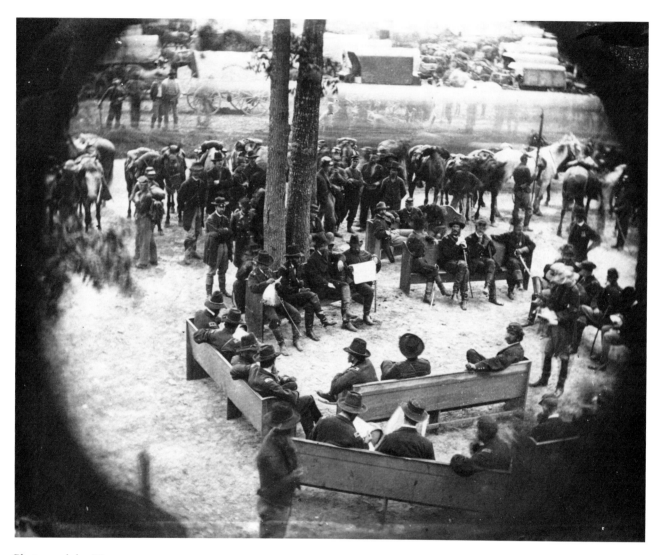

Photograph by Timo-
thy O'Sullivan of Gen-
eral Grant meeting with
his generals near the
Massaponax Baptist
Church in Virginia,
May 21, 1864. Library
of Congress.

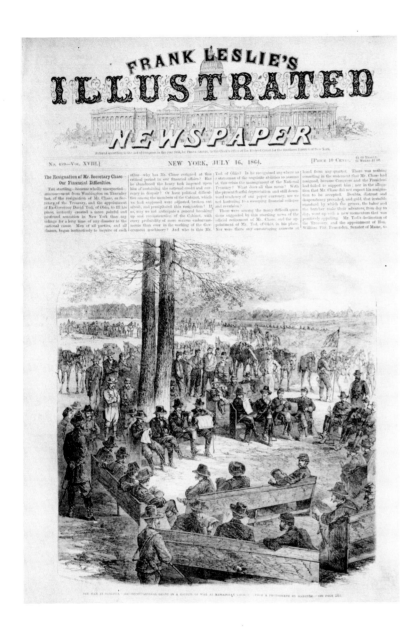

Wood engraving of Grant and his generals at Massaponax Church, from the photograph by Timothy O'Sullivan. Published in *Frank Leslie's Illustrated Newspaper,* July 16, 1864, with an incorrect attribution to Alexander Gardner. Otto Richter Library, University of Miami.

others, and kept them in specially constructed albums. Stereographic views of the scenes of great battles and those of important new developments in military technology such as ironclads and gigantic mortars mounted on railway cars consistently sold well during the war. The public wanted to see actual photographs of the things about which they read in newspapers and magazines. At approximately fifty cents each, stereos provided the public with an inexpensive and inexhaustible supply of eyewitness glimpses of the Union war efforts. However, despite the popularity of stereos and other formats during the war years, their sales never entirely met the enormous costs involved in securing the images. Large-scale operations such as those run by Brady and Gardner, which involved prodigious amounts of equipment and supplies as well as salary payments to a large number of employees, fared poorly despite the public's enthusiasm for the photographs they produced.

The fidelity of the images, especially when the illusion of depth was added through stereoscopy, made them effective visual communications. The utterly graphic and realistic portrayal of war was something entirely new, and contrasted significantly to the more imaginative and romantic work produced by sketch artists like Winslow Homer and Alfred R. Waud. Published by the hundreds of thousands in the North throughout the war, stereo cards kept the public apprised of the progress of the fighting as well as the awful human cost of battle. "These specimens of [stereo] photography . . . are among the cleverest and best we have seen," editorialized the *Nation* in 1865. "A dozen that lie before us bring up vividly the drama of the late rebellion. Here are alike the instruments of ruin and the ruin itself." There was little romance in the pictures, just the graphic finality of war. Images such as those depicting "a battered cathedral in Charleston" or the "desolate walls of fire-ravaged Richmond" stood out "with lamentable distinctness."[39]

That the public regarded the photographs, especially stereo views, as unaltered, and therefore more realistic and believable than the work of artists, is clear. General Ulysses S. Grant, in a letter to the New-York Historical Society shortly after the war ended, wrote that Brady's images had been "taken on the spot while the occurrences represented were taking place," hardly a startling observation today, but worth mentioning in 1866. Photographs, unlike sketches, could not be made from memory. Grant added that he owned many of the photographs and was convinced "that the scenes are not only spirited and correct, but also well chosen."[40]

Grant's authoritative testimonial notwithstanding, it is now known that Civil War photographs were not always perfectly truthful representations. Occasionally photographers sought to enhance the visual impact of their pictures by altering the scenes in front of their cameras. Photographic his-

torian William Frassanito points out, for instance, that Timothy O'Sullivan and Alexander Gardner carefully arranged both the rifle and the body of the young Confederate soldier shown in the well-known image *Home of the Rebel Sharpshooter,* taken in the rocky area called "the Devil's den" below Little Round Top at Gettysburg.

They initially photographed the body in a relatively open area about forty yards away from the rocks shown in the famous picture. They then moved it to its final location, placed a knapsack under the head, and propped a rifle, though not the type used by southern sharpshooters, against the rocks. Although Gardner credited O'Sullivan as the photographer in a catalogue of views issued two months after the battle, in his *Sketch Book* he claimed credit for the picture. The image was probably a joint effort. It is known that the two men worked closely at this location, carefully arranging

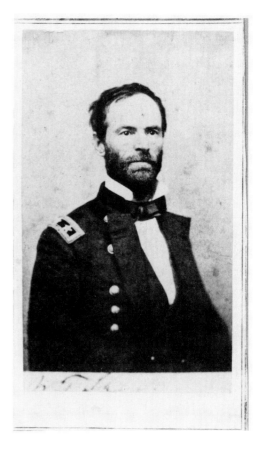

Carte de visite of General William Tecumseh Sherman by Morse's "Gallery of the Cumberland," Nashville, Tennessee. Collection of David Kent, Miami, Florida.

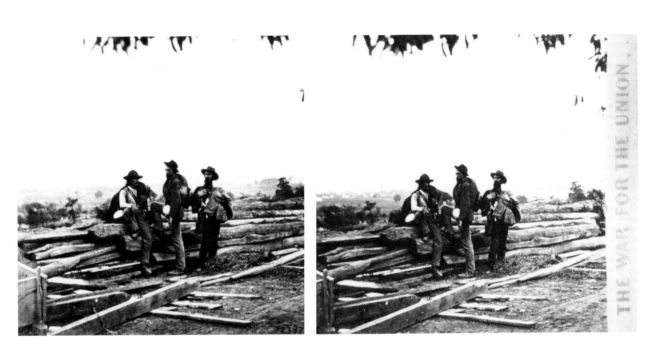

Stereograph by Alexander Gardner of captured Confederates at Gettysburg. American Antiquarian Society.

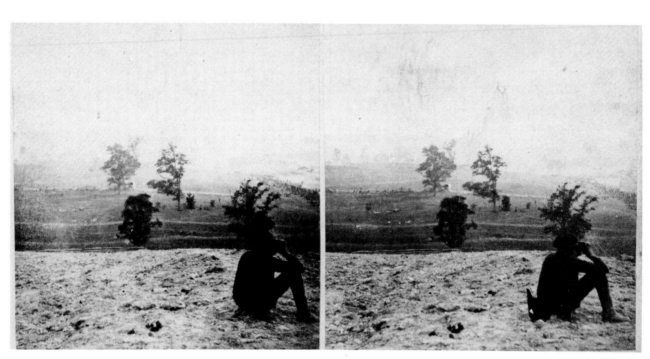

Stereographic view by
Alexander Gardner of
the smoke-shrouded
battlefield at Antietam,
taken during the battle
on September 17, 1862.
International Museum
of Photography at
George Eastman House.

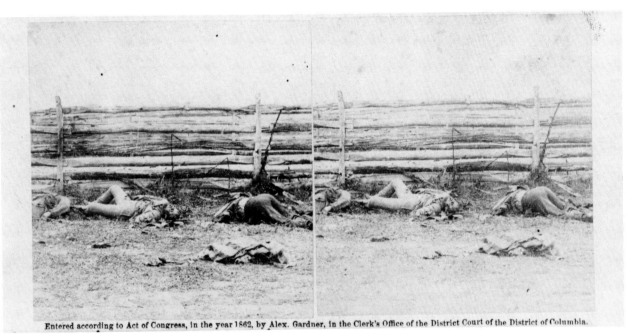

Entered according to Act of Congress, in the year 1862, by Alex. Gardner, in the Clerk's Office of the District Court of the District of Columbia.

Stereographic view of Confederate dead at Antietam, made by Alexander Gardner and published by E. and H. T. Anthony. Collection of David Kent, Miami, Florida.

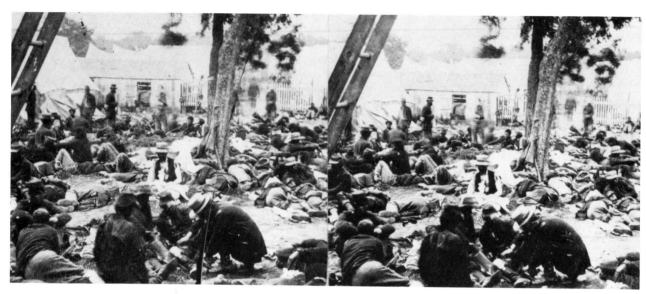

"Field hospital at Savage [*sic*] Station, after the battle of June 27, 1862." Published by Mathew Brady's gallery, Washington, D.C. American Antiquarian Society.

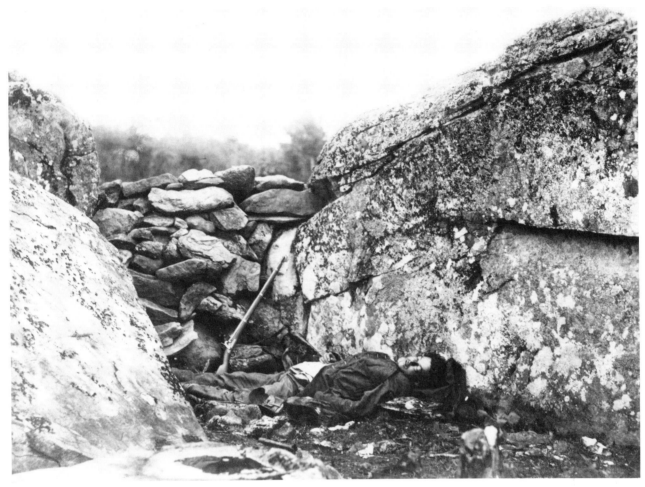

"Home of the Rebel Sharpshooter," made by Alexander Gardner at Gettysburg, July 1863, with the assistance of Timothy O'Sullivan. Library of Congress.

the scene, sensitizing the plates, making and developing the exposures. They produced a total of six photographs of the body, in large format and in stereo. Frassanito credits Gardner with two of the views made in the open area, and O'Sullivan with four others, including the most famous image.[41]

Gardner's lengthy caption in the *Sketch Book* was clearly designed to enhance the emotional impact of the image. Wounded in the head by a shell fragment, wrote Gardner, the sharpshooter had "laid down upon his blanket to await death." The photographer wondered what the last moments of the boy's life had been like. "Was he delirious with agony, or did death come slowly to his relief, while memories of home grew dearer as the field of carnage faded before him? What visions, of loved ones far away, may have hovered above his stony pillow!" Gardner added that when he returned to the battlefield in November, the boy's remains were still in that rocky bier and his now rusted rifle was still leaning against the rocks.[42] The caption, though a masterful bit of purple prose, is apocryphal. The boy did not die there; he was probably not a sharpshooter; Gardner may well have brought the rifle to the scene; and it is unlikely that burial details would have overlooked the body or that relic hunters would somehow have missed the rifle.

In September 1862, Brady advertised that his Broadway gallery had for sale "Consecutive Views of the Leading Scenes and Incidents of the War," photographs unrivaled in "beauty and fidelity, taken by corps of

trained artists, which have accompanied the great Union Armies in their several campaigns."[43] Two months later, the Anthony brothers' photographic supply house in New York City published a similar catalogue of war photographs in stereo form, all of which were taken by Brady's photographers. Perhaps Brady, already strapped for funds, was paying for his supplies with stereo negatives and prints instead of money. It is known that he supplied the Anthonys with negatives for the production of cartes de visite, and it is reasonable to assume he made a similar deal for his stereos.[44] The introductory message in the Anthony catalogue foretold the historical value of the pictures and placed the work of Brady's photographers with that of other communications workers.

Mr. Brady's "Scenes and Incidents," of which a year's product is now offered to the public, are inestimable chroniclers of this tempestuous epoch, exquisite in beauty, truthful as the records of heaven, appealing with ever increasing interest to the art-lover, the historian, and the patriot—to the eager delight of childhood and the memories of age. Their projector has gone to his work with a conscientious largeness becoming the acknowledged leader of his profession in America. "Brady's Photographic Corps," heartily welcomed in each of our armies, has been a feature as distinct and omni-present as the corps of balloon, telegraph, and signal operators. They have threaded the weary stadia of every march; have hung on the skirts of every battle-scene; have caught the compassion of the hospital, the romance of the bivouac, the pomp and panoply of the field . . . , even the cloud of conflict, the flash of the battery, the after-wreck and anguish of the hard-won field.[45]

In the Confederacy, there was no comparable attempt to document the actions and activities of the armies, not because of a lack of will, but primarily because of a shortage of supplies. In early 1862, Samuel Humphrey remarked that when the war ended, "our Southern Photographic friends will . . . be 'let out of jail,' as it were. They must be all out of stock and materials, and our dealers here will then have their hands full of business."[46]

In the southern states there were indeed shortages of equipment and especially of the supplies necessary to make pictures, but it was never quite as bad as Humphrey intimated. The Anthony brothers, ever on the lookout for new markets for their goods, continued to send supplies southward after the outbreak of hostilities. They managed to smuggle small amounts through the lines and even openly shipped supplies to photographer Andrew D. Lytle in Baton Rouge under "orders to trade" that Union military authorities in the West had issued rather profligately. Lytle used his ill-gotten materials to secretly photograph Union fortifications in the area (he made pictures from the windows in the upper stories of houses and from the bell tower of a local church). For a time he was able to signal nearby Confederates news of the deployment of Union forces.[47]

The publishing firm of Ayers and Wade of Richmond even managed to produce and disseminate an illustrated weekly newspaper, the *Southern Illustrated News,* from 1862 until early in 1864, but not without constant problems. The quantity and quality of the paper stock varied with each issue, and there were never enough engravers to do the work. In the summer of 1863, the newspaper printed an advertisement for draftsmen who could make wood engravings "in a style not inferior to the *London Illustrated News,*" but there was little response. In late August and again in October, the newspaper did run front-page engravings made from photographs of Thomas "Stonewall" Jackson and Robert E. Lee, but the pictures were crudely executed. By November 1863, illustrations of any kind were rarities.[48]

Lacking the wherewithal to conduct the kind of operation run by Brady and Gardner, photographers in the South contented

Wood engraving of
Robert E. Lee by John
Torsch, from a photo-
graph by George Min-
nis and Daniel Cowell.
Published in the *South-
ern Illustrated News,* Oc-
tober 17, 1863. National
Portrait Gallery, Smith-
sonian Institution.

Wood engraving of
General Thomas
"Stonewall" Jackson by
A. Hurdle from a pho-
tograph by Daniel
Cowell. Published in
the *Southern Illustrated
News,* August 29, 1863.
National Portrait Gal-
lery, Smithsonian Insti-
tution.

themselves with the production of photographic portraits, at least as long as their supplies held out. In June 1862, Stonewall Jackson's cavalry commander, General Turner Ashby, was fatally wounded near Harrisonburg, Virginia, while leading an attack against a Pennsylvania regiment known as the Bucktail Rifles. After the battle, a tintype of Ashby's body was made by a local photographer; the body was then taken to the home of Frank Kemper in Port Republic. "After the fight was over," remembered Captain Charles Hilary, "we had his picture taken as he lay there—beautiful as if carved in marble, only there was a dark spot above the heart."[49] The making of a postmortem photographic portrait was a simple and straightforward process for nineteenth-century photographers, and not one that was considered overly gruesome or macabre. Sometimes live subjects made even the simplest of portraits considerably more challenging.

A Richmond photographer, George W. Minnis, who operated a studio with Daniel T. Cowell, had to use equal amounts of persistence and guile in his quest for portraits of Stonewall Jackson shortly before the battle at Chancellorsville. Henry Kyd Douglas, a member of the general's staff, recalled, "Having been warned that he could not hope to get General Jackson to sit for his picture, [Minnis] resorted to strategy." The photographer called upon the general and told him that his real purpose in visiting the army had been to secure a new portrait of General Lee in camp for the folks back in Richmond. Surprisingly, said Minnis, General Lee declined to sit for him "unless General Jackson would have his [picture] taken first." Jackson hesitated a moment and then replied that "General Lee ought to have his picture taken for the people and should not get out of it that way." Minnis got his picture.[50]

This reminiscence is evidence of the development of what has become a time-honored tenet of photojournalism: It is the picture that counts, not the methods used to procure it. Or to put it another way, a news photographer ought never take a simple no for an answer, for persistence may well pay off in pictures. The story also suggests that Minnis's pictures were intended to be seen by "the people" and that General Jackson both understood and approved of this use of photographs.

Another photographer from Richmond, George O. Ennis, must have been equally tenacious, if not as devious, when he photographed Union troops engaged in the construction of the ill-fated Dutch Gap Canal on the James River. After the war, Ennis's view of General Benjamin Butler's troops hard at work in the canal was published in carte-de-visite form by W. D. Selden, his former partner. Seldon listed himself as a dealer in "photographic views [and] Confederate relics of the late war," suggesting that at least a few southern photographers managed to make pictures during the war.

In July 1863, nearly a year after the northern and southern armies fought for a single bloody day in the fields and woods along Antietam Creek, Oliver Wendell Holmes spoke of the photographs he had seen of the battlefield. Most of these images were made by two of Brady's most talented operators, Alexander Gardner and his assistant James Gibson, who arrived on the field of battle shortly after the fighting ended. "Let him who wishes to know what war is look at this series of illustrations," Holmes wrote, no doubt remembering his own anguish upon learning that his eldest son, a captain in the Twentieth Massachusetts Volunteers, had been wounded in the neck during heavy fighting near Keedysville, Maryland.[51] "These wrecks of manhood thrown together in careless heaps or arranged in ghastly rows for burial were alive but yesterday. . . . An officer, here and there, may be recognized; but for the rest—if enemies, they will be counted, and that is all." Photographs such as these, he con-

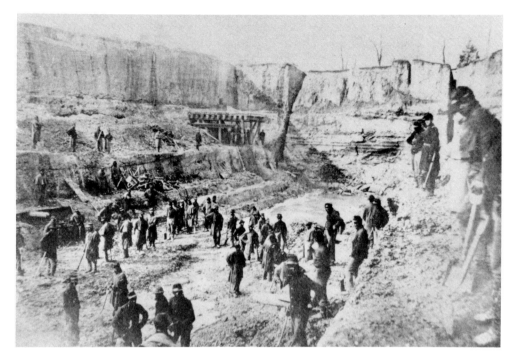

Carte de visite of Union troops at Dutch Gap Canal on the James River in Virginia, made by George O. Ennis of Richmond. Published by W. D. Selden and Company, "dealer in photographic views, Confederate relics, of the late war." Collection of Robert Cauthen, Leesburg, Florida.

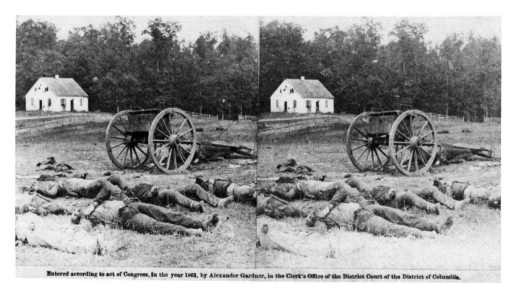

Entered according to act of Congress, in the year 1862, by Alexander Gardner, in the Clerk's Office of the District Court of the District of Columbia.

Stereograph (*Completely Silenced*) by Alexander Gardner of dead Confederate soldiers near the old Dunker church at Antietam. International Museum of Photography at George Eastman House.

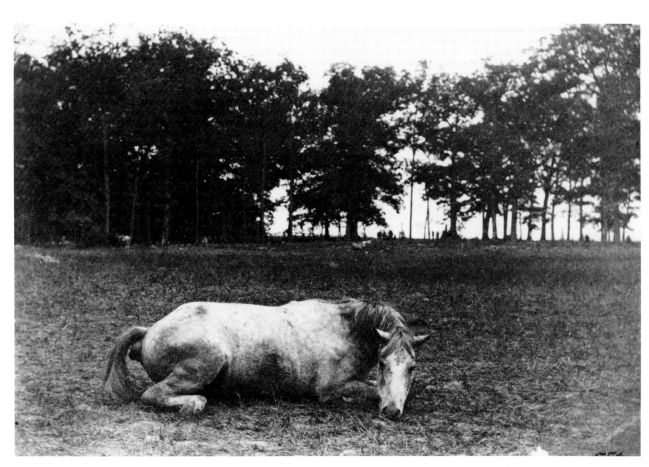

Dead horse photographed by Alexander Gardner near the Hagerstown Pike at Sharpsburg, Maryland, shortly after the Antietam battle. The horse's owner, Confederate Colonel Henry B. Strong of the Sixth Louisiana, was also killed. Library of Congress.

cluded, provide a "commentary on civilization such as the savage might well triumph to show its missionaries." For Holmes and others, the images were really too terrible, and he was determined to bury them "in the recesses of our cabinet as we would have buried the mutilated remains of the dead they too vividly represented."[52]

Similar sentiments had been printed in the *New York Times* barely a month after the battle. Brady's gallery on Broadway had an exhibition of the Antietam images, announced by a small placard on the outside door to his gallery. Brady, wrote the reporter for the *Times,* had "done something to bring home . . . the terrible reality and earnestness of war." The public was at once shocked and fascinated by the photographs. According to the *Times* reporter, crowds of people trudged up the stairs to Brady's opulent showroom to see for themselves what the bloodiest day in American military history looked like. "You will see hushed, reverend [*sic*] groups standing around these weird copies of carnage, bending down to look in the pale faces of the dead, chained by the strange spell that dwells in dead men's eyes," he wrote. The pictures were clear and vivid, offering unobstructed and apparently unadulterated views of battlefields littered with the dead. One could even make out the features of the slain with the aid of a magnifying glass. "We would scarce choose to be in the gallery," wrote the reporter, "when one of the women bending over them should recognize a husband, a son, or a brother in the still, lifeless lines of bodies that lie ready for the gaping trenches."[53]

In June 1865, *Harper's Weekly* published a set of engravings made from photographs that expressed the horror of war and served as an indictment against those in the South most responsible for wounding the nation. Before this, published photographs had most often eschewed blame and vituperation. The pictures made of the dead at Antietam, Gettysburg, and Petersburg, of the

wounded at Fredericksburg and Savage's Station, of the ruin of southern cities caught in Sherman's long march down to the sea, suggested the terrible reality of war but avoided assigning blame. Not so with *Harper's* images describing the physical condition of former Union prisoners at Andersonville prison in Georgia. The pictures themselves and their skillful use on the printed page were clearly meant to prove the willful malevolence of certain persons in the Confederate high command.

The original photographs were delivered to *Harper's* by Chaplain J. J. Greer of the 183rd Ohio Volunteers. Made into carte-de-visite-size engravings, they were grouped in a semicircle around an article entitled "Rebel Cruelties." The three vertical photographs on the outside edge of the page are especially horrific. In each a wizened soldier sits on the edge of a hospital bed, his legs bare and hanging over the side. They stare blankly into the lens of the camera. The viewer's attention is drawn inexorably to the foul remains of the soldiers' lower limbs, rotted off in the fetid swamplands of the prison camp. The picture on the bottom right-hand corner of the page shows the feet of Calvin Bates placed neatly on a stool beside his bed. But his feet are no longer connected to the rest of him.

Two-page spread of wood engravings made from photographs by Alexander Gardner and James Gibson of the battlefield at Antietam. Published in *Harper's Weekly* and incorrectly credited to Mathew Brady. American Antiquarian Society.

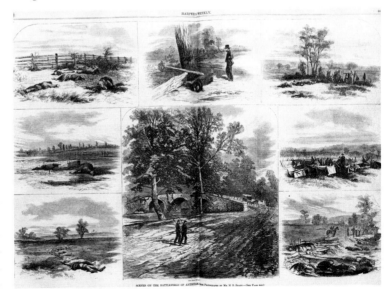

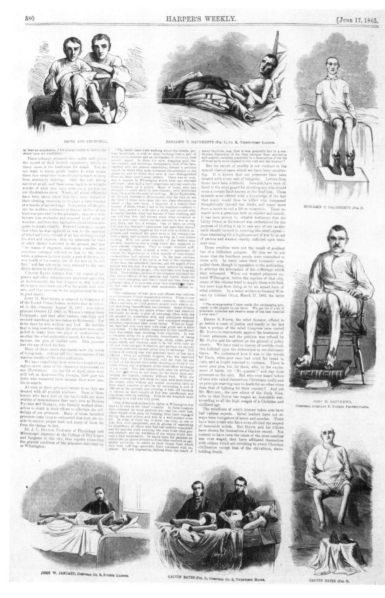

"Rebel Cruelties," wood engravings from photographs by an unnamed photographer of former prisoners at Andersonville prison. Published in *Harper's Weekly,* June 17, 1865. American Antiquarian Society.

The layout is sophisticated and effective. One reads the images from left to right; they form a visual dirge to the three columns of words. The pictures were selected, wrote the editors, "not because they were more effective than a hundred others we might give, but because we had not space to give all. . . . They do not come to us from a distance." [54] This story and these pictures suggest that whereas the long national nightmare might have been over, the time for punishment had just begun. As if to remind northern readers of the South's monumental perfidy, these and other photographs of Andersonville's cadaverous survivors were widely published; *Frank Leslie's Illustrated Weekly* even put a group of them on the cover. [55] The pictures surely led to the public's demand for swift and deadly punishment (Henry Wirz, the prison's commandant, was executed) and gave rise to the notion that the South's policy toward prisoners of war was far worse than that of the North. In fact, the policies of both sides toward prisoners was decidedly inadequate and often inhumane.

It may be that Brady, Gardner, Barnard, and the other photographers who set out to make pictures of the war did their work too well, for a public grown weary of war and of its awful toll could not be persuaded to purchase graphic visual reminders of the conflict when the war ended. Thousands of glass plates were sold to gardeners who used them in the construction of greenhouses. [56] Even during the war, many images described scenes too awful to appeal to a mass audience. The great battles at Antietam, Gettysburg, Shiloh, Petersburg, and Atlanta were photographed in retrospect. Unable to capture on their glass plates the surge and tumult of battle, photographers recorded instead the dreadful aftermath: the grotesque, swollen bodies of unburied dead soldiers; houses, barns, and other structures pocked by bullets, artillery, and shrapnel; burned bridges; the littered remains of caissons, wagons, and other implements of

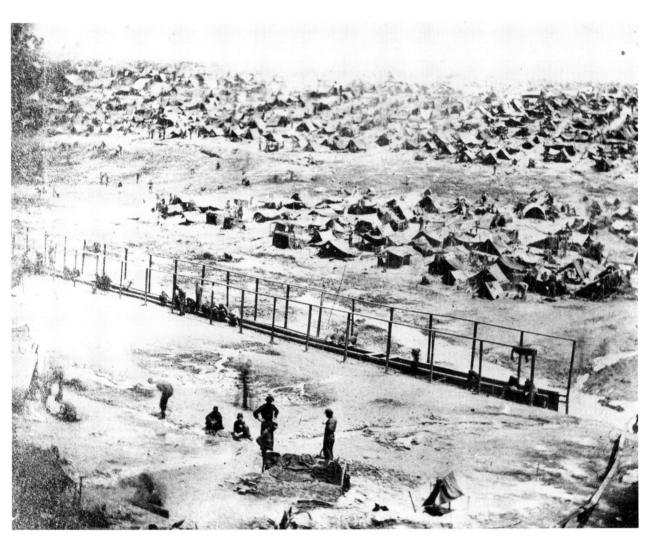

"Bird's eye view" of
Andersonville prison,
made by A. J. Riddle of
Macon, Georgia, on
August 17, 1864. Na-
tional Archives.

Frank Leslie's Illustrated Newspaper cover illustration of Andersonville survivors, made from photographs "without exaggeration." Otto Richter Library, University of Miami.

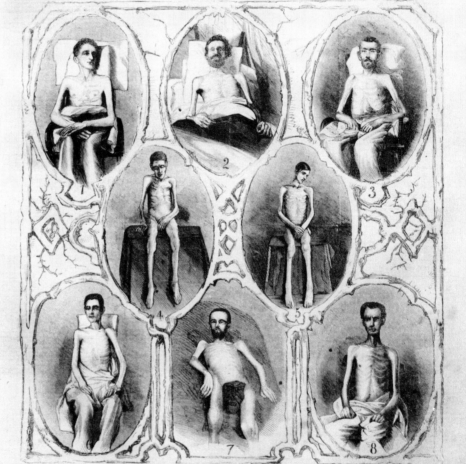

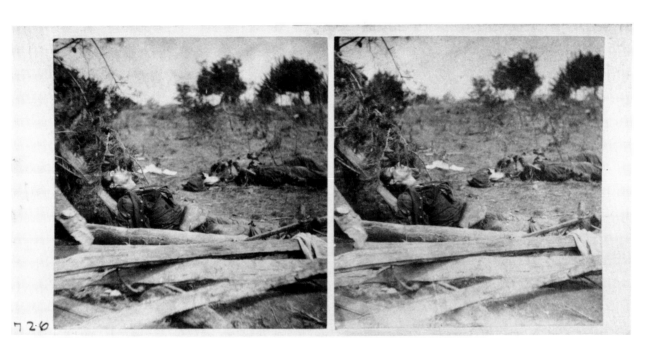

726

Stereograph by Timothy O'Sullivan of a Confederate soldier killed on Mrs. Alsop's farm at Spotsylvania, Virginia, May 20, 1864. American Antiquarian Society.

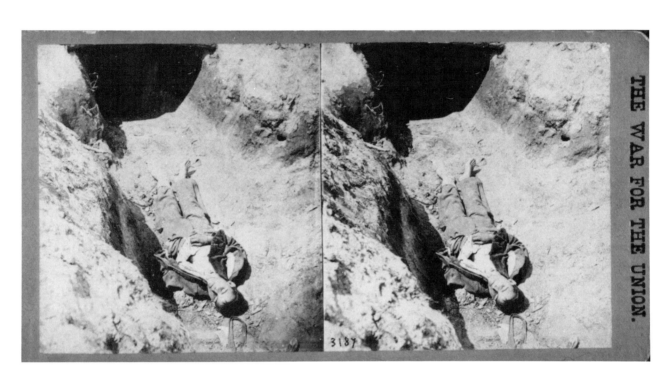

Stereograph of a young
Confederate soldier,
killed during the final
assault of Union forces
at Petersburg, Virginia,
April 2, 1865. Made by
Thomas C. Roche for
the firm of E. and H. T.
Anthony. American An-
tiquarian Society.

"Scene of General
McPherson's Death"
by George N. Barnard.
Published in Barnard's
*Photographic Views of
Sherman's Campaign*. International Museum of
Photography at George
Eastman House.

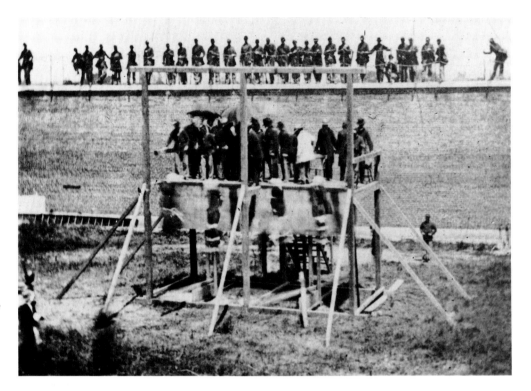

Alexander Gardner's view, entitled *The Drop,* made at the hanging of the Lincoln conspirators, July 7, 1865. Library of Congress.

war; the hollow-eyed wounded, huddled together awaiting medical attention. The photographs, wrote Andrew J. Russell, taught that "war is a terrible reality"—a reality that the public preferred to forget after Appomattox.[57]

The two-volume *Gardner's Photographic Sketch Book of the War,* published in 1866 by Philip and Solomons, contained one hundred albumen prints. Originally, two hundred sets were planned, but it is not likely that that many were finally produced. In any event, the project was a commercial failure. Barnard's *Photographic Views of Sherman's Campaign* was also published in a limited edition with sixty-one gold-toned albumen prints tipped onto stiff pages. The small edition and high price of the book (it sold for one hundred dollars) assured a limited public impact.

After the war, Brady's financial situation was especially precarious. He still owed a great deal of money to Edward and Henry Anthony but found that the public was little interested in purchasing paper prints made from his collection of some twelve thou-

sand glass-plate negatives. In July 1874, one set of about six thousand plates was auctioned off to satisfy unpaid warehouse fees. The buyer, paying a bargain price of $2,840, which reflected the public's lack of interest in old war photographs, was the War Department. A year later a duplicate set of plates, Brady's only remaining pictures of the war, was delivered to the Anthonys in lieu of unpaid debts.[58] Brady was destitute. He continued to run his Washington gallery for a time, helped somewhat by the largesse of several of his friends in the government, but he never regained his prewar prominence.[59]

On April 16, 1894, while crossing the street in front of the Riggs Hotel in Washington, D.C., Brady was struck and run over by a carriage, and his leg was badly broken. He was bedridden in Washington for nearly a year, during which time his creditors closed in on him. When they repossessed his house, Brady went to New York. Still bothered by his injury, he was placed in the Presbyterian Hospital. He finally died there, in the poor ward, on Janu-

ary 15, 1896. He was buried in the Congressional Cemetery in Washington, next to the body of his wife.[60]

The final, closing acts of the war years, the trial and execution of four of the Lincoln conspirators, were photographed by Alexander Gardner with the assistance of Timothy O'Sullivan. Gardner made portraits of the accused, which he sold to the picture press. And on the day of the execution, July 7, 1865, he made three memorable photographs of the prisoners as the sentence of the court was carried out at the old federal arsenal in Washington. The first picture was made as white hoods were placed over the heads of the condemned. A long line of soldiers stands on the parapet behind the scaffold; in the shade under the scaffold are several more soldiers who will release the trapdoors under the prisoners' feet.

Gardner's second photograph was made shortly after 1:26 PM when General Winfield Scott Hancock, commander of the Veteran Reserve Corps, ordered General John Frederick Hartranft to proceed with the execution. As the four bodies "swung into the air and the law was vindicated," Gardner made his exposure.[61] The slight back-and-forth swaying of the bodies at the ends of the ropes created a blur on Gardner's plate. The final view, taken from the same vantage point as the previous two, shows the bodies, now motionless, shortly before they were cut down. Most of the military and civilian witnesses have gone.

Gardner's execution photographs, his pictures of the Lincoln funeral procession in Washington, and his views of the various parades for homeward-bound soldiers mark the end of the war years. The nation turned away from the brutal truths contained in photographs. The war would be remembered, of course, but increasingly as something grand and noble, more triumph than tragedy. The work done during the war by Brady's and Gardner's men, and by independent and military photographers,

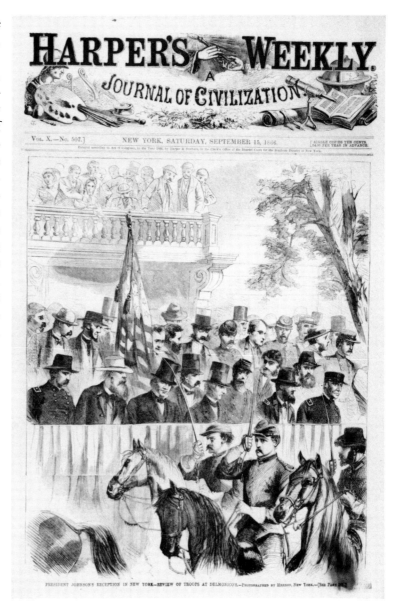

was largely forgotten when the fighting stopped. Gardner, like Brady, was financially strapped at the end of the war. He, O'Sullivan, and Russell all headed west, looking for new opportunities in territories beyond the Mississippi. They and many others found in the West a place to start over.

Wood engraving from a photograph by Herron of President Andrew Johnson reviewing troops passing in front of Delmonico's Restaurant in New York City. American Antiquarian Society.

FOUR

THE WEST AS PHOTO OPPORTUNITY

*Adventure and opportunity in the West
had been a familiar idea to the
American-born since the earliest
settlement of the country. When times
were hard in the East; when there
were too many children to share the
New England farm; when you left the
Army after serving through a war,
and were restless and footloose; when
you had a broken heart, or too much
ambition for your own good; there was
always the West. Horace Greeley's
advice was far too obvious to be
startling. Go West? Of course go West.
Where else?*

WILLIAM HENRY JACKSON
Time Exposure

THE LAND OF THE FRONTIER, evanescent, romantic, and apparently free for the taking, beckoned when the Civil War ended as it had before the fighting began. Frederick Dellenbaugh, who surveyed the Southwest with Major John Wesley Powell in the 1870s, wrote that after the war "the wilds of the Far West again called in seductive voice to the adventurous and scientific." Though the fur trade was no longer viable, he added, "mining, prospecting, ranching, and scientific exploring took its place."[1] He might have added photography to the list.

For photographers interested in producing pictures for mass distribution and publication, the trans-Mississippi West was a territory rich in subject matter. Alexander Gardner and his son James, Timothy O'Sullivan, Andrew Russell, and Thomas Roche were among the photographers who headed west after the war; all had demonstrated a commitment to the publication of news photographs. Although events in the West were not often as carefully organized for visual description as a modern presidential campaign or the visit of a head of state (the "meeting of the rails" ceremony at Promontory Point, Utah, in 1869 is an exception), enterprising photographers had no shortage of newsworthy subjects, and they could be reasonably confident about finding markets for their pictures.

There was great curiosity in the East about life on the frontier, stimulated in part by extensive journalistic coverage of the geological surveys sponsored by the federal government, the construction of the first transcontinental railroad, and intermittent wars with Indians. Glass-plate negatives produced by the wet-plate process were used to make thousands of paper prints in stereo, cabinet, and carte-de-visite form that were sold to the public and to the periodical press, which continued to use photographs as source material for wood and steel engravings. The West was news, and illustrations based on photographs were a vital component of postwar journalism.

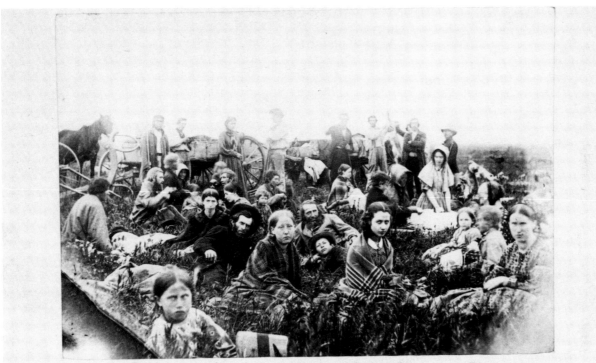

People escaping from the Indian Massacre of 1862, in Minnesota, at Dinner on a Prairie. Photographed by one of the party.

WHITNEY'S GALLERY. SAINT PAUL.

Cabinet card photograph by Adrian Ebell of refugees from the Santee Sioux uprising in Minnesota in 1862. Published by the Joel Whitney Studio in St. Paul. Minnesota Historical Society.

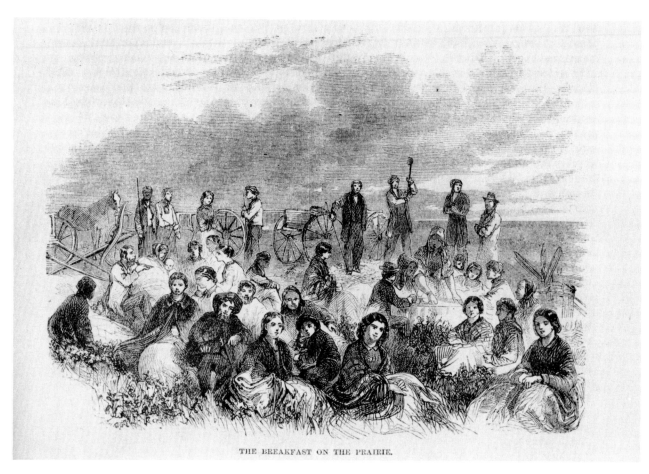

THE BREAKFAST ON THE PRAIRIE.

Wood engraving from
Adrian Ebell's photo-
graph of refugees. Pub-
lished in *Harper's New
Monthly Magazine,* June
1863. Otto Richter Li-
bary, University of
Miami.

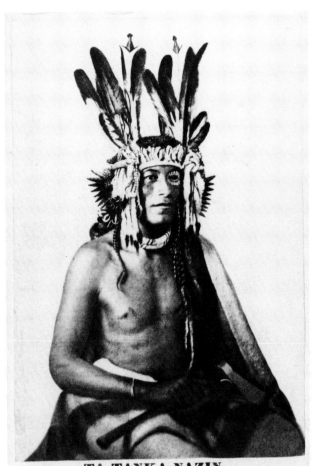

TA-TANKA-NAZIN,
(STANDING BUFFALO.) A hereditary Chief of the Sioux, and a
Participator in the *Massacre of* 1862, *in Minnesota.*

Entered according to Act of Congress, by J. E. Whitney, in the year 1862,
in the Clerk's Office of the U. S. District Court for Minnesota.
WHITNEY'S GALLERY SAINT PAUL.

STANDING BUFFALO.—[FROM A PHOTOGRAPH BY C. A. ZIMMERMAN, ST. PAUL, MINNESOTA.]

Carte de visite of Ta-
tanka-nazin (Standing
Buffalo), a Santee
Sioux, published by Joel
E. Whitney. Minnesota
Historical Society.

Wood engraving from
the photograph of Ta-
tanka-nazin. Published
in *Harper's Weekly,* Sep-
tember 9, 1871, with
credit to Charles A.
Zimmerman. Otto
Richter Library, Univer-
sity of Miami.

Much of the romantic mystique of the
American West and its appeal to photogra-
phers was due to its transience. The West of
the Plains Indians and the cavalry, of wild,
untrammeled open spaces, of gold nuggets
and gunfighters, vanished forever within a
generation or so after the Civil War. Fred-
erick Jackson Turner's famous essay, "The
Significance of the Frontier in American
History," presented on July 12, 1893 at the
annual meeting of the American Historical
Association in Chicago, merely confirmed
what many had long suspected: The wild
western frontier was long gone.

Cabinet card photograph of a crude prison for Santee Sioux in St. Paul, published by Joel Whitney. Minnesota Historical Society.

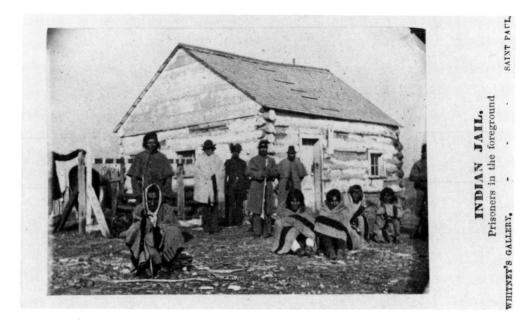

Cabinet card of William "Buffalo Bill" Cody by an unidentified photographer, ca. 1887. National Portrait Gallery, Smithsonian Institution.

"Both, Indian and buffalo, have probably disappeared . . . from these plains," wrote geologist Ferdinand Vandeveer Hayden in 1870, just a year after the ceremonies at Promontory Point and more than two decades before the Wounded Knee massacre.[2] Edwards Roberts, author of a popular guidebook about the West published in 1888, noted that what had been untamed just a few years before was now gone, either destroyed altogether or transformed. The traveler in search of barbarism, he wrote, would be disappointed. "The era which the novels of brilliant hue depict is an era of the past." Although the West was still pretty raw in some places, the yeoman farmer and his plow were "fast obliterating all traces of that wild West which 'Buffalo Bill' delights to illustrate."[3]

Laton Alton Huffman, who recorded on glass-plate negatives the swift transformation of the Great Plains after the Civil War, spoke of the end of one way of life and the beginning of another. "Round about us," he recalled, "the army of buffalo hunters . . . were waging the final war of extermination upon the last great herds of American bison seen upon this continent." Huffman knew that the future belonged to husbandmen, stockmen, and especially to those who subdued wildness with iron rails.

Then came the cattlemen, the "trail boss" with his army of cowboys, and the great cattle roundups. Then the army of railroad builders.

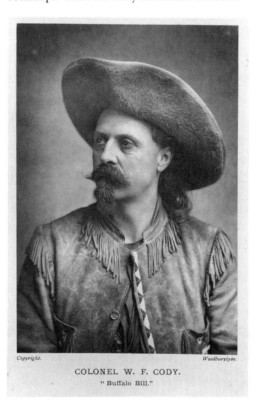

Photograph by Fisk expedition photographers William Illingworth and George Bill of the bluffs near Fort Berthold in the Dakota Territory, 1866. Montana Historical Society.

Wood engraving of a
view of Cathedral
Rocks from a photo-
graph by Charles L.
Weed, associate of Rob-
ert Vance in San Fran-
cisco. Published in
[J. M. Hutchings,]
Scenes of Wonder and Cu-
riosity in California,
1862. Otto Richter Li-
brary, University of
Miami.

That—the railway—was the fatal coming. One looked about and said, "This is the last West." It was not so. There *was* no more West after that. It was a dream and a forgetting, a chapter forever closed.[4]

The evolution of the western frontier from virgin land to settlement and statehood was recorded by photographers like Huffman who were attracted as much by the promise of adventure as by the potential to establish successful studios in new towns and cities. In the early days before the Civil War, most of the photographic work was daguerreian and confined to the settled areas on the West Coast and to the towns and cities along the Mississippi River. Especially in California, photographers produced portraits as well as views of mining operations and burgeoning cities with much the same energy as their eastern counterparts. Thus, for photographers Robert H. Vance, William Herman Rulofson, George Robinson Fardon, and Isaiah Taber, all of whom worked in San Francisco, the only real difficulty was obtaining sufficient supplies, since photographic materials had to be hauled slowly cross-country or shipped around Cape Horn or through the jungles of Panama.[5]

Later, after the war, government agencies and a variety of businesses used photographs both to record the settlement of the frontier and to lure more citizens out West. Pictures of the land itself—the endless plains, the great spinal ridge of the Rockies, the extraordinary canyons, chasms, and buttes of the Southwest, the forests of the Pacific Northwest—were published in magazines such as *Harper's New Monthly Magazine, Scribner's Monthly, Frank Leslie's Popular Monthly,* and *Lippincott's Magazine,* as well as in guidebooks, and were widely distributed in the form of stereo cards.[6] Illustrated journals vied for the opportunity to show their readers how work was progressing on the transcontinental railroad, the greatest technological wonder of the immediate postwar years. And pictures of

Wood engravings of photographs made by James Fennemore, E. O. Beaman, and Jack Hillers on John Wesley Powell's surveys of the Colorado River. Published without credit in the *New York Daily Graphic,* October 11, 1875. American Antiquarian Society.

Indians expressed American attitudes about that vanishing race, revealing a profound moral ambivalence toward official and unofficial policies. Indians were depicted by some as savage and unregenerate, by others as noble children of the forest, worthy of preservation and veneration.[7]

Especially for young photographers eager to establish themselves in a profession in which there was already a good deal of competition in the East, the new settlements offered the possibility of financial success, provided, of course, that one could find a way to transport the necessary materials into the frontier. Prior to the completion of the railroad, travel west of the Mississippi was slow and occasionally dangerous. It took considerable determination and perhaps a bit of luck to successfully transport cameras, lenses, and an adequate supply of glass plates and chemicals into the wilderness.

In the narrative of her capture by the Sioux in July 1864, near Fort Laramie in the present state of Wyoming, Fanny Kelly told how one unfortunate young photographer's attempts to make a career in the West came to naught. Kelly's friend Mrs. Larrimer, who had assisted her photographer husband before his untimely death, had hoped to begin anew as a photographer in the mining towns of Idaho, but she saw her dreams destroyed by Indians who failed to see the value or purpose of her many boxes of equipment and supplies. "As she saw her chemicals, picture cases, and other property being destroyed, she uttered a wild, despairing cry," wrote Mrs. Kelly. The would-be photographer was silenced by Ottawa, the leader of the Oglala war party, who brandished a "gleaming knife . . . [and] threatened to end all her further troubles in the world." Mrs. Larrimer took heed and shut up.[8]

After two years of captivity, Mrs. Larrimer found her way back to civilization but did not renew her photographic efforts. That she had even attempted to reach the frontier settlements of Idaho is instructive, however. It was not easy for women to take up and practice any trade in America in the 1800s, but on the frontier the division of labor according to gender was somewhat relaxed. A woman could aspire to a photographic career in the West. Indeed, the first photographer to set up a practice in Minnesota was Sarah Judd, who opened a studio in Stillwater in 1848.[9] Until quite late in the century, however, few women photographers received any special notice in the photographic press, probably because editors and photographers in the East thought only in terms of the photographic "fraternity."

The difficulty of establishing a photographic business on the frontier did little to stem the migration westward of picture makers of all kinds. Partly in response to the long anguish and anxiety of the Civil War, Americans in the East, on both sides of the Mason-Dixon Line, relished news, especially pictorial news, from the West. There was romance and adventure in the lurid stories that were printed in dime novels and serialized in magazines, and pictures that could illustrate them were in constant demand.[10] The reliability of the information contained in photographs, as opposed to the efforts of traditional artists, was a constant selling point. "The explorer furnished with his photographic apparatus which is now constructed in such a manner that it can be used with ease in any part of the world," wrote Tissandier in 1877, "brings back . . . documents invaluable, because no one can deny their accuracy. A photograph represents an object just as it is . . . [and] nothing is deficient in the print. A painting or watercolor can never have such rigorous precision."[11]

This is not to say that the work of painters was easily or cursorily dismissed, even by men of science. John Wesley Powell, for instance, used artists as well as photographers to illustrate his numerous writings on the West. He felt that those who painted

Carte de visite of photographers Adrian Ebell (facing the camera) and Edwin Lawton at work in Minnesota, ca. 1861. Minnesota Historical Society.

western landscapes could be divided into two categories: those who depict "mountains with towering forms that seem ready to topple in the first storm," and those whose mountains "frown defiance at the tempests." He added that "[Frederick] Church paints a mountain like a kingdom of glory," while "[Albert] Bierstadt paints a mountain cliff where an eagle is lost from sight ere he reaches the summit." Powell contended that Thomas Moran's work "marries these great characteristics, and in his infinite masses cliffs of immeasurable light are seen."[12]

Hank Smith, a self-taught landscape painter who lived and worked in the Sierra Nevada, was less generous about his competition. His caustic comments about Albert Bierstadt centered on what he considered to be an egregious lack of verisimilitude in the famous painter's landscapes. "It's all Bierstadt and Bierstadt and Bierstadt nowadays!," Smith complained bitterly to Clarence King. "What has he done but twist and skew and distort and discolor and belittle and be-pretty this whole doggoned country? Why, his mountains are too high and too slim; they'd blow over in one of our fall winds."[13]

It was not so with photography. The camera was still popularly understood to be a scientific instrument capable of recording reality without distortion or artifice, the perfect combination of technological precision and aesthetic insight. Bierstadt's painted mountains might be suspect, but a photograph of the same mountains seemed infallible. "Nothing seems beyond the reach of photography," wrote Edward Wilson in 1867. "It is the railway and telegraph of art."[14]

In the West, the camera and the railroad did indeed form a natural alliance. Harbinger of civilization, symbol of the modern age, the railroad was the visual centerpiece of postwar photography. Photographs were an important component of the surveys that platted the land in order to locate and secure the most favorable routes across the continent. And when construction began on the lines that fanned out across the country, hired photographers recorded each significant facet of the enterprise. Publications issued by the railroads contained illustrations based on photographic images; and individual photographers, the railroad companies, and photographic clearinghouses in the East all distributed stereographs.

One of the first to take advantage of the opportunities offered photographers in the West was William Abraham Bell, who was not a photographer at all, but a physician. In the account of his experiences in the West, *New Tracks in North America,* Bell told how he came to occupy the position of official photographer on General William Palmer's survey of the Southwest for the Kansas Pacific Railroad in 1867. Bell, an Englishman, was in Philadelphia when he heard that the railroad was hiring. Apparently, he thought a tour of the West would be interesting and exciting, so he applied for work. The only position available was that of photographer. "I accepted the office with, I must confess, considerable diffidence," he wrote, "as only a fortnight remained before starting to learn an art with which I was then quite unacquainted."[15]

While Bell's experiences failed to yield much in the way of photographs,[16] the account of his western adventures, illustrated with engravings made from his photographs, sold well. It quickly went into a second printing and was translated into German. Part of its allure was undoubtedly in Bell's enthusiastic recitation of various adventures, many relating to the difficulty of making pictures far from civilization. For instance, Bell told about his ultimately futile efforts to make pictures in the spectacular canyons of the Purgatoire River in southern Colorado. Having to master the delicate collodion process was hard enough; being forced to use mules to carry one's equipment and supplies into the wilderness made everything more difficult. On the

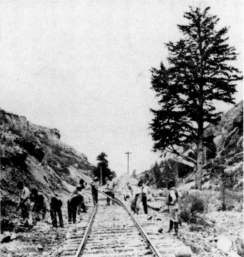

Stereograph of construction workers at the "thousand-mile tree," made by William Henry Jackson, published by the Union Pacific Railroad. Collection of David Kent, Miami, Florida.

banks of the river, it took Bell and his friend Walter Hinchman "four hours to lead a mule packed with [a] photographic 'outfit' two miles, in which short distance we nearly lost our valuable quadruped in a quicksand, and had to load and unload at least half-a-dozen times." Travel on the plateaus above the river was not much better. Later, in one of the great canyons of the Purgatoire "the huge rocks and fissures which blocked up the sides, and the trees and brushwood which choked the passage, made our advance so difficult that we were obliged to relinquish the idea of taking any views of the gorgeous scenery."[17]

Bell was replaced in 1868 as the official survey photographer by Alexander Gardner, who became something of an expert in photographing western railroads. Bell returned to England in the summer of 1868 just long enough to write and publish his book. By the end of 1870, he was back in the American West, though he no longer practiced either medicine or photography. He served for many years as the vice-president of the Denver and Rio Grande Railroad and was long an ardent advocate of the speedy and complete development of the country.[18]

In Omaha, eastern terminus for the Union Pacific Railroad, the flurry of railroad activity attracted the attention of William Henry Jackson, a young photographer who had journeyed west in 1866 after a quarrel with his betrothed in Rutland, Vermont. In 1869, he left his Omaha studio in the hands of his brother Edward and headed farther west along the line of the new railroad, hoping for adventure and a profit from the sale of railroad pictures. "The papers were full of exciting news about the progress of the railroad," he wrote later. "Their columns were filled daily with stories of the marvelous speed of the track laying, accounts of Indian attacks on the men at work, and descriptions of the numerous parties, military, civilian, and official, on their trips along the newly constructed line." Jackson was convinced that the building of the transcontinental railroad was the most significant event of the day, and he was "eager to get in picture form some of the scenes and some suggestion of the activities connected with the mighty national enterprise."[19]

There were other stories in the West, of course, stories that inevitably attracted the attention of photographers. Jackson, for example, made pictures of Nebraskan Indians and documented the evolution of Omaha from cow town to dusty metropolis. Eventually, he achieved real fame as a

Photograph by William Henry Jackson of the staff of the *Daily Reporter* in front of their temporary office at Corinne, Boxelder County, Utah Territory, 1869. National Archives.

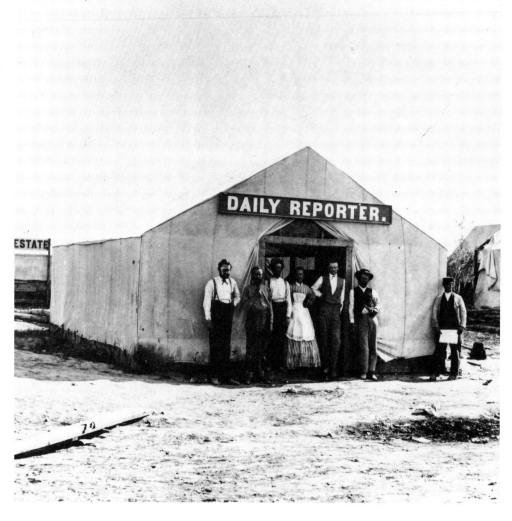

landscape photographer, especially for his magnificent, large-format views of Yellowstone. In the beginning, however, the Jackson brothers "stuck pretty closely to the usual work of studio photographers." There were always portraits and group pictures to be made, Jackson remembered, and the usual run of "outdoor shots that gratified civic pride." Storefronts and interior views were frequently commissioned, and occasionally "somebody would order pictures of his new house; or of his big barn, and along with it his livestock." But it was the building of the railroad that first captured Jackson's attention. "Here was something truly earth-shaking," he wrote in his autobiography, *Time Exposure,* "and, whether or not there had been a dime in it for me, sooner or later I would have been out on the grade with my cameras."[20] Quite simply, the railroad was the most important news story of the day, and photographers wishing to make pictures for public consumption were naturally attracted to it.

Though Jackson professed enthusiasm for photographing the railroad, it was not until shortly after the ceremony at Promontory Point on May 10, 1869, that he finally left Omaha for points west. One reason for not leaving sooner was that Jackson's new fiancée, Mary Greer, had chosen May 10 as their wedding day. "Since she was doing *me* the honor," he wrote, "the joining of the rails became for the moment insignificant."[21] Another compelling reason was Jackson's admitted reluctance to photograph along the railroad, or anywhere else for that matter, without an official sponsor. During his career, Jackson rarely worked for long without some kind of guarantee—of payment or publication or preferably both. After what he later called some "intensive soliciting," Jackson received an order from Edward and Henry T. Anthony in New York for ten thousand stereographic views along the route of the Pacific railroad.

Jackson's urge to pack up and head west along the rails was undoubtedly stimulated by Arundel C. Hull, a young photographer who worked as an assistant in the Jacksons' studio in Omaha. He had already made one trip west, making pictures of railroad workers and of the towns that sprang up beside the tracks. He concentrated in his work on the human drama of western settlement. Hull's images describe the main streets of towns but a few months or weeks old, nameless towns that had no future and others that would somehow find a way to prosper and grow. In Hull's pictures, groups of citizens, most of them young men, pose stiffly in front of new buildings or tents. Neither the men nor their buildings seem permanent: Hull's West is a place in transition.

On more than one occasion, Hull managed to record the grim aftermath of some swift vigilante justice. He did so not in response to a personal proclivity for the prurient but because such events had already come to symbolize the American West and were, therefore, photographic best-sellers. The picture of a bad man, alive or dead, evoked the primal struggle between lawlessness and civilization. Hull and others

Photograph of the hanging of murderer Thomas Walsh by a mob at Lordsburg, New Mexico, April 29, 1883. A notice was pinned to Walsh's pants warning all persons to leave the body hanging until the next day. They complied. National Anthropological Archives, Smithsonian Institution.

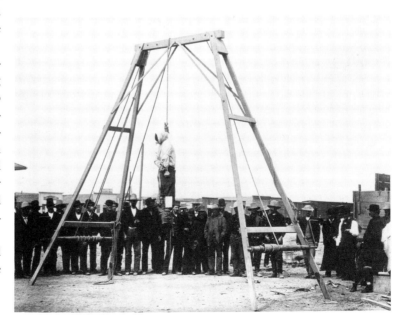

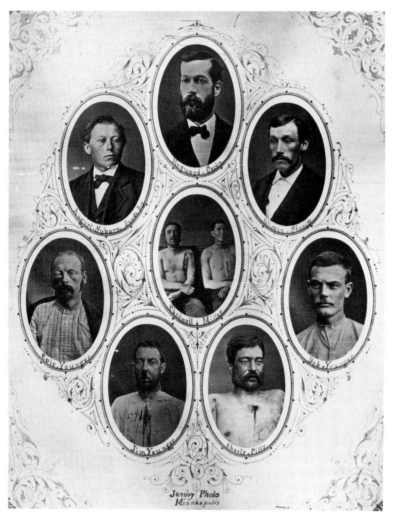

Souvenir card, published by the Jacoby Photographic Studio in Minneapolis, containing portraits of the perpetrators and victims (top three) of the Northfield, Minnesota, bank raid of September 1876. Of the bandits, the James brothers, Jesse and William, managed to escape; the Younger brothers were captured alive; and Chadwell, Miller, and Pitts were killed during or shortly after the raid. Minnesota Historical Society.

who occasionally made and sold pictures of the violent and seedy side of frontier life were making pictures of what many believed was the essence of the Wild West. As John Cawelti maintains, the West of good guys and outlaws, of cowboys and Indians and six-gun law and order, though a "relatively brief stage in the social evolution of the West," was "erected into a timeless epic past in which heroic individual defenders . . . without the vast social resources of police and courts stand poised against the threat of lawlessness or savagery."[22] Photographers who depicted some aspect of the struggle between law and disorder were not significantly different in their motivations from those who photographed the bloody aftermath of Prohibition wars in the 1920s or of street-gang violence in the 1950s and today.

Hull's photographs of dead men, trussed up and hanged from lampposts or trees or telegraph poles by outraged and impatient citizens, were news pictures. Indeed, on at least one occasion, a picture session at an impromptu hanging assumed the character of a modern media event or photo opportunity, with churlish cameramen vying for position, shoving and elbowing their competitors.[23] While photographing one Sanford Dugan, hanged from the branch of a cottonwood tree by a mob in Denver on December 1, 1868, Hull became embroiled in a bitter feud with a competitor, probably N. Delavan, a local photographer, who was apparently equally anxious to record the grisly scene. Each claimed the exclusive right to make pictures, and their argument degenerated into a shoving match. The *Rocky Mountain News* reported the hanging as well as the photo dispute on December 2. "We are told certain artists were fighting over [Dugan's body] this morning, for the . . . privilege of taking photographic views of it," wrote the reporter. It has been said that both men eventually made pictures, a likely assumption since Dugan was clearly not going anywhere.[24]

That this nasty little dispute occurred in the frontier West between two young photographers determined to make unique pictures of an event with inherent news value is not surprising. "At the present time," wrote H. J. Rogers in 1873, "reliable sketches and truthful representations of the various modes and usages of human life, landscapes, views, machinery, architecture, scenes of joy or sadness, disasters . . . form a very instructive and useful aid to books, periodicals, and newspapers."[25] The competition to tell the story of the West in pictures was sometimes fierce, and photographers were bound to clash in their efforts to supply timely and telling pictures to the public.

On June 22, 1869, Jackson and Hull climbed aboard a westbound train, beginning an extended trip that Jackson believed—correctly as it turned out—would establish him "as a front rank scenic photographer." However, it was not merely the prospect of gaining a reputation for landscape photography that persuaded Jackson to leave the safe confines of his Omaha studio. "It was a great opportunity to start a collection of negatives," he wrote, negatives that would yield prints that could be marketed and sold nationwide for many years.[26] That first order for ten thousand stereo prints guaranteed both a profit and wide public exposure, and the negatives would form the genesis of an extensive collection of western views. There was no way Jackson could lose.

Hull and Jackson worked through the summer of 1869, making photographs of the land and the people along the tracks and, in the process, earning the enduring goodwill of the trainmen by giving them free pictures. In return, the engineers were generally obliging about helping the photographers obtain the best pictures. They let them off between stations, stopped their trains atop spindly wooden bridges that spanned gorges, and picked them up when they were finished.

Not all the pictures by Jackson and Hull were meant to fulfill the original stereo order. To meet unexpected expenses on the road, the photographers occasionally worked in the itinerant tradition, soliciting business along the way. In Cheyenne, Wyoming Territory, they had one particularly good week, as the citizens were eager to purchase pictures of themselves and their prosperous little town. After some initial reluctance, even the ladies at Madame Cleveland's bordello were persuaded to buy a set of portraits.

"Hull and I thought we would go around and see if we couldn't get a job out of them," Jackson wrote in his journal on June 24. Though indifferent at first, the ladies warmed up to the idea of being photographed after Jackson bought and passed around a bottle of wine. When he purchased a second bottle, they became positively "hot and heavy for some large pictures to frame and [they] began to count up how many they should want." Thanks in no small part to the largesse of Madame Cleveland and her employees, Jackson and Hull left Cheyenne with a neat profit of sixty dollars, and yet more negatives for Jackson's expanding collection of western views.[27]

From the end of July to late September, when they returned to Omaha, Jackson and Hull worked in eastern Utah, compiling pictures (all of which were credited to Jackson) that told the story of the railroad and described other aspects of the western adventure.

I photographed the "last rail" at Promontory Point; for, although a stretch of empty road is in itself a dull subject, this particular one had instantly established itself as a popular choice. From many angles I took the spectacular bridge just completed at Devil's Gate. I recorded [the] Thousand Mile Tree (exactly one thousand Union Pacific miles west of Omaha). And, of course, Hull and I made expeditions to all the striking natural views of the surrounding country, Devil's Slide, Pulpit Rock, Death Rock,

Monument Rock, Hanging Rock, Castle Rock and Needle Rocks are only a few of the wonders we visited and bagged for our collection.[28]

Unlike Jackson, whose work along the Union Pacific was independently financed, several photographers worked directly for the railroads, producing pictures that were used primarily in company publications. As a rule, photographers who worked for the railroads were encouraged to distribute and sell stereos on their own in order to augment their railroad salaries and reach the greatest possible audience with the visual story of railroad construction. The relationship between the railroads and photographers in the West was decidedly friendly. Railroad managers knew well the value of photographic publicity, and many of them went to great lengths to assure the comfort, and maximize the productivity, of photographers. From 1885 to 1905, for instance, Frank Jay Haynes, a photographer from Moorhead, Minnesota, was allowed to use a specially constructed Pullman car, a plush photographic studio and gallery on wheels, in his work for Jay Cooke's Northern Pacific Railroad.

Haynes designed the car in 1884 and supervised its construction in the Northern Pacific Railroad yards in Brainerd, Minnesota, agreeing to pay the railroad a total of six thousand dollars for the refurbishment. In return, Haynes was paid $1.50 for each view he produced for the railroad and was allowed complete access to the company's entire network. This arrangement was similar to one he had made in 1881 with both the Canadian Pacific and the St. Paul, Minneapolis and Manitoba railways. They designated Haynes "authorized photographer" and required him only to provide them with a dozen paper prints from each negative made specifically for the railroads. In addition, he was permitted to retain all negatives, even those made at the behest of the railroads, and market prints on his own.

Room, board, and transportation were supplied at no charge.[29]

Jay Cooke, like other railroad moguls in the latter half of the nineteenth century, was adept at eliciting the interest and active participation of the press in his construction projects. One of his favorite methods was to organize trips to the remote frontier and invite well-known reporters and publishers to come along, all expenses paid. More often than not, journalists were delighted to take advantage of the opportunity to see the sights in grand style.[30] In 1870, for instance, Cooke needed to drum up public support for land-grant bonds the sale of which financed construction of his railroad. But in the East, where the money was, few potential investors were familiar with the Northern Pacific's territory. Cooke's solution was to organize what historian Freeman Tilden called "an excursion in the grand manner." Charles Dana of the *Chicago Sun,* Samuel Bowles of the *Springfield Republican,* George Evans of the *Herald* in New York, and C. C. Coffin of the *Boston Journal* all agreed to accompany Cooke, despite the fact that the purpose of the trip was clearly "to get a write-up in the paper." The journalists experienced the frontier in an exceedingly comfortable manner; Cooke received his free publicity; and enough bonds were sold to continue work. It was, wrote Tilden, "a prodigious feat of diplomacy."[31]

Cooke's handling of the press was patterned on several successful excursions organized by Thomas Clark Durant, vice-president of the Union Pacific. In October of 1866, Durant put together such a trip to the one hundredth meridian, the magical halfway point between Chicago and the Rocky Mountains. Among the two hundred guests who accepted Durant's invitation were reporters from most of the major metropolitan newspapers in the Northeast. Their willingness to head West with the railroad that autumn may have been stimulated by the spread of cholera through the urban areas of the East.

Durant hired Chicago photographer John Carbutt to compile a visual record of the trip and provide each guest with photographic remembrances of their journey into the hinterland. Colonel Silas Seymour, consulting engineer for the Union Pacific, noted in his journal that when the train reached rail's end, some forty miles west of the one hundredth meridian near the present town of Gannett, Utah, the photographer was suddenly in great demand. "The Professor finally succeeded in obtaining some excellent groupings," Seymour wrote, "as well as camp and landscape views before the train started eastward." Later, when the train stopped briefly at the one hundredth meridian, Carbutt made photographs "representing the excursion train, with groupings of Government Officers, members of Congress, Directors of the road and excursionists."[32]

It is difficult to say with certainty that particular images made along the iron rails were either commercial or journalistic. The same image might be used in a railroad brochure; mass produced and sold by the photographer, often in stereo form; and published as an engraving in one of the illustrated weeklies. This was certainly the case with the photographs made of the meeting-of-the-rails ceremony at Promontory Point. The same blurring of the distinction between journalistic and commercial photography can be seen in a series of magazines collectively entitled *Wonderland,* which were published by the Northern Pacific Railroad. Charles Fee, general passenger agent of the company, gathered together a group of professional writers and, using engravings made from Haynes's photographs, published the series in the early 1870s. The quality of the writing and illustrations was enhanced by fine printing, for which, according to Tilden, the company spared no expense. In the end, *Wonderland* was considerably more than mere advertising or public relations, though perhaps not exactly straight journalism either.[33]

Photography in America was not neatly divided into discrete specialties in the nineteenth century. Especially in the West, photographers were likely to make images that could be used in a variety of ways—as decoration, record, advertisement, journalistic illustration—in order to make a living. Eadweard Muybridge, the California photographer best known today for his pioneering work in high-speed photography and his magnificent landscapes of Yosemite, also worked as a photographer for the Central Pacific Railroad in 1868 and made photographs of the Modoc Indian War in 1873. Jackson worked at times for the government and for the Union Pacific. And throughout his career, F. Jay Haynes explored both the journalistic and commercial aspects of photography. He was, by turns, a portrait photographer, photojournalist, and landscape and fine-art photographer. "I call your attention to the fact that during the past ten years I have produced at my Fargo gallery 65,000 cabinet portraits,"

Press representatives on an all-expenses-paid excursion to the one hundredth meridian, 275 miles west of Omaha, Nebraska Territory. Detail of a stereograph by John Carbutt for the Union Pacific Railroad, October 24, 1866. National Archives.

wrote Haynes to C. M. Warren, general passenger agent of the St. Paul, Minneapolis and Manitoba Railroad. "At the same time, I have produced and sold, in connection with my field work, 540,000 stereoscopic views of Northern Pacific scenery." He added that he had produced and sold some eight thousand 22-by-26-inch views and over thirty thousand 8-by-10-inch views of Mammoth Hot Springs.[34]

Andrew J. Russell and Alexander Gardner, who spent the war years as photographers, found employment with the Union Pacific Railroad in the late 1860s. When the market for their war views dried up, both men seized the opportunity to make pictures in the West. In 1867, Gardner left his studio in Washington, D.C., to cover construction on the Eastern Division of the Union Pacific in Kansas. Late that year he published a set of 150 stereographs entitled *Across the Continent on the Union Pacific Railway, Eastern Division.*

Like Haynes and Jackson, Gardner did not confine his work in the West to images of construction along the new railroad. Indeed, he seems to have seen the railroad assignment as the means to begin compiling his own set of marketable Western views. Side trips to places of interest, to military forts, for instance, and to nearby geological wonders, invariably produced images that appealed to the public. Gardner's series on the Union Pacific thus included several views of Leavenworth, Kansas, of the countryside between Leavenworth and Lawrence, and of the area around Fort Harker.[35] The railroad was always the hero of the story, the magnificent technological achievement that made exploration and settlement possible, but rails and trains were not necessarily included in every image.

For the railroads, catering to the needs of photographers was simply good business. And in the towns and cities that grew up beside the tracks, photographers were likely to find the same spirit of boosterism that impelled the railroad's largesse. "Mr. Gardner," noted a civic-minded reporter for the *Lawrence Daily Tribune* in 1869, has "come to Kansas for the purpose of taking photographic views of remarkable and noted places in our state." He had been hired to make "draughts of points on the road," wrote the reporter, and he planned to make pictures along Massachusetts Avenue in Lawrence in the early afternoon of September 21. "These views will be a fine advertisement for our state," the reporter added, "and we hope the artist may have all the assistance and courtesy which our citizens can render him."[36] This is not at all unlike the response of the local press in modern times to news that a photojournalist from *Life* or *National Geographic* is in town.

Andrew Russell brought to his assignment with the railroad his experiences during the Civil War, when as a captain of infantry, he was attached to the Military Railroad Construction Corps. In 1869, he began producing pictures of the race of the Union Pacific construction crews to lay tracks across the plains. In the introductory statement to a portfolio of his photographs published by the railroad company late in 1869, Russell wrote that his pictures were "calculated to interest all classes of people, and to excite the admiration of all reflecting minds as the colossal grandeur of the Agricultural, Mineral, and Commercial resources of the West are brought to view."[37]

His pictures aggrandized the enterprise and determination of the men who built the railroad, juxtaposing the tracks, trains, and work crews against a forbidding landscape. Several wide-angle views showed through-truss cast-iron bridges laid across foaming streams or rock-strewn gullies. Another depicted the extraordinary eighty-five-foot-high, four-story wooden trestle that spanned a four-hundred-foot chasm near Promontory Point, Utah. All were mute testimony to what Samuel Bowles called "the greatest triumph of modern civilization, of all civilization, indeed." Russell's

images extolled the company that had "brought into harmony the . . . jarring discords of a Continent of separated peoples" and would make America the "first nation of the world" in terms of commerce and government.[38]

The best-known work of Russell's long career in photography was produced on a single day, May 10, 1869, when the rails of the Central Pacific and the Union Pacific met in southwestern Utah. Russell worked alongside two other photographers that day: Alfred A. Hart, official photographer for the Central Pacific, and Charles Savage, a highly regarded photographer from Salt Lake City. Each man produced several views of the golden spike ceremony, using stereographic equipment as well as large-format cameras, yet only a single image by Russell became truly famous. The carefully composed picture shows the two engines almost touching, their flanks all but hidden by the tracklayers and trainmen who sit or stand everywhere except atop the smokestacks. Slightly below the engines stand the money men, politicians, dignitaries, and some local sightseers, all staring seriously back at the camera. The chief engineers of the two railroads, S. S. Montague of the Central Pacific and Grenville Dodge of the Union Pacific, are in the center of this crowd of men, shaking hands. The one light touch in the picture is directly in the middle of the frame, slightly above the figures of Montague and Dodge, where two men stand on top of the trains' cowcatchers, waving bottles of whiskey or beer in the air.

Russell's picture was reproduced countless times, though there is no evidence that the photographer profited much from its sale.[39] Photographic historians Karen and William Current suggest that Russell was well paid by the railroad and not overly concerned with subsequent sales of his picture. Rather than market his own images, Russell turned all the western negatives over to his former assistant, Stephen Sedg-

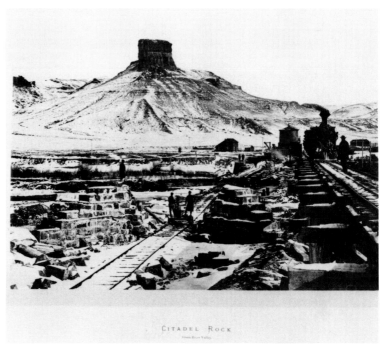

CITADEL ROCK

wick, who apparently had a better appreciation of the financial potential of Russell's work. Sedgwick toured the East, delivering a colorful lecture on the Wild West and selling both large-format and stereo copies of Russell's pictures.[40]

After the ceremony at Promontory Point, Russell spent more time photographing away from the railroad. He was eager to explore the land with his camera, his interest no doubt piqued by the work being done on the geological surveys. He described his travels in the high country of the Rockies in an article published in 1870 in *Anthony's Photographic Bulletin*. In the mountains, "the truthful camera tells the tale," he wrote, "and tells it well."[41] Although at this time, in early 1870, Russell still worked for the Union Pacific, he made his mountain pictures available to Hayden's United States Geological and Geographical Survey of the Territories. Hayden was delighted with Russell's images and used several of them in his *Sun Pictures of Rocky Mountain Scenery*. The book was designed to be used as a guide to the geological wonders of the West and to advertise the work

Photograph by Andrew Russell of Union Pacific Railroad construction near Citadel Rock in Utah. Published in Andrew Russell, *The Great West Illustrated*, vol. 1 (New York: Union Pacific Railroad Company, 1869). Library of Congress.

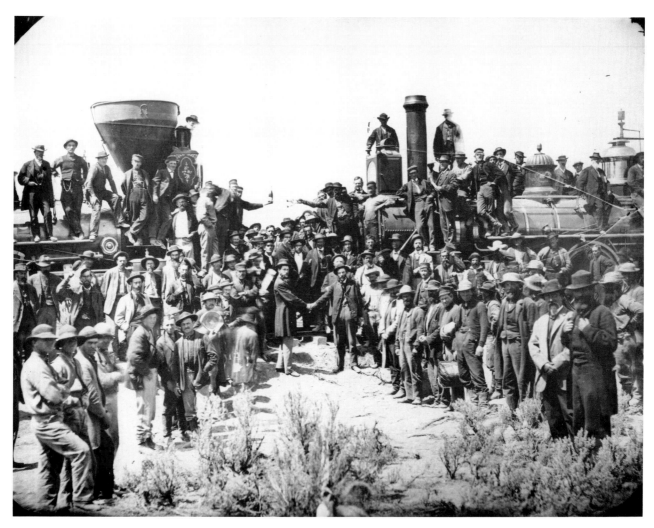

"East and West Shaking
Hands," the ceremony
commemorating the
completion of the trans-
continental railroad at
Promontory Point,
Utah, by Andrew J.
Russell, May 10, 1869.
Utah State Historical
Society.

of Hayden's group. "For several years past," wrote Hayden, "I have earnestly desired to present to the world some of the remarkable scenery of the Rocky Mountain region, through the medium of photography, as the nearest approach to a truthful delineation of nature." The thirty views included in the book describe various "peculiar" geological features of the countryside; Hayden hoped they would demonstrate the "grand opportunities for geological study" in the West. [42]

The use of real photographs in Hayden's picture book was occasioned by the absence of a practical, low-cost, and effective method of mechanically reproducing photographs on the printed page. Such a method had been sought from the earliest days of photography, and while a number of photomechanical printing processes had been developed over the years, none of them were commercially viable. "It must be stated," commented W. H. Hyslop in *Wilson's Photographic Magazine,* that the lithographic processes used for illustration are "open to the fatal objection that they must be printed separately from the letter press." The same was true, he said, of the various gelatin-relief processes such as the Woodburytype and collotype, "the most beautiful of the photographic processes." [43]

Printing processes that could not combine words and pictures in a single operation were considered to be impractical and expensive. As a result, in the 1860s and 1870s, illustrated books and periodicals continued to rely upon wood and steel engravings, many of them copied from photographs. In 1862, for instance, James Mason Hutchings published a guidebook to California scenery containing over one hundred engravings; the views of Yosemite were all made from photographs by Charles Leander Weed, an associate of San Francisco photographer Robert Vance, and the first to produce glass-plate negatives of Yosemite. [44]

Hutchings described in great detail his excursion into Yosemite—his experiences with Indian guides and mule teams, and each long, exhausting hike up into the highlands. Finding it impossible to convey in words all that he saw and felt, he relied upon Weed and his camera to give the reader a sense of the place. Hutchings included two views of the great Yosemite waterfall, one a close-up and one made from perhaps half a mile away, for it "was beyond the power of language to describe the awe inspiring majesty of the . . . overhanging mountain walls of solid granite that here hem us in on every side." [45]

The principal drawback of using engravings made from photographs, at least from the photographer's point of view, was that the draftsmen who converted photographic originals to engravings often failed to do so exactly. They took liberties, usually excused as "artistic license," with the mechanical precision of the photograph. Occasionally, the original was significantly altered, details added or deleted to fit a draftsman's fancy or an editor's notion of graphic effectiveness. Such meddling was anathema to photographers, ranking with the failure to properly credit the creator of the photographic original. Even some editors bridled at the license of engravers. In November 1874, *Frank Leslie's Illustrated Newspaper* printed an angry letter from Henry Blackburn, art editor of *London Society* and *Pictorial World,* who railed at the carelessness of engravers. "I venture to say that there is a want of truth and originality in most of our artists," he wrote. Considering the fact that "every careless line is repeated 60,000 times," such gross liberties with the truth were "unpardonable." [46]

To avoid the heavy hand of sloppy engravers, photographers continued to issue their images in the form of stereos, cartes de visite, and cabinet cards. Stereo cards were especially popular in the decades following the Civil War and became the principal source of photographic information for Americans throughout the remainder of

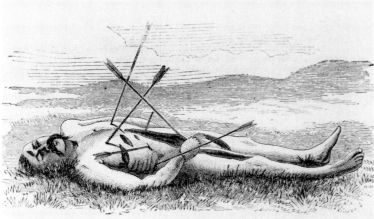

Photograph by William A. Bell of the body of Sergeant Frederick Wyllyams, killed by a band of Sioux, Arapaho, and Cheyenne warriors near Fort Wallace, Kansas, June 26, 1867. National Anthropological Archives, Smithsonian Institution.

Wood engraving of Bell's photograph of the unfortunate Sergeant Wyllyams, published in *Harper's Weekly,* July 27, 1867. Otto Richter Library, University of Miami.

the century. At the turn of the century, the stereo publishing firm run by Elmo and Ben Underwood in New York was still producing some seven million stereo cards and three hundred thousand stereo viewers each year.[47]

The twin-lensed stereo camera was the tool most often employed for the purpose of producing pictures for public distribution. William Culp Darrah, the preeminent historian of stereography, estimates that a total of six million separate stereo views were produced in America; many of these were reproduced hundreds, even thousands, of times.[48] Carleton E. Watkins, one of the best-known California photographers in the decades after the Civil War, and his colleagues may have preferred their large-format views for the wealth of detail and range of tonality that they yielded, but their income was most likely derived from the sale of stereographs.

Stereographs, printed by the thousands and distributed at low cost to the general public, made the Wild West visible to Americans. From the comfort and safety of their middle-class homes far from what remained of the frontier, Americans could vicariously visit the sites and see the people that were written about in newspapers and magazines. "Photographs have done more than authors and oil paintings together to give a clear idea of the scenery of the [Yosemite] valley to the multitude," wrote a reporter for the *Daily Alta California* in 1871. "Watkins, Houseworth, Muybridge, and Chas. Bierstadt have all taken numerous stereoscopic views of much merit."[49]

Publishing companies in the East took advantage of the popularity of stereo cards by hiring photographers to provide a steady flow of new pictures. They also purchased negatives and copy negatives from photographers. Thomas Roche continued to work for the Anthony brothers after the war, for instance, supplying them with several thousand stereo views of work along the Union Pacific and Central Pacific rail-

roads. The Anthonys also purchased images of railroad construction from Russell, Hart, and Jackson. The volume of stereo production at the Anthonys' combination factory and warehouse increased steadily throughout the 1870s. In a letter to the editor of the *Photographic News,* the British writer John Werge described the Anthonys' firm as "one of the many palaces" on lower Broadway. "This is the largest store of the kind in New York," he wrote, and it contains "a stock of all sorts of photographic goods, from 'sixpenny slides' to 'mammoth tubes,' varying in aggregate value from one hundred and fifty thousand to two hundred fifty thousand dollars." [50]

Not to be outdone, in 1873 the Kilburn brothers built a printing plant in Littleton, New Hampshire, that produced up to three thousand stereo cards a day. A year later, they advertised that their collection consisted of over two thousand separate titles. The Underwood brothers originally set up their stereo-publishing business in Ottawa, Kansas, intending to act as corporate middlemen in the distribution of eastern stereos to new western markets. By the turn of the century, the Underwoods were outproducing all their rivals.

Book publishers wishing to take advantage of the public's appreciation for photographs produced works in which actual photographs were affixed to the printed page. Though expensive, these limited-edition albums competed successfully with books that included fine steel or copper engravings. "The illustration of books by photographs," wrote Henry Hunt Snelling, former editor of the *Photographic Art-Journal,* "could be made an important branch of the art." He noted that there were thousands of illustrated books published each year, and he held that most of them could "be more cheaply illustrated by photography than by steel, copper, or wood engraving." Photographers had become so adept at making paper prints from glass-plate negatives that "a thousand photographs of a given size [could] be furnished . . . at less cost . . . than the engraving of the steel or copper plate." [51]

Boston photographer John Payson Soule, founder of the Soule Photographic Company of Boston, a firm he operated with his brother William until 1882, found that negatives used to print stereo cards could also be used to make prints for books. In 1871, Soule made enlargements from several stereo views of Yosemite, ten of which were included in Samuel Kneeland's *Wonders of Yosemite Valley.* A later edition contained twenty Soule prints. Kneeland, a professor of zoology at the Massachusetts Institute of Technology, credited Soule as the maker of the Yosemite stereos, although it is clear now that the original images were produced by two California photographers, James Reilly and Martin Mason Hazeltine. According to historian Peter Palmquist, Soule purchased the stereo negatives as well as all rights in 1870 in order to take advantage of the public's interest in western landscapes. Thereafter, neither the original stereos nor the prints made from them and published in Kneeland's book made mention of Reilly or Hazeltine. [52]

The sale of mass-produced paper prints of the West, whether in stereo, cabinet, or carte-de-visite form or as book illustrations, constituted an important portion of many eastern photographers' annual incomes. Soule was by no means the only prominent easterner to collect saleable images of the West. In 1860, for instance, the Bierstadt brothers of New Bedford, Massachusetts, published a catalogue of their stereo views. The cards sold for four dollars per dozen and included pictures made by Albert Bierstadt of Sioux Indians near Fort Laramie; emigrants at St. Joseph, Missouri, just setting out on their long journey across the plains; and Shoshone warriors and children in Nebraska. Albert made these pictures when he accompanied Captain Frederick Landers as official artist-photographer on his survey of the territory stretching

from Puget Sound to the South Pass in the Wind River Range of the Rockies. All three Bierstadt brothers, Edward, Charles, and Albert, photographed. The views of the West made by Albert and Charles were augmented by an extensive series of stereos of New Bedford and the White Mountains.[53] "These Views," wrote the Bierstadts, "were procured at great expense, and as far as we know are the only views in the market giving a *true* representation of Western Life and Western Scenery."[54] This statement clearly characterizes the Western stereos as reportage; the pictures were meant to be viewed as pictorial journalism. They were not fiction.

Western photographers who managed to find outlets for their work in the East occasionally did very well, both in terms of reputation and financial remuneration. Under the Helios Flying Studio imprint, for instance, Eadweard Muybridge of San Francisco distributed photographs he made throughout the West. On the reverse of each stereo card, Muybridge affixed a printed list of the kinds of pictures available at his gallery at 12 Montgomery Street; not surprisingly, it included a full range of western subjects. He noted in particular that he had made pictures along both the Central Pacific and Union Pacific railroads, as well as of the mammoth trees and geysers of Yosemite, various mining areas, Chinese railroad workers, and Indians.

Like the Bierstadts, Muybridge made pictures of subjects that were in the news, and he distributed his views in various formats to the general public. An article in the July 1873 issue of *Philadelphia Photographer* gives an indication of Muybridge's marketing strategy. A set of images made in Yosemite in the early 1870s was published in sizes designed to appeal to every income group. There were one hundred 16-by-20-inch prints (the most expensive), another one hundred 8-by-10s, and seven hundred stereo views. "The examples sent us," wrote the editor, "are from capital negatives."[55]

Although known today chiefly for his large-format "fine art" landscapes, Watkins, like Muybridge and the Bierstadts, was a versatile photographer who mass produced and published pictures of a variety of subjects. At times, he worked as a photojournalist, producing pictures of newsworthy subjects that were distributed in a variety of forms to the general public.

A native of New York, Watkins went to California in 1849, hoping to find a bit of Sutter's fabled gold. His efforts on the American River were futile, however, and he moved to San Jose, where he worked for several years in the studio of Robert Vance. In 1854, he began working on his own in San Francisco, where he developed an enviable reputation as a photographer. Like many of his contemporaries, Watkins photographed a wide variety of subjects in virtually every format, and he was assiduous about seeing that his work was published and exhibited.

An impressive display of his photographs at the Centennial Exhibition in Philadelphia received special mention in the *Philadelphia Photographer*. "Mr. Watkins is said to be one of the pioneers of photography in California," wrote Henry Snelling, the editor. "These are certainly a magnificent series of views, and Mr. Watkins deserves great credit for his skill and energy."[56] During his career, Watkins produced urban landscapes, portraits, and views of work along the tracks of the Central Pacific. But he was best known for his elegant photographs of California scenery, many of which he made using a specially constructed view camera that produced glass-plate negatives measuring up to twenty-two by twenty-six inches. Prints from these negatives were exhibited both in the United States and Europe.

In an article written for the *Philadelphia Photographer* just after the Civil War, Utah photographer Charles Savage noted that

even "among the most advanced in the photographic art," none stood higher than Watkins. His photographs were "second to none in either the eastern or western hemispheres," and "great quantities" of them were sold throughout the United States and in Europe.[57]

Watkins's reputation, based in no small part on an ability to market stereo views of western subjects in the East and in Europe, led to his selection in 1867 as official photographer on Josiah Whitney's California Geological Survey. Whitney was determined to furnish "a reliable guide" in book form to the natural wonders of California, and Watkins was the ideal choice to provide the illustrations. The two met in Yosemite in the spring of 1867 and agreed to collaborate on a book about the area. Since Whitney had already hired a photographer, one W. Harris, who was hard at work making pictures in the high country, the decision to use Watkins as well may have been motivated by a desire to trade upon Watkins's reputation. Whitney implied as much when he described Watkins as "the well-known and skillful photographer, whose views of Pacific Coast scenery have been highly praised by good judges in this country and in Europe."[58] Watkins had access to the survey's special Dallmeyer landscape lens, an expensive and hard-to-find piece of equipment, and he ultimately provided more pictures of Yosemite to the survey than the now all but forgotten Mr. Harris. Whitney's limited-edition book describing the survey contained twenty-four photographs by Watkins and only four by Harris, the "official" photographer.

Exhibitions of photographs and illustrated books such as Whitney's *Yosemite Book* (1868) received good notices in the press, but they were not ideal vehicles for reaching a mass audience. The stereograph remained the principal medium of photographic communication throughout the last half of the nineteenth century. Watkins and others, lionized today for their magnificent large-format photographs of western landscapes, were prodigious producers of stereo cards. They made pictures that had universal appeal and the potential to earn money. "Popular taste controls or influences directly or indirectly every profession," wrote photographer Charles A. Zimmerman from St. Paul, Minnesota, in a paper read before the National Photographic Association Conference in 1873. "The love of the sensational is inherent in the masses, whether it be the morbid curiosity attending a murder or suicide, a fire, riot, curious or misshapen rocks, gnarled trees, the most sensational will always find the greatest number of worshippers." Ever the realist, Zimmerman told his colleagues that those desiring to make a living with their cameras must augment their fine-art landscapes with a great many "bread and butter" views.[59] Some photographers who did just that were employed by the federal government.

In the late 1860s and 1870s, the government funded four surveys of the western territories, each designed to explore, map, and determine the economic potential of what was still largely unknown land. The work of these federal surveys has been carefully studied.[60] What is important to note here is that photography was an essential component of each group's efforts. Photographs were intended to make the work of the surveys known to the public and especially to those in Washington who controlled the nation's purse strings. Survey photographs were valued more for their potential to reach large numbers of people than for their scientific accuracy. Dr. Ferdinand Vandeveer Hayden, director of the United States Geological and Geographical Survey of the Territories, was clear about the reasons for hiring William Henry Jackson as official photographer. As Jackson recalled:

If taxpayers and Congressmen alike wanted more evidence, none of them wanted it half so much as Dr. Hayden. He had a double motive. The abstract scientist in him wanted more facts to work with, while the practical planner in the man at once saw how a widespread public interest could keep his Survey alive permanently. Hayden knew that Congress would keep on with its annual appropriations exactly as long as the people were ready to foot the bill, and he was determined to keep them wanting to.[61]

Hayden believed that photographs "would aid him greatly in furthering the object of his explorations," Jackson wrote, which was to "familiarize people with the nature and the resources of the regions visited."[62] Pictures would be used to enhance the survey's annual reports to the Congress, and the distribution of photographs by Jackson would stimulate public support for continued appropriations. Hayden was correct in his assumptions about the publicity value of Jackson's photographs. Jackson noted that "an astonishing number of people bought finished photographs to hang on their walls, or to view through stereoscopes."[63]

Photographs were unmatched in their capacity to describe landscape, and the ease with which they could be reproduced, combined with their continued popularity, made them the ideal means of informing the Congress and the general public about the scientific work being done in the West. Survey photographers William Jackson, Timothy O'Sullivan, William Bell, Jack Hillers, and E. O. Beaman were encouraged to make and distribute their stereo views of the West and were allowed to keep the proceeds from the sales. Their images illustrated the annual reports to Congress and, as engravings from the originals, illustrated books and periodicals. As far as the general public was concerned, photographs in stereo form and engravings in the popular press had considerably more impact than the dry, erudite ramblings of scientists.

The best-known and perhaps most effective pictures made by Jackson on the Hayden survey were produced on an excursion to the Yellowstone valley in the summer of 1871. Three photographers made the trip to Yellowstone that year, all of them connected in some way with the survey, though only Jackson's images received national recognition. Thomas Hine, a photographer from Chicago who specialized in landscape photography, accompanied one party led by army engineers Colonel J. W. Barlow and Captain D. P. Heap. Hine is known to have produced a large number of glass-plate negatives during the summer. He returned with them to Chicago, eager to begin making and selling prints, only to have the entire collection destroyed in the great fire.[64]

J. J. Crissman, a photographer from Bozeman, Montana, joined Jackson in the valley and even borrowed some of his equipment after his own was blown off a cliff by high winds.[65] Crissman returned to Bozeman in the fall and sold his views of Yellowstone locally, evidently satisfied with the proceeds derived from this limited distribution.

William Henry Jackson, on the other hand, was never satisfied with local sales. He worked industriously to establish a national reputation as a photographer, selling enlargements and stereos of his western views, and he made sure the press was kept well informed about his treks through the wilderness. Jackson later contended with some justification that his images "did a work which no other agency could do and doubtless convinced everyone who saw them that the region where such wonders existed should be carefully preserved . . . forever."[66]

Of the twenty-two hundred negatives he produced for the Hayden survey between 1870 and 1879, more than a third were published by the Anthonys. The Jackson brothers also published their own series of western stereos. "In addition to lofty mountains, wondrous rock formations,

and deep ravines," commented Edward Wilson in the *Philadelphia Photographer* about a set of Jackson's Yellowstone images, "we have boiling mineral springs, puffing mud springs, extinct craters, gushing waterfalls, yawning canyons, beauteous lakes, and hundreds of other wonders of that region." The quantity and quality of the work was especially noteworthy, wrote Wilson, considering that "everything had to be carried on mule-back." [67]

Jackson's pictures were used prominently in Hayden's year-end reports to Congress and in other official publications, making the photographer something of a celebrity in Washington. The distribution of his pictures to the public in the form of stereographs and enlargements further enhanced his reputation. "I had established myself as one of the foremost landscape photographers in the country," he wrote. "My career was assured. I loved my work. I could ask nothing more." [68] Jackson's landscapes helped to persuade members of Congress to pass legislation establishing the National Park Service to protect and preserve areas like Yellowstone. [69] "The expeditions of Professor Hayden, and current literature, have made the Yellowstone region as famous as the land of the Arabian Nights,"

commented a reporter in *Frank Leslie's Illustrated Newspaper.* [70]

While Jackson was supplying pictures to document and publicize the Hayden survey, others were similarly employed by competing government departments and agencies in Washington. Timothy O'Sullivan worked for Clarence King's survey of the fortieth parallel under the aegis of the War Department from 1867 to 1869, and for the United States Geographical Surveys West of the One Hundredth Meridian, led by Lieutenant George Montague Wheeler of the Corps of Engineers, from 1871 to 1875. Carleton Watkins also supplied pictures to the King survey in 1871, and William Bell (not the same as Dr. William Bell who worked on Palmer's survey for the Kansas Pacific) accompanied the Wheeler survey during the 1872 season.

Major John Wesley Powell, the one-armed Civil War veteran whose explorations of the Colorado River are regarded by some as the most thorough and astute of all the federal surveys, employed several photographers. Powell, it seems, had little success initially in selecting persons hardy enough to survive his several trips down the Colorado, or skilled enough to make useful pictures along the way. On his second voy-

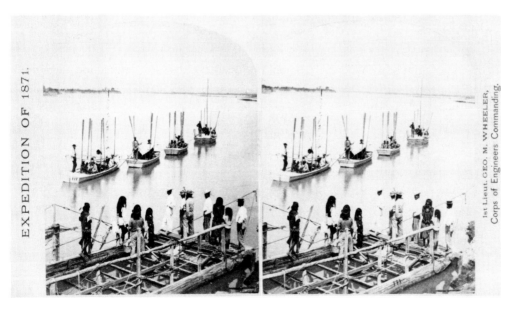

Stereo view, *The Start from Camp Mojave, Arizona, September 15, 1871*, by Timothy O'Sullivan for Lieutenant George Wheeler's United States Geographical Surveys West of the One Hundredth Meridian. Collection of David Kent, Miami, Florida.

age down the Colorado in 1871 and 1872 (there were no pictures made on the first voyage), Powell secured the photographic services of E. O. Beaman, a New York photographer recommended to him by Edward and Henry Anthony. Beaman made more than 350 images, but his relations with Major Powell were, at best, strained, and he left the survey suddenly in January 1872. William Goetzmann, who has written extensively about the role and influence of visual imagery in the West, characterizes Beaman's sudden departure at Kanab in southern Utah as desertion. Powell's photographer, he writes, was determined to sell the story of the major's voyage, complete with illustrations made from his photo-

graphs, to the popular press, and so left in midstream.[71] A letter from H. M. Alden, editor at *Harper's Weekly,* indicates that Powell was also trying to sell the survey's story and Beaman's photographs to the popular press. "We should also like to have you contribute an article on the remains of Aztec civilization in Arizona," wrote Alden, "to be illustrated by Capt. Beaman's photographs and such sketches or photographs as you may be able to furnish in addition. Will it be necessary for you to take Capt. Beaman's material with you?"[72]

James Fennemore of Salt Lake City was the next photographer hired by Powell, but his health was shattered by the rigors of the expedition, and he left at the first available opportunity. Finally, Jack Hillers, originally hired as an oarsman, the lowest paid position, was promoted to photographer. He received some rudimentary training from the major's younger brother, Clem, and the rest he learned on his own. Hillers worked out very well indeed.

None of the men hired by Powell, or by any of the other survey leaders for that matter, were expected to furnish pictures of a strictly scientific nature. Lieutenant George Wheeler, for example, made it clear that O'Sullivan's images were useful primarily as devices to enlist the support of the money men in Washington. The barely hidden agenda of Wheeler and the War Department was always to receive the maximum amount of publicity in the popular press in order to strengthen "Congressional support for funding of further military surveys in the postwar era of severe retrenchment."[73]

Whereas the public continued to accept without reservation the information presented in photographs, scientists were more realistic. "The remark is frequently made . . . that this newly-invented art gives a perfectly truthful representation of objects," wrote photographic expert Dr. Hermann Vogel in 1875. But, he continued, such a view is "not absolutely true," and he

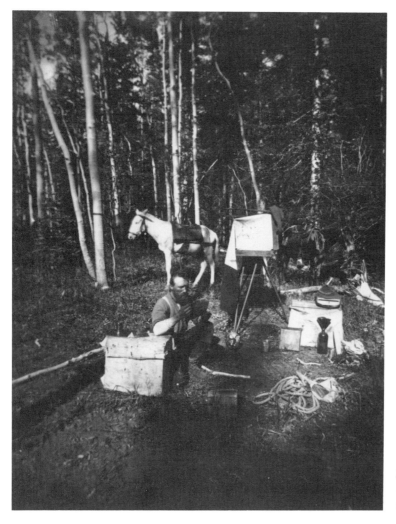

Photographer Jack Hillers examining a glass-plate negative in camp on the Aquarius Plateau, July 1875. Photograph by Almon Harris Thompson or Grove Karl Gilbert. National Archives.

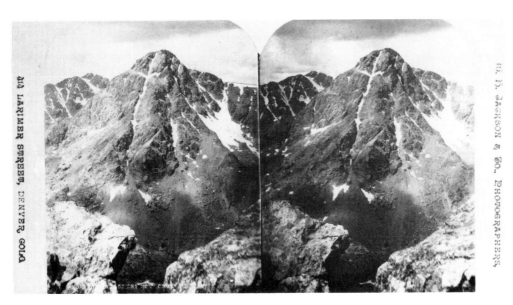

Stereo view of the
Mount of the Holy
Cross, made and pub-
lished by William Henry
Jackson. Collection of
David Kent, Miami,
Florida.

enumerated the various distortions and "sources of inaccuracy" in photographs.[74] The real scientific work on the surveys was performed by scientists—geologists, geographers, and topographical engineers. Jackson's famous image of the Mount of the Holy Cross was useful as a public relations tool, but it was Hayden and his assistants who proved the mountain was precisely 13,998 feet high and that the vertical arm of the cross was fully fifteen hundred feet long. "Pictures were essential to the fulfillment of the Doctor's plan for publicizing this Survey," wrote Jackson, "but the basic purpose was always exploration. I cannot be too careful in emphasizing the fact that in this and all the following expeditions I was seldom more than a sideshow in a great circus."[75]

For the public, however, the photographic sideshow had the power to mesmerize. In John Samson's "Photographs from the High Rockies," printed in *Harper's New Monthly Magazine* in September 1869, the western survey photographer is depicted as an archetypal frontier character, and the piece reads like a western dime novel. Though not mentioned by name, the hero is Timothy O'Sullivan, then employed on Clarence King's United States Geological Exploration of the Fortieth Parallel, and

the article is accompanied by thirteen rather crude wood engravings made from his photographs.

Working as a photographer in the West, according to Samson, was no picnic.[76] For a start, there was the constant threat of losing one's stock, supplies, or hair to roving bands of hostile mountain Indians. And if one was lucky enough to escape their notice and bad intentions, foul weather, hordes of mosquitoes, great nests of rattlesnakes, and recurring bouts of fever would surely combine to test one's endurance and survival skills. The photographer described by Samson was not some effete artist, content to produce lovely photographic masterpieces in the secure confines of a city studio. The territory through which he roamed with his cameras was "absolutely wild and unexplored, except what the Indians and fur trappers who frequent the mountains may have accomplished in the way of exploitation." Intrepid, daring, adventuresome, and possessed of both physical strength and an artist's sensibilities, Samson's photographer hero was ideally suited to the rugged terrain he sought to capture on glass plates. "People and places are made familiar to us by means of the camera in the hands of skillful operators," wrote Samson. They compete with each

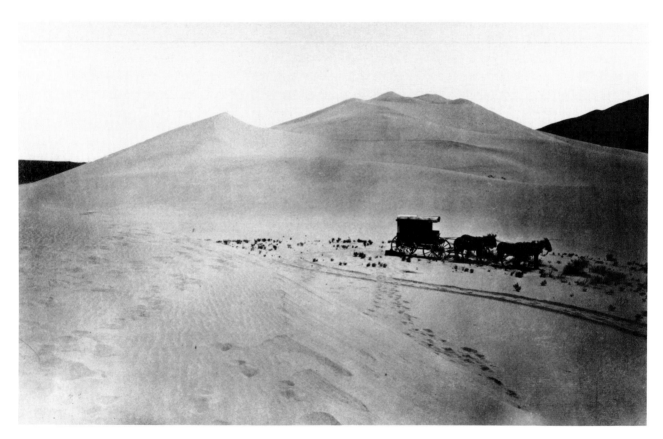

Timothy O'Sullivan's
horse-drawn photo-
graphic outfit near Sand
Springs in the Carson
desert, Nevada, 1867.
National Archives.

other "in the artistic excellence of their productions, avail themselves of every opportunity to visit interesting points, and care to lose no good chance to scour the country in search of new fields of photographic labor."[77]

Samson's article in *Harper's Weekly* made the profession of photographer seem respectable, even heroic. It is the first real description in the national press of a photojournalist, someone who roams the country in search of "interesting points" and whose pictures make the world at once familiar and understandable. Samson's photographer is not a disreputable character but a figure who displays equal parts of artistry and courage in his quest to make known the unknown. The illustrations printed with the article are visual proof of his success.

A series of articles written for *Scribner's Monthyly* by John Wesley Powell and illustrated with engravings made by Thomas Moran from photographs by Jack Hillers were additional evidence of the ability of photographers to bring back pictures from the wildest and most remote places.[78] When Hillers toured the Indian Territory in 1875, making photographs that would eventually be used by Powell in the Bureau of Ethnology, he discovered how profoundly these pictures had touched the lives of the people who saw them.

In a letter written to his brother William in San Francisco in 1875, Hillers told of visiting the Ladies' Seminary at Tahlequah, capital of the Cherokee Nation. Introduced to the assembled students as "Professor Hillers, government photographer," he was surprised to learn that they had already seen the *Scribner's* articles and were duly impressed with his camera work. One of the young ladies was especially enthusiastic. "A lunch had been set out for Alvoretta and myself," wrote Hillers. "After a thorough absolution from dirt I sat down and enjoyed a first class lunch. She had read *Scribner's* . . . and seen my pictures . . . , which of course she praised to the skys, and no doubt she meant [it]."[79] In the middle of the Indian Territory, at a school for children with mixed blood, Hillers was given a neat lesson in the power of published pictures to entertain and inform.

It was a lesson that Powell and his competitors in the survey business seem to have learned as well. All of them used photographs in their various writings. Powell

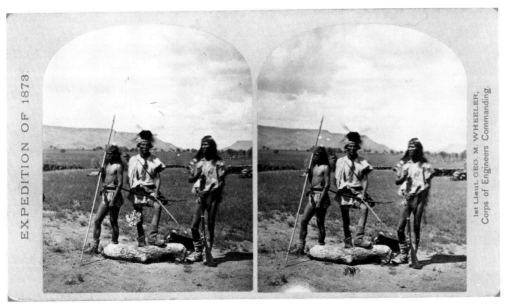

Stereograph by Timothy O'Sullivan of Apaches "ready for the war-path," made on the Wheeler survey of 1873. National Anthropological Archives, Smithsonian Institution.

even entered into partnerships with two of his photographers, Beaman and Hillers, to produce and distribute stereographs made on his surveys of the Southwest. After he and Beaman parted ways in January 1872, Powell bought out Beaman's interest. The partnership with Hillers included Powell's brother-in-law, Almon Harris Thompson, and they divided proceeds three ways, with 40 percent going to Powell and 30 percent each to Thompson and Hillers. Although precise figures for Powell's stereo enterprise are not known, he did report that during the first six months of 1874, Hillers's stereos earned a total of $4,100, representing the sale of well over eight thousand stereo cards.[80]

Among Hillers's consistent best-sellers were his photographs of Indians. Powell had a strong interest in the language, tribal organization, and customs of the Indians he encountered, and he encouraged Hillers and his other photographers to make pictures of them.[81] Photographs of Indians, whether depicted as noble or savage, exotic or depraved, were sure to find an audience. Today they provide an invaluable record of the twilight years of Native American cultures.

It is not, however, a visual record that includes photographic images of battles between Indians and the army, of encampments of "hostiles," or of more than a few warriors during their fighting days. Photographic methods in the 1870s and 1880s demanded willing subjects, complete stillness for a moment or two, and enough time to carefully coat and sensitize the glass plates prior to exposure. Battles were obviously out of the question. And many Native Americans, pressured by the incessant encroachments of white settlement, were loathe to have their likenesses "captured" by scruffy white men with cameras. "I planted my camera on the [Los Pinos] Agency porch for the purpose of taking in the general gathering on the [annuity] issuing ground," recalled Jackson of his adven-

tures among the Utes in 1874. "At once Peah and five or six other Indians rode up in front of me, protesting vehemently, meanwhile pulling away the tripod legs, jerking the focusing cloth from over my head, and occasionally throwing a blanket over the camera and myself."[82] Beaman had a similar experience with Pai-Utes near Kanab, and those who photographed the Sioux and Cheyennes on the northern plains never had an easy time of it.[83]

No one had more trouble than Ridgeway Glover, a young photographer from Philadelphia who left his home in the summer of 1866 in search of pictures and adventure in the West. He arranged to be a special correspondent for both *Frank Leslie's Illustrated Newspaper* and the *Philadelphia Photographer*. Neither association lasted long, however, for on September 17, 1866, Glover was killed when he attempted to photograph Red Cloud's Sioux warriors near Fort Phil Kearny in present-day Wyoming. He had earlier tried to make pictures during the attack of a band of Sioux on an army detachment near Crazy Woman's Fork on the Powder River, but was ordered by the commander to put his camera away.[84] Undaunted by the army's rebuke or the dire warnings of his friends, Glover sallied forth alone a few weeks later and died a short distance from the fort. Both the post chaplain, David White, and Samuel L. Peters of the Eighteenth Infantry wrote to *Leslie's* explaining what had happened to their "special correspondent." The letters were printed in full on October 27 in an article entitled "The Fate of a Frank Leslie 'Special.'"[85] It was not a pretty story.

According to Peters, Glover, "an eccentric and peculiar being," had gone out to make pictures. When he failed to return, a search party was sent out, which found his body but not his camera or plates. "He was very careless of life," wrote Chaplain White, "traveling frequently by himself . . . with nothing but a butcher knife, though the country abounds with wolves,

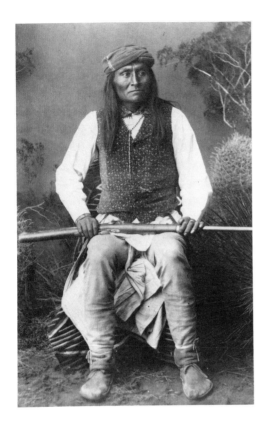

MANGUS.

Studio photograph of Mangas, son of Mangas Coloradas, an Apache, made by A. Frank Randall, ca. 1880. National Anthropological Archives, Smithsonian Institution.

Wood engraving of A. Frank Randall's photograph of Mangas, published in *Harper's Weekly,* April 17, 1886. Otto Richter Library, University of Miami.

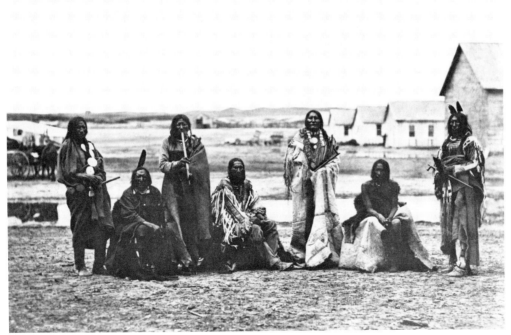

Photograph made and published by Alexander Gardner of Sioux Indians at Treaty Council of 1868 at Fort Laramie, Wyoming Territory. *Left to right:* Spotted Tail (Brule), Roman Nose (Miniconjou), Old Man Afraid of His Horses (Oglala), Lone Horn (Miniconjou), Whistling Elk (Miniconjou), Pipe, and Slow Bull (Oglala). National Anthropological Archives, Smithsonian Institution.

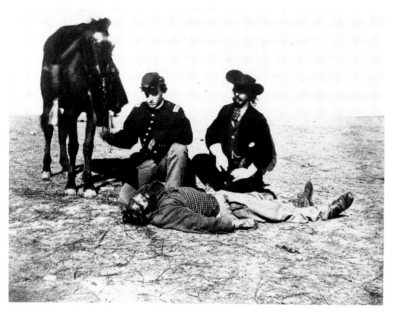

Photograph by William Soule of Ralph Morrison, a hunter who was killed by Cheyennes near Fort Dodge, Kansas, December 7, 1868. Posing with the body are, *left,* Lieutenant Read of the Third Infantry and, *right,* John O. Austin, chief of scouts. National Anthropological Archives, Smithsonian Institution.

black, gray and cinnamon bears and ferocious savages."[86] Young Glover may ultimately have been more fool than anything else, but his determination to make pictures for the press seems thoroughly modern. Glover was the first photographer killed while making or attempting to make news pictures in America. He would not be the last. And his short and unproductive career on the plains turned out to be a useful lesson for his fellow photographers; after 1866, they were far more circumspect in their dealings with the tribes.

Chief Joseph of the Nez Percé, for example, was photographed by Orlando Scott Goff, the leading photographer in Bismarck, Dakota Territory, only after his surrender to the army in October 1877. Later, when Sitting Bull stopped at Bismarck after surrendering with a few of his followers at Fort Buford in July 1881, Goff was again ready. He managed to persuade the medicine man to sit for a single portrait by offering him fifty dollars, an indication of Goff's well-placed faith in the monetary value of such a picture. Thereafter, Goff advertised himself as the "photographer of Sitting Bull, Chief Joseph, and all the hostile Sioux Chiefs."[87] In Arizona, Camillus

Fly had similar success with Geronimo, but only after he was finally persuaded to surrender to General George Crook.[88]

David Frances Barry, Goff's protégé, also compiled an impressive collection of Indian portraits during the last two decades of the nineteenth century, and he made every effort to see that his pictures were published. A reporter for the *Duluth News Tribune* wrote in 1898 that Barry "is known in the office of every publication of note in the country on account of his Indian pictures."[89] Barry began working as an itinerant in 1880, traveling between the settlements, military posts, and Indian agencies in the Dakota Territory, making pictures of Native Americans, military men, and the small communities that dotted the northern plains. Like Goff, Barry knew the value of such photographs. His 1881 portrait of the Hunkpapa chief Gall, one of the leaders of the Sioux at the Little Bighorn, was widely circulated and eventually helped to make both the photographer and Gall famous.

No doubt, Barry's colorful account of the sitting and its dramatic aftermath enhanced the allure of the image. According to Barry's biographer, Thomas Heski, Gall went to Barry's temporary studio at Fort Buford after being paid twenty-one dollars to pose. At first he stood before the camera with his buffalo robe pulled over his head, just his eyes showing. But the photographer felt that "such a photograph would be worthless" and coaxed the chief to lower the robe and so reveal his face.[90]

Critics felt that Barry's portrait revealed Gall as the embodiment of the noble savage. Even Libby Custer was impressed. "Painful as it is for me to look upon a pictured face of an Indian," she wrote in 1927, "I have never dreamed in all my life, there could be so fine a specimen of a warrior, in all the tribes."[91] Chief Gall, however, was considerably less pleased with Barry's effort. According to one account, Gall returned to Barry's studio soon after the sitting and asked to see the picture. He was

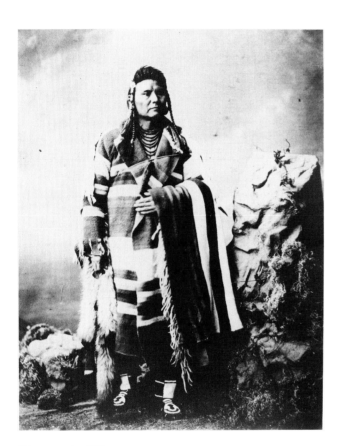

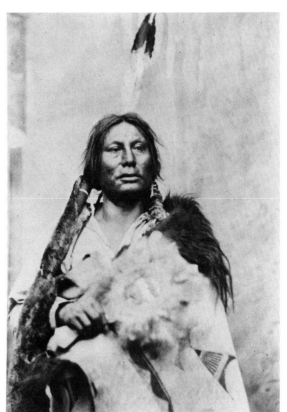

Photograph of Nez
Percé leader Hinmaton
Yalatkit (Thunder Com-
ing from the Water up
over the Land), known
by whites as Chief Jo-
seph, by Charles Milton
Bell. National Anthro-
pological Archives,
Smithsonian Institution.

Photograph of Hunk-
papa Sioux leader Gall
made by David Barry at
Fort Buford, Dakota
Territory, 1881. Na-
tional Anthropological
Archives, Smithsonian
Institution.

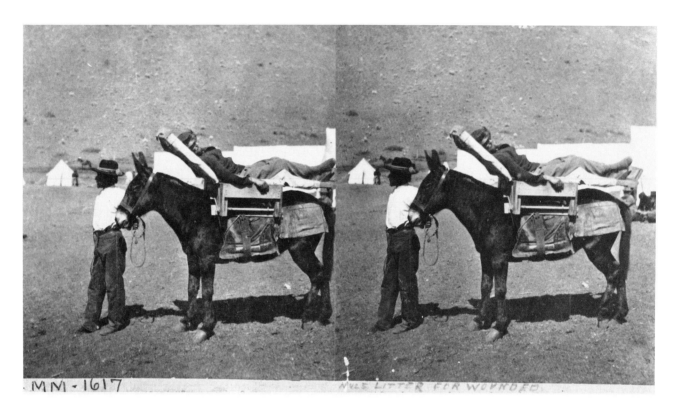

MM-1617

MULE LITTER FOR WOUNDED

Stereograph by Louis
Heller of transportation
for soldiers wounded in
the fighting near the
Tule Lake lava beds dur-
ing the Modoc War.
National Archives.

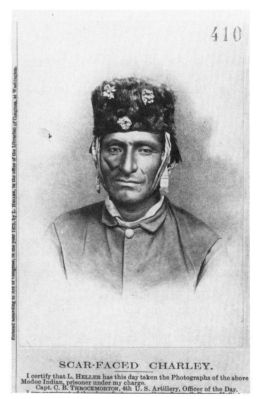

410

SCAR-FACED CHARLEY.

I certify that L. HELLER has this day taken the Photographs of the above
Modoc Indian, prisoner under my charge.
Capt. C. B. THROCKMORTON, 4th U. S. Artillery, Officer of the Day.

Carte de visite made by
Louis Heller in 1873 of
Modoc warrior Scar-
faced Charley, including
printed statement of au-
thenticity. National An-
thropological Archives,
Smithsonian Institution.

shown the glass plate negative, which was all that Barry had had time to prepare. Gall hated the negative image, and when Barry placed it in the small darkroom for safe-keeping, Gall attempted to retrieve it. Barry, apparently thinking his work was about to be destroyed, shoved Gall to one side.

Quick as a flash the Indian, furious, drew a knife and as quickly the photographer covered him with his revolver. . . . Pausing for a few moments in indecision, apparently attempting to fathom the determination of the holder of the revolver, Gall backed slowly out of the studio and the picture was safe.[92]

Given the difficulty and occasional danger of dealing with hostile Indians, some photographers concentrated on making pictures of the army. Commanders in the West, well aware of the eastern public's growing dissatisfaction with federal policies toward the Indians, were generally solicitous of photographers' requests to accompany expeditions into the field. Thus in

1872 and 1873, both Eadweard Muybridge and Louis Herman Heller made pictures of the army's inept but ultimately successful efforts to subdue a small band of Modoc Indians in their northern California stronghold. Led by warriors Scarfaced Charley and Captain Jack, fewer than one hundred Indians held off more than a thousand U.S. troops for more than seven months.

Heller's studio was located in Yreka, not far from the lava pits near Tule Lake where the Modocs made their stand. Though fighting began in November 1872, Heller apparently did not make any pictures relating to the war until the following April. By May, however, he had completed work on a series of twenty-four stereo views that the *Yreka Journal* described as unexcelled in terms of "beauty, shade and artistic finish." The paper further noted that when the stereos were put on the market, they would "undoubtedly sell with a rush, as everyone wants to see what the lava bed looks like."[93] Heller also made his pictures available to the national press, and on June 14, 1873,

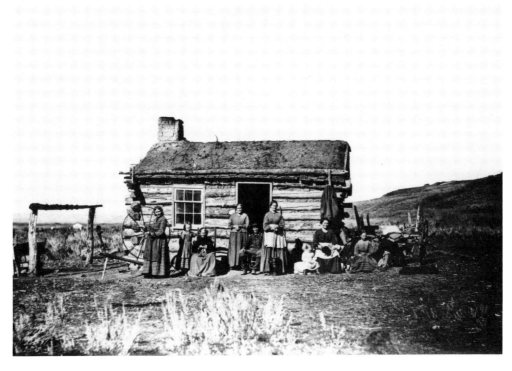

Photograph by Andrew J. Russell of Mormons, often misidentified as a Mormon man and his many wives. Utah State Historical Society.

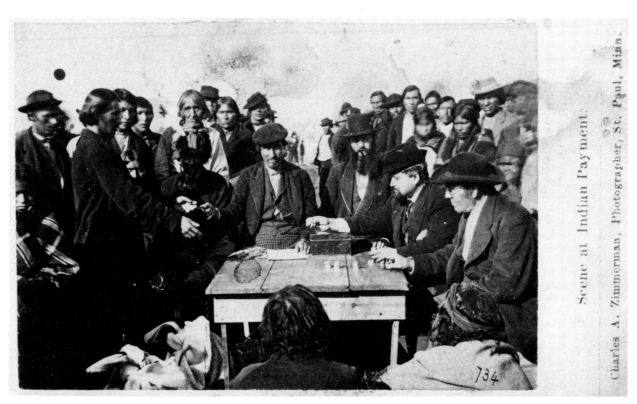

Cabinet card by Charles
Zimmerman of Winne-
bago Indians receiving
annuity payments in
Wisconsin, ca. 1871.
Minnesota Historical
Society.

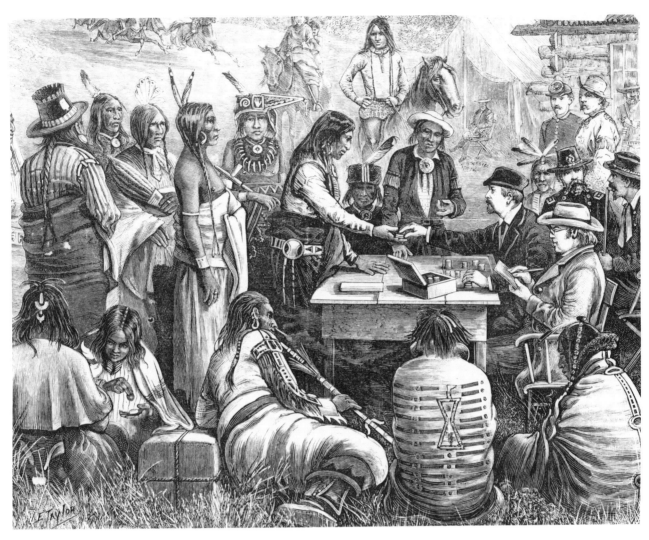

Wood engraving by James Earl Taylor from Charles Zimmerman's photograph of annuity payments. This copy of the engraving was kept in Taylor's personal album and included no acknowledgment of the original photograph by Zimmerman. National Anthropological Archives, Smithsonian Institution.

Wood engravings from photographs made by William Illingworth during George Armstrong Custer's expedition to the Black Hills in 1874. Published in *Harper's Weekly,* September 12, 1874. American Antiquarian Society.

CAMP WHERE GOLD WAS FIRST DISCOVERED—CUSTER GULCH ON THE LEFT.

THE BLACK HILLS EXPEDITION.

No expedition since the war has attracted more attention or excited more interest than the one which left Fort Abraham Lincoln, Dakota, on the 2d of July, to explore the Black Hills. This region of country, lying in the southwestern part of Dakota, and extending some distance into Wyoming, and slightly indenting Montana (as shown in the map printed in a recent number of the *Weekly*), has, until this summer, in its interior been enclosely unexplored by the white man. Previous expeditions have skirted the hills, but never penetrated them, and we have been dependent on the reports and traditions of the Indians for the little we have known of them. The hostility of the Indians has defeated any attempts to explore the country by civilian parties.

The present expedition was entirely a military one, and consisted of ten companies of the Seventh cavalry, two companies of infantry, and three pieces of artillery, in all about 700 soldiers, with the addition of a train of 120 wagons, and about as many teamsters, the whole under command of Major-General George A. Custer. Colonel Frederick D. Grant, the President's oldest son, accompanies the ex-

pedition as aid to General Custer. The scientific corps consists of Colonel William Ludlow, U. S. Engineer Corps; W. H. Wood, assistant, Professor N. H. Winchell, geologist; Professor A. B. Donaldson, assistant; George B. Grinnell, palæontologist; L. H. North, assistant; Dr. J. W. Williams, chief medical officer, botanist.

The expedition reached the Black Hills about the 20th of July, after a march of eighteen days, mostly over an arid, treeless, desert country. General Custer, in spite of the prophecies of his Indian guides, who declared the thing impossible, succeeded in penetrating to the very interior of the hills with his wagon train, and by sending off detachments of cavalry here and there, has succeeded in exploring and mapping the hills through their entire length and breadth. The country is found to be of great scenic beauty, as shown by our illustrations on this page, and is luxuriant in vegetation, abundant in game, timber, and good water. Thousands of acres of fertile land invite settlement. The country, however, is a part of the Sioux Reservation, and can not be opened to the whites until the government shall make some satisfactory arrangement with the Indians.

On the 31st of July gold was discovered along the banks of a creek on which the expedition was encamped, the best pans yielding from five to ten cents' worth of gold, equivalent to fifty dollars a day to the man, if the yield should prove as good as promised. We present a view taken on the spot, showing the camp near which gold was discovered. A portion of Custer Gulch, as it was named by the miners, is seen on the left. The Organ-pipe Range was so called by the party from the peculiar shape of the tall granite range found near the park. A camp view of the principal park in the hills gives some idea of the size of the expedition. This site was selected for the permanent camp, and from this point detachments radiated for several days.

ORGAN-PIPE RANGE.

THE CAMP IN THE PARK.

THE BLACK HILLS EXPEDITION.—[FROM PHOTOGRAPHS BY W. H. ILLINGWORTH.]

they were used as the basis for three unattributed wood engravings that ran on page one of *Harper's Weekly*.

Muybridge, well known for his magnificent landscapes of Yosemite and the pictures he made along the line of the Central Pacific, was hired by the army in the summer of 1873 to make photographs showing its side of the conflict. Later, in an article written for the *San Francisco Examiner,* Muybridge was described as not only the best but the only photographer of the Modoc war.

Mr. Muybridge was dispatched to the front during the Modoc War, and the widespread and accurate knowledge of the topography of the memorable Lava Beds and the country roundabout, and of the personnel of the few Indians who . . . defied and fought the army of the Union, is due chiefly to the innumerable and valuable photographs taken by him.[94]

This glowing testimonial was supplied to the paper by Muybridge himself, and it apparently worked as he had planned; the public soon forgot the name of Heller, attributing every image from the lava beds and all portraits of captured Modocs to Muybridge. Heller's only recourse was to include a written statement of authorship and authenticity on every card he sold, but the words were small and easily overlooked.

Occasionally, the work of photographers was appropriated by sketch artists for the pictorial weeklies, a practice that no doubt encouraged photographers to mass produce their images in the form of cartes de visite, cabinet cards, and stereographs. James Earl Taylor, a prolific artist-correspondent for *Frank Leslie's Illustrated Newspaper,* often used photographs as the basis for his "firsthand" reports and sketches. Born in Cincinnati in 1839, Taylor graduated from Notre Dame at the age of sixteen. He joined the Union army in 1861 and then went to work for *Leslie's* two years later.

During the war, he covered events and fighting in Virginia; after Lee surrendered at Appomattox, he headed west, still in search of news pictures. Taylor's dramatic eyewitness accounts and sketches helped to create certain enduring popular notions about the western adventure, for his pictures of Indians on the warpath, of gallant soldier heroes, of life in the tough, hardscrabble towns on the high plains, were prominently displayed for twenty years on the pages of one of America's most popular publications. His personal scrapbook, which he titled "Our Wild Indians in Peace and War: Surveys, Expeditions, Mining, and Scenery of the Great West," is now in the National Anthropological Archives at the Smithsonian Institution. It provides a unique glimpse into the working methods of a nationally known sketch artist.

As one would expect, the album is filled with printed copies of his many wood engravings. Also included, however, are the photographs that he used to create his sketches. The album contains, for instance, Taylor's drawing of A. J. Russell's photograph of one male and several unrelated female Mormons in Utah, together with the misleading caption, "Mormon family." Several of Heller's portraits of Modocs are there, as is Camillus Fly's photograph of General Crook and Geronimo and a printed linecut of Charles Zimmerman's photograph of government annuity payments to Indians near St. Paul, Minnesota. Taylor credited few of the photographs in his album, suggesting that the artist felt no obligation to acknowledge the origins of his pictures; and it is unlikely he told his editors at *Leslie's* that his sketches were merely copies of photographs.

In 1874, photographer William Illingworth accompanied Colonel George Armstrong Custer on his controversial excursion into the Black Hills. Custer, never one to shun the attentions of the press, was apparently delighted to be able to take a photographer along. In a letter written to his

wife on August 15, 1874, he noted that the expedition had "exceeded the most sanguine expectations" and that his superior officers would no doubt "be pleased with the extent and thoroughness of these." Among his accomplishments, Custer listed a "complete stereopticon view of the Black Hills Country" made by Illingworth.[95]

William Illingworth was no stranger to expedition and military photography. In 1862, he and George Bill, an assistant, were hired by Captain John Liberty Fisk to make pictures on a federally sponsored journey from St. Paul to the mining regions of Montana and Idaho.[96] Illingworth's images of Fisk's military escort and of Forts Abercrombie, Union, and Benton were widely distributed in the form of stereo cards. The set of fifty-five stereos of Custer's 1874 expedition was sold nationwide and distributed to the illustrated papers in the East. Apparently, Illingworth was more eager to

sell his pictures to the press and general public than to provide the army with a complete set, as he had originally promised. Colonel William Ludlow, commander of the Engineering Department for the Black Hills expedition, complained to his superiors in Washington of Illingworth's failure to deliver pictures in a letter dated January 12, 1875.[97]

Stanley J. Morrow began working as a photographer during the Civil War, when as a member of the Seventh Wisconsin Volunteer Infantry he helped Mathew Brady and an assistant make a series of photographs at Fort Lookout Prison in Maryland. After the war, he settled in Yankton, Dakota Territory, and began working as a photographer, augmenting the routine work of a small-town photographer with pictures of the Wild West that were marketed nationwide. In the summer of 1876, he and his brother-in-law, Frank Ketchum, joined the gold rush into the Black Hills and came away with an extensive series of stereo views of mining operations on land that was once sacred to the Sioux. In September, when word reached the settlements that General Crook's Big Horn and Yellowstone Expedition was desperately in need of food supplies, Morrow joined the rescue party. He made a series of stereos that depicted soldiers fighting with each other over slabs of raw meat just cut from their slaughtered horses. The photographs were fakes. Although a few horses had indeed been killed for food, Morrow's images were carefully choreographed reenactments, made after the troops had been resupplied.

Morrow continued making excursions into the unsettled territory of the northern plains, steadily adding images to his stereographic series "Gems of the Northwest." In 1879, he accompanied Captain George Sanderson of the Eleventh Infantry to the scene of Custer's demise, and he came away with some of his most memorable images. Morrow's battlefield series included several

Detail of a stereograph by William Illingworth of George Armstrong Custer posing with a grizzly bear he killed on the 1874 Black Hills expedition. Others shown are, *left to right:* Bloody Knife, Custer's Crow Indian scout; Private Noonan; and Captain William Ludlow of the Corps of Engineers. National Archives.

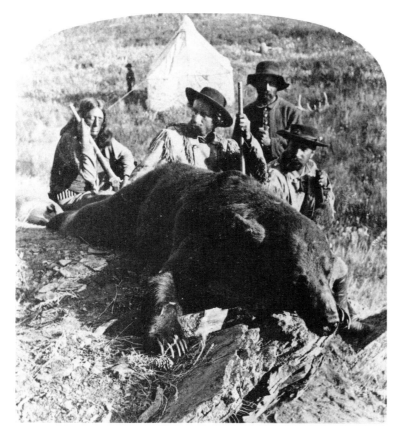

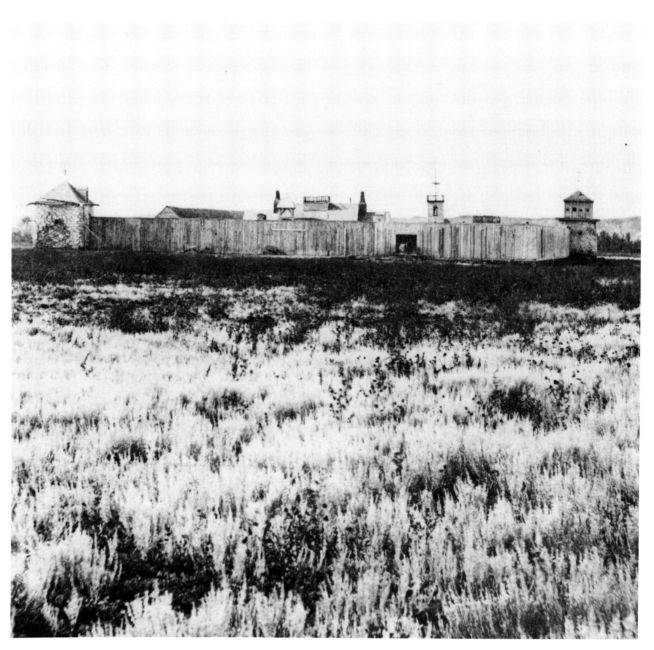

Photograph of the Northwest Fur Company trading post at Fort Union, Montana, made by William Illingworth and George Bill during the Fisk expedition of 1866. Montana Historical Society.

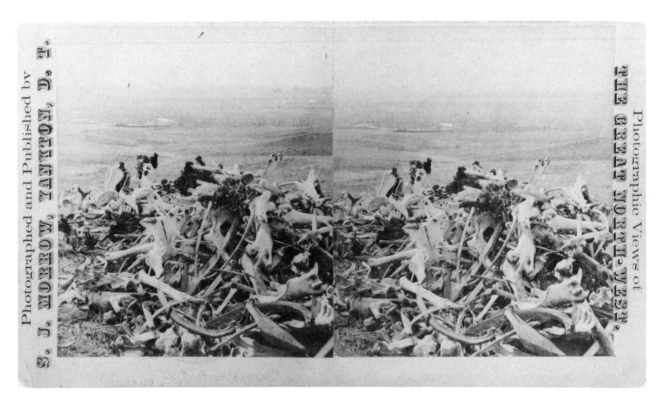

Stereograph by Stanley
Morrow of skeletal re-
mains piled at the site of
the Little Bighorn battle
in 1876. Montana His-
torical Society.

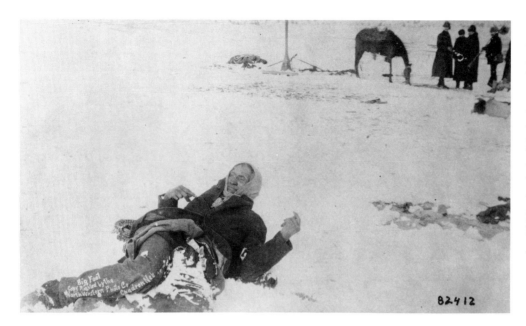

photographs showing piles of bleached bones lying on the prairie, and eerie views of the graves of Custer and his men.[98]

Morrow closed up his gallery in Yankton and moved to northern Florida in 1883 when his wife's health failed. Six years later he moved again, this time to Atlanta. During the second move, all of his glass negatives were lost. After a search lasting five years, Morrow located his collection, intact, in the studio of a photographer in Jacksonville, Florida; it had been purchased for but ten dollars at an unclaimed property sale. Before Morrow could establish himself as rightful owner of the work, a fire swept through the business district of Jacksonville, destroying every negative. All that is left of Morrow's work are the stereos he produced and sold from his small Dakota studio.[99]

By the time Morrow and his wife, Isa, left Yankton for the easy life in Florida, there was not much left of the Wild West. The Sioux had been beaten. There would be just one more spasm of violence on the northern plains—the army's brutal knee-jerk reaction to the ghost dance at Wounded Knee Creek in December 1890. Sitting Bull himself went to work for Buffalo Bill, touring the cities and towns of the East, playing the part of Custer's killer in Cody's fantastic Wild West extravaganza. After 1880, photographers wishing to capture on film the faces of red men and women were likely to have to pay for the privilege and do so on reservation land.

In the post–Civil War American West, photographs served a variety of purposes. They were used as personal mementoes, of course, and often displayed and sold as works of art. Their most important function, however, was to help make the frontier known to Americans living in the East. "The driving of the golden spike [1869] was a signal for a new rush for the settlement of the West," wrote photographer William Henry Jackson. "Now that there was railroad transportation, the vast plains, the Rocky Mountains with their rich treasures, and the valleys of the Rockies and the Sierras were brought within easier, surer reach of the farmer, the stockman, and the miner. It was essential that more definite information about these regions be made available."[100]

The publication of photographs, whether in the form of stereos, cartes de visite, or cabinet cards, or as engravings on

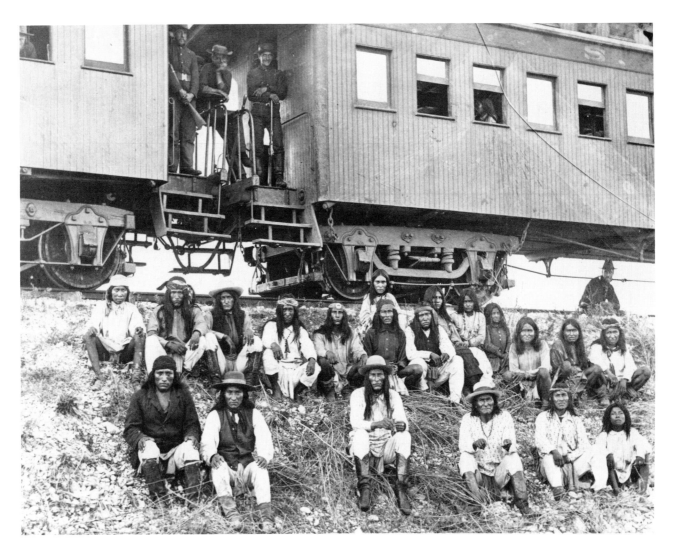

Geronimo, *first row, third from right,* and other Apaches outside the train taking them to captivity in northern Florida. Photographed by A. J. McDonald, September 10, 1886, on the Southern Pacific Railroad near the Nueces River in Texas. National Archives.

the pages of books and magazines, made the West visually accessible and stimulated emigration. They provided information about the lay of the land and depicted the progress of work on the railroad and the plight of the Native American cultures. Many of the photographers who worked in the West were impelled both by a desire to document important and newsworthy events and a determination to make their pictures available to the general public.

Though encumbered by bulky equipment and the complicated wet-plate process, photographers traveled widely and compiled impressive collections of views that described the frontier experience. Their comparatively primitive equipment and the lack of an inexpensive process for printing their pictures with text may have made photographers' work more difficult, but these obstacles did not preclude progress toward modern photojournalistic practice.

FIVE

DRY PLATES AND HALFTONES

Throughout the history of photography there have been many dramatic and far-reaching inventions. Unquestionably, one of the most important of these was the development of the halftone plate in the closing years of the nineteenth century. This invention made it economically possible for photographs to be printed in newspapers, books, and magazines, and led to . . . news photography and photojournalism.

MARTIN W. SANDLER
The Story of American Photography

DURING THE 1870s, TECHNOLOGICAL changes in photography and publishing dramatically altered the way photographs were made and how they were printed in magazines and newspapers. By the end of the decade, the introduction of factory-made dry plates, fast shutters, and magnesium flares for night photography, as well as the development of an effective, mechanical means of reproducing photographs with text, revolutionized photography and ushered in the modern era of photojournalism.

"With the spread of photography has arisen a demand for some means by which its productions may be brought before the masses in a manner that shall give the most enjoyment and instruction to the largest number," wrote an editor of the *Magic Lantern* in 1874.[1] Photographs made and published during the Civil War, and those depicting the postwar rush to subdue and settle the West, demonstrated the feasibility of using photographs to describe the news. Even as early as 1853, few doubted that the public would respond favorably to illustrations in magazines, newspapers, and books. "It needs but the most casual reflection to convince any one, that every day teems with events which cannot be suitably presented except by pictures," announced Frank Leslie in the inaugural edition of the *New York Illustrated News*. "No descriptions of persons, or works of art, or scenes in nature, however admirably written," he continued, "can convey as vivid an impression as an engraving equally authentic."[2] Two decades later, the editors of the *New York Daily Graphic* were just as enthusiastic, especially about the prospect of using photographs as the basis for their illustrations. "We propose to illustrate daily occurrences in such a way that the life of our times shall become photographic; and the illustration of events will be as accurate and pleasing and elegant as any word painting in the text."[3]

The demand for pictures of news events encouraged photographers to make images

specifically for the picture press and led them to a kind of psychological ambivalence toward natural and man-made disasters. Events such as railroad wrecks and the fires that plagued American cities in the latter half of the nineteenth century were considered by some members of the photographic fraternity to be more than tragedy or disaster. Stereographs of city fires sold well, and the tabloids could always be counted on to run illustrations of the smokey ruins. For photographers who managed to escape the flames with equipment intact and uncharred, fires and other disasters were ideal photo opportunities.

Photographer Elerslie Wallace vividly recounted his experience photographing a railway accident in an article written for a trade publication late in the century. He noted that "the pictorial possibilities" of such events varied greatly, and he then described his own mostly failed attempts to make usable pictures of an "exceedingly picturesque heap of ruined railroad stock." Wallace advised those wishing to make pictures of calamities and catastrophes, "Keep cool, don't get over-excited, and work as deliberately as possible."[4]

James Wallace Black, former associate of John Adams Whipple in Boston, made a stunning series of views of the aftermath of the great Boston fire in November 1872. John P. Soule had done the same in Portland, Maine, when that city was devastated in the spring of 1866. Soule's series of stereographs included several views of the temporary tent city erected with the help of the military in the heart of the burnt district.

When Barnum's famous American Museum on lower Broadway burned to the ground on March 3, 1868, during a brutal cold spell, several photographers made pictures of the ice-covered ruins. "The cold was so intense that the water froze almost as soon as it left the hose[s] of the fire-engines," wrote Barnum. When at last the flames were extinguished, the unburned granite façade of the building and the signs

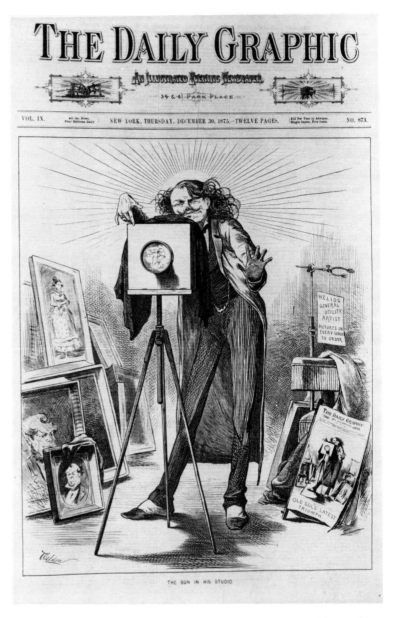

Cartoon of the working photographer, *New York Daily Graphic* cover, December 30, 1875. American Antiquarian Society.

Wood engravings of the aftermath of the great Boston fire of 1873, made from photographs by James Wallace Black. Published in the *New York Daily Graphic,* June 3, 1873. American Antiquarian Society.

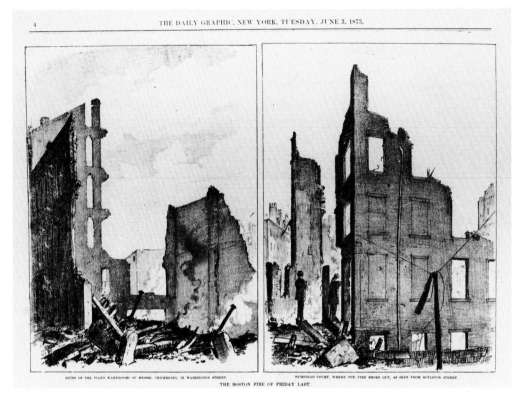

RUINS OF THE PIANO WAREROOMS OF MESSRS. CHICKERING, IN WASHINGTON STREET. BUMSTEAD COURT, WHERE THE FIRE BROKE OUT, AS SEEN FROM BOYLSTON STREET.

THE BOSTON FIRE OF FRIDAY LAST.

Stereograph by John Soule of tents for survivors of a fire in Portland, Maine, July 1866. Collection of David Kent, Miami, Florida.

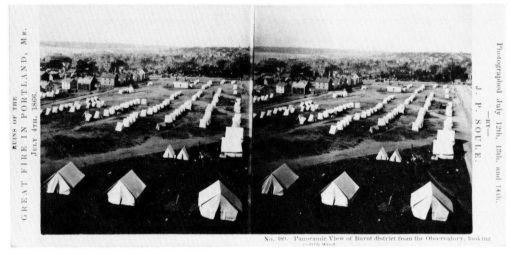

RUINS OF THE GREAT FIRE IN PORTLAND, ME. JULY 4TH, 1866.

Photographed July 12th, 13th, and 14th. —BY— J. P. SOULE.

No. 489. Panoramic View of Burnt district from the Observatory, looking south west.

and lampposts along the street "were covered in a gorgeous framework of transparent ice, which made it altogether one of the most picturesque scenes imaginable."[5] The illustrated newspapers and magazines loved it.

For some photographers the great nineteenth-century urban fires were more disaster than anything else. Several well-known cameramen were completely burned out, losing equipment, furnishings, and invaluable collections of negatives and prints. George N. Barnard and Alexander Hesler were wiped out in the Chicago fire of October 8, 9, and 10, 1871, for instance. Barnard managed to escape with a camera and a few glass plates. Although much later some said that Barnard made pictures of the fire while standing with an assistant waist-deep in the Chicago River, it was actually several days before he acquired enough additional equipment to begin producing photographic records of the ruins.[6] "Like many others, I was cleaned out by the great fire," Hesler wrote in a letter dated December 11, 1871. "I lost all my fine collection of daguerreotypes. . . . The scene of the fire seems sadder the more I see of it. It is like viewing Niagara, or any other great thing in nature or art; it grows on you the more you see of it, and each day seems more terrible than the last."[7]

The loss of equipment and files by fire was occasionally made worse by justifiable suspicions that the conflagration had begun in the photographer's own studio. In the days of the collodion process, photographic materials, especially ether and guncotton, were known to be fire hazards. Thus, when the cause of the Chicago fire was discovered to have been bovine, not photographic, professionals nationwide breathed a collective sigh of relief. J. C. Elrod, chairman of the Committee on Insurance of the National Photographic Association, reported with unconcealed glee in December 1871 that "it is now a fixed fact that the great Chicago fire did not originate in a photo-

graphic gallery."[8] Mrs. O'Leary's cow provided the profession with an unassailable alibi.

Whatever their cause, city fires were major news events. Robert Benecke, a photographer from St. Louis with a penchant for recording news events with his cameras, hurried to Chicago after the fire. He sent a set of stereos of the ruins to the *Philadelphia Photographer*. Edward Wilson, the editor, was impressed. "Nothing has brought the sad fate of Chicago to our mind so sensibly as these views," he wrote in the November 1871 issue.[9]

Photographers determined to produce pictures of news events for publication continued to press for an improved system of making their glass-plate negatives. The collodion (wet-plate) system had stimulated the production and mass distribution of paper prints, but it was slow and tricky to use. The preparation of collodion, which involved the use of highly flammable and noxious substances, was bad enough; but the necessity of pouring the collodion onto glass plates evenly and without spilling, then sensitizing the plate in darkness, and finally making and developing the image before the emulsion dried made photographers yearn for a less complicated process.

The first successful experiments with dry plates were made in the late 1850s, but it was not until 1864 that the photographic magazines began publishing detailed descriptions of the new processes. By and large, these early efforts still relied on collodion as the base for light-sensitive salts of silver; the difference was that the collodion was allowed to dry.[10] Collodion in its dry form, however, greatly diminished the sensitivity of the plates, and most photographers considered the resulting long exposure times a major obstacle. The search continued for a more practical process.

In September 1871, Robert Leach Maddox, an English physician, announced in the *British Journal of Photography* that he had developed an alternative to the collodion

dry plate. Maddox used gelatin instead of collodion, in part because he detested the heavy smell of ether that permeated the darkrooms of his photographer friends. He was delighted with the preliminary results, though he admitted that more work would have to be done before the process was perfected.[11] Maddox's article attracted the attention of the American photographic community, and there were immediate and concerted efforts to improve his product. Troubled by failing health, Maddox declined to continue his experiments but vowed not to patent his process, thus earning for himself the goodwill of American photographers.

Chicago photographer John Carbutt, well known for his photographs of the Union Pacific Railroad during Thomas Clark Durant's grand excursion to the one hundredth meridian, had begun experimenting with collodion dry plates as early as 1868. Carbutt, a native of Sheffield, England, emigrated to the United States in 1853 at the age of twenty-one. In the fall of 1870, he moved to Philadelphia, where he began working with various permutations of Maddox's process. In 1875, Carbutt began mass-producing dry plates, but while there was plenty of demand for such a product, his plates did not sell well. After only a year, Carbutt stopped advertising his new plates in the *Philadelphia Photographer*.[12] His early efforts were apparently spoiled by imperfections such as spotting and streaking in the emulsions of his plates as well as by their relative slowness.[13]

In 1879, Carbutt reintroduced his dry plates, this time under the name "Keystone Rapid Gelatin Plates." He had managed to increase their speed considerably while perfecting the coating of the plates. Success was immediate. Photographers in America, especially those whose work was not confined to the studio, had long awaited such a process and product. "I have just returned from a trip, one hundred miles west on the railroad and one hundred and twenty miles

south with team," wrote F. Jay Haynes on June 10, 1880. Of the twenty-four dry plates Haynes used on this excursion, only one had failed, and that was due to improper focus, not to any imperfection in the plate. "I am ever so much pleased with your plates," he wrote. "I considered this last trip a trial. My plate-box, covered with canvas, was, during a heavy rain-storm, entirely without protection, and standing in three inches of water. Hot weather and cold does not affect them."[14] Carbutt received similar glowing testimonials from William Henry Jackson and Alexander Hesler and used them in a series of advertisements run in the *Philadelphia Photographer* in 1880 and 1881.

Carbutt was not alone in the search for an alternative to wet-plate photography. Joshua Smith, a photographer in Chicago, introduced his process in December 1881, at a meeting of the Chicago Photographic Association, while in St. Louis, Gustave Cramer and Herman Norden began manufacturing "Extra Rapid Dry Plates."[15] And in 1877, twenty-three-year-old George Eastman, a seventh-grade dropout, gave up his position as a junior bookkeeper at the Rochester Savings Bank in Rochester, New York, in order to devote himself full time to experiments in photography. In January 1880, he perfected his own dry-plate process. A few months later, in April, he patented a method of applying gelatin bromide emulsions to glass plates. By the end of the year, Eastman had agreed to allow the Anthony brothers in New York to market his plates, virtually assuring their rapid and widespread distribution.[16] Eastman would not be recognized as the preeminent manufacturer of photographic goods until 1889, when he introduced the first Kodak miniature camera, but these first successful forays into dry-plate photography helped establish his reputation as a friend of the working photographer.

Whether produced by Carbutt, Smith, Cramer and Norden, or George Eastman, dry plates were a huge improvement over

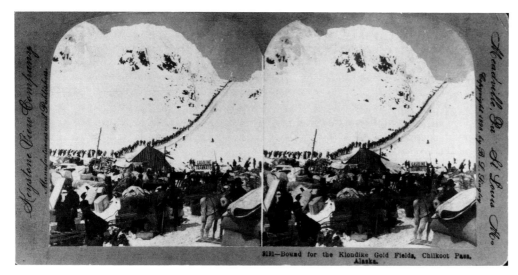

Stereographic view of miners hiking up Chilkoot Pass on the way to the Klondike goldfields in 1898. Author's collection.

the old wet-plate process. They were much more sensitive to light and thus required shorter exposures, and they were relatively impervious to changes of temperature and humidity. Most important, they came ready to use. Photographers no longer had to set up portable darkrooms where they laboriously coated and sensitized glass plates prior to each exposure. Dry plates simplified and standardized the practice of photography; after 1880, photographers no longer had to master complicated chemical formulas. "The dry plate caused a revolution in our business in many ways," reported George Gentile in a speech delivered to the annual convention of the Photographers' Association of America in 1884. Dry-plate photography led to a "rapid increase in the number of amateur photographers" and enabled the "smallest country photographers . . . to use exactly the same chemicals as the best operator[s] in our profession." [17]

"The time required to take a sunlit view . . . will be only a few seconds—one or even less is often sufficient," wrote photographer George Searle in 1882. "And with specially prepared instantaneous plates . . . the time may be so reduced that correct pictures may be taken of moving objects." [18] New York photographer George Rock-

wood described how the new plates changed portraiture.

People nowadays feel that their rooms are really a part of themselves, or that they are part of their rooms, which ever you prefer. So now, instead of coming to the photographer, the photographer goes to them. He takes with him a supply of instantaneous plates, poses his subject in his or her own particular armchair, and with good taste and judgment in the arrangement of the light and pose he is likely to secure a result far removed from the conventionalities of the "gallery" picture. [19]

At about the same time that Carbutt, Eastman, and the others were perfecting dry-plate photography, Eadweard Muybridge, whose images of Yosemite and the Modoc War had earned him an enviable international reputation, was involved in the construction of a camera with a shutter that could open and close faster than any then on the market. He did so, at least initially, to help settle a bet.

Leland Stanford, president of the Central Pacific and former governor of California, had made a twenty-five-thousand-dollar wager with a friend and colleague, Frederick MacCrellish, that his famous trotting horse, Occident, lifted all four feet off the ground at certain gaits. He wanted photo-

graphs to prove it. Muybridge was hired in 1872 and again in 1873 to make a series of "instantaneous" pictures of Stanford's trotter at the Sacramento racetrack. A story in the *San Francisco Examiner,* later reprinted in the *New York Daily Graphic,* described Muybridge's unique solution to the problem of stopping motion photographically.

A few days ago [Muybridge] announced to the owner of Occident that he believed he could take the picture. He procured all the stable sheets to be had . . . and with these made a reflecting back-ground. Over this Occident was trained to trot, and everything was then in readiness for the trial. The great difficulty was to transfix an impression while the horse was moving at the rate of thirty-eight feet to the second. . . . On the third day, the artist, having studied the matter thoroughly, contrived to have two boards slip past each other by touching a spring, and in so doing leave an eighth of an inch opening for the five-hundredth part of a second, as the horse passed, and . . . secured a negative that shows Occident in full motion—a perfect likeness of the horse.[20]

The pictures fully satisfied Stanford but merely piqued the interest of Muybridge. However, from 1874 to 1877 Muybridge was out of the country and unable to continue his experiments with instantaneous pictures. One of the more compelling reasons for his leaving America was that early in 1874 he murdered the seducer and lover of his young, pretty wife, Flora. Though he was acquitted four months later by a sympathetic state jury that believed he had done what any real man would have done, Muybridge did not return to California until 1877.[21]

Soon after his return, he began working again with Stanford's horses, this time at the latter's Palo Alto stock farm. He constructed an elaborate, whitewashed outdoor studio that included a row of twelve cameras, each fitted with a special Dallmeyer lens and a mechanical shutter that opened and closed in approximately one-

five hundredth of a second. Fast shutters and the use of highly sensitive glass plates enabled Muybridge to produce images in which motion, even that of galloping horses, was completely stopped.

On June 15, 1878, at Stanford's plush ranch, Muybridge demonstrated his technique before invited members of the press. Not surprisingly, the pictures he made that day of Stanford's horse, Abe Edgington, were an immediate sensation. *Scientific American* ran a wood engraving of Muybridge's galloping sequence on the cover of its October 19 edition; the article within was suitably laudatory. American photographic journals were especially enthusiastic. "Mr. Muybridge," wrote Edward Wilson in the *Philadelphia Photographer,* "you have caught more *motion* in your photographs than any previous camera ever dreamed of. They are truly wonderful, and we congratulate you."[22]

Muybridge's success was due in no small part to his practice of making images during the middle part of the day, when the light was brightest. While he was working to perfect his system of high-speed photography, others were wrestling with the difficulty of making photographic images when the level of light was insufficient: early and late in the day, at night, and in dimly lit interior spaces. The greater sensitivity to light of rapid-dry plates had gone a long way toward solving this problem. Instantaneous dry plates were used to make pictures in situations that would have stymied the efforts of the first photographers. However, photographers still searched for a reliable method of illuminating a scene with predictable and controllable artificial light sources.

William Henry Fox Talbot, inventor of the calotype, had experimented with artificial light in the form of electronic flash as early as 1852, though he directed his efforts principally at the use of flash to stop motion. He described his work in an article published in *Humphrey's Journal* in April

1852. In a darkened room of the Royal Institution, Talbot attached a small, rectangular piece of printed paper to a wheel capable of revolving at a high rate of speed. He set up a camera across the room, opened the shutter, then discharged a flash from a Leyden jar. When the plate was developed, the motion of the wheel was frozen, and even the smallest print on the paper was perfectly legible.

"From this experiment the conclusion is inevitable," Talbot wrote, "that it is in our power to obtain the pictures of all moving objects, no matter in how rapid motion they may be, provided we have the means of *sufficiently* illuminating them with a sudden electronic flash."[23] In America there was little progress in the use of controlled electronic flash until some three decades after Talbot's experiments at the Royal Institution. In 1882, Edward Anthony reported that "today the people have pleasant anticipations of having their pictures taken at any time in the 24 hours by electric light." He added that photographers ought to "use the new instantaneous gelatin dry plate process, which is peculiarly susceptible to the influence of electric light."[24] Anthony's report appears to have been based more on wishful thinking than anything else, for until well after the turn of the century, most photographers wishing to add light of their own to their subjects demonstrated a marked preference for the bright light provided by burning magnesium powder.

The American Magnesium Company of Boston, which advertised the sale of magnesium tapers "for photographic purposes" in 1866, wrote that its products were as "safe and convenient to use as a common lamp and give a light by which negatives may be taken as quickly, easily and satisfactorily as by the noontide sun." The variety of photographic opportunities available to those using artificial light was impressive. The company wrote that "pictures of [the] interior of caves, of mines, of machinery, of

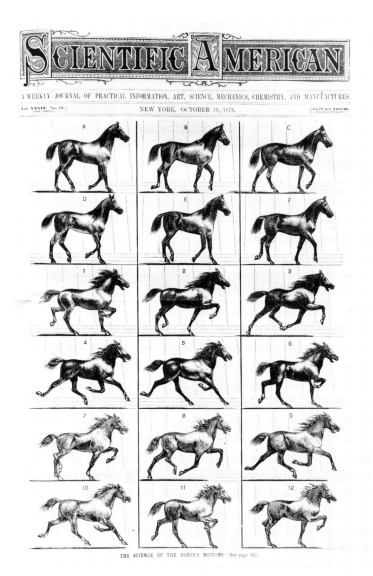

Cover illustration of October 1878 *Scientific American* made from stop-action photographs by Eadweard Muybridge. American Antiquarian Society.

the dead, of persons who prefer to be taken surrounded by all the comforts of their home . . . are taken without a moment's delay, whether by night or day, sunshine or cloud." [25] Amateur photographer Frances Stevens was equally upbeat. "Daylight is very uncertain and very deceptive," she wrote in 1892. But with "the flash-light, it is always 'so many grains of magnesium, so much light.'" [26]

It really was not as easy as that. Magnesium is extremely volatile, especially when used in conjunction with guncotton, and the small explosions that provided enough light to make pictures created dense clouds of smoke. If used improperly or carelessly, magnesium powder could start fires and seriously injure nearby persons. "My experiments were brought to an end by a flash powder accident," wrote Professor W. K. Burton in *Wilson's Photographic Magazine* in 1892. Although Burton was not badly injured, just deafened for several days, his assistant "had one of his thumbs blown off and was generally somewhat badly damaged." [27]

Notwithstanding the dangers of working with such materials, most photographers felt there was no real choice: Either they used magnesium or they returned with no pictures. Electric flash was neither as reliable nor as widely available as magnesium flares. For photographers working on assignment, the bother and danger of working with magnesium was a small price to pay to avoid the ignominy of returning empty-handed because the light was too poor to make pictures.

Charles Waldack, a photographer and co-author with Peter Neff of a popular handbook on collodion photography, used magnesium flares to produce pictures inside Mammoth Cave in central Kentucky in 1866. [28] A set of forty-four stereographs of the picturesque limestone caverns was published by the Anthony brothers shortly thereafter. Timothy O'Sullivan also went underground with his camera. In 1867 and 1868, while at work on Clarence King's fortieth parallel survey, O'Sullivan ventured into several of the mines along the Comstock Lode in Nevada. He made images of the fantastic underground formations of stalactites and stalagmites, and of miners at work. [29] And California photographer Carleton E. Watkins used magnesium in 1869 and 1870 to light several of the tunnels he photographed for Colis Huntington's Central Pacific Railroad. [30]

Throughout the 1870s and 1880s, photographers used magnesium, gradually perfecting its use. By 1891, one expert reported that most professional photographers employed magnesium flash powder or flares and that various devices had been developed to "overcome the hard shadows that were to be found in the first pictures made by its use." [31] It was discovered, for instance, that dividing the magnesium into several small charges that could be set off

Detail of a stereographic view made by S. V. Albee of the aftermath of the railroad strike in Pittsburgh, Pennsylvania, in July 1877. Carnegie Library, Pittsburgh.

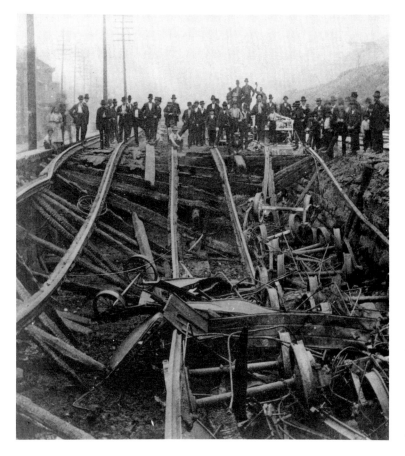

simultaneously was far safer than setting off one large flash.

Factory-made dry plates, fast shutters, and the use of artificial light sources made photography suddenly easier, less mysterious and arcane; and photographers were better able to depict life outside the studio. The introduction of small, "detective" cameras after 1880 further stimulated the growth of candid "naturalistic" photography. Cameras shaped like anything but cameras—like briefcases, for instance, or handbags—allowed photographers to make images surreptitiously or at least without the old insistence upon a formal pose.[32]

Improvements in camera and film technology also made it possible for photographers to illustrate a broader range of news stories and to do so in greater depth and detail. During the railroad riots throughout the Northeast in July 1877, for instance, S. V. Albee of Pittsburgh produced a series consisting of forty-two stereographs that depicted clashes between railroad workers and the local police in Pittsburgh as well as the utter destruction of the railroad yards. At the same time, in Baltimore, photographer David Bendann made at least one image showing the Maryland National Guard firing into a crowd of strikers. The August 11, 1877, issue of *Harper's Weekly* ran a wood engraving made from Bendann's photograph. This was the dark side of decades of unhindered industrial and corporate expansion. In the coming years, photographs would offer convincing evidence of the necessity of enacting social and labor reforms.

Series of photographs made during the 1870s that depict riots or conflagrations or mine workers demonstrate the extraordinary progress made in photographic technology since Daguerre's time. In 1844, the Langenheim brothers in Philadelphia had managed to produce a single image shortly after the military put an end to the bloody riots between Irish Catholic immigrants

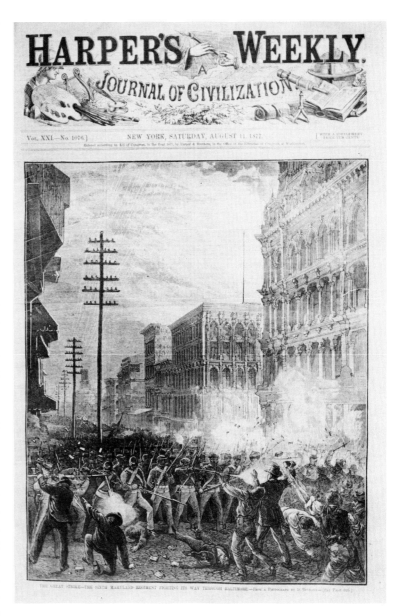

Wood engraving of U.S. troops firing at striking railroad workers in Baltimore, Maryland, from a photograph by David Bendann. Published in *Harper's Weekly,* August 11, 1877. Otto Richter Library, University of Miami.

and nativist Protestants; and in 1853, George N. Barnard managed to make a few daguerreian views of a fire that destroyed a good part of Oswego, New York. By the 1870s, new processes and equipment made such limited coverage of major news events obsolete. Photographers discovered that they could go nearly anywhere with their cameras and make pictures that had instant viewer appeal.

Even as late as 1880, however, photographers and publishers were still seeking an effective, inexpensive means of reproducing photographs, of transferring all the delicate halftones in photographs to the printed page. Many were dissatisfied with the old system of making engraved copies or woodcuts of photographs, contending with some justification that such copies were time consuming and expensive to produce and often resulted in patently incorrect and distorted pictures. But that situation was about to change as well.

Charles August Theodore Ehrmann, who in 1853 made important contributions to Whipple's crystalotype process, rightly believed that the quest for a mechanical process of reproducing photographs was a natural outgrowth of the desire to mass-produce images. "In the earlier days of photography, the desire to multiply the negative . . . soon became manifest everywhere," he said in a speech delivered to the Photographic Section of the American Institute on May 6, 1884. Eventually, however, "the tedious process of printing silver proofs led to the desire for cheaper and easier methods of reproduction."[33] The quest for such a process, according to one contemporary expert on printing and engraving, was as old as photography itself.

The nearer photography approaches perfection the more evident it becomes that the real aim to which its applications tend is that of printing by the ordinary methods. If we go back to the origin of photography, we recognize that such was the solution sought from the very first. . . .

The attempts made in this direction have been abandoned for a long time, and it is only within the last few years that they have been resumed; but they have made, in a very short time, such rapid progress that the moment is not far distant when photographic pictures will be produced upon the largest scale, under conditions suitable for being printed at the press.[34]

There were indeed several methods of transferring photographs to the printed page introduced prior to 1880. Although they were generally capable of yielding luminous and beautifully detailed prints, most were expensive, suited only to limited editions, and impossible to print together with words. Alphonse Poitevin, a French chemist and photographer, secured the first patent for a mechanical photolithographic process in 1855. He had recognized the capacity of gelatin mixed with bichromate of potassium to be altered (hardened) by light, and discovered that the greasy ink used in lithography adhered only to hardened, insoluble bichromated gelatin.[35]

Poitevin's process, known now as collotype printing, was the basis for several photomechanical printing processes developed in the 1860s and 1870s. The best known of these in America was the Woodburytype, patented in 1864 and named after its inventor, Walter B. Woodbury, an English photographer and inventor who died from an overdose of laudanum in 1885. Woodbury's process, which involved the creation of a lead-plate cast of a hardened gelatin relief mold, was considered by many to be the best of the collotype processes. Photographic historian Beaumont Newhall contends that it is still "the most permanent and one of the most beautiful of all the ways to reproduce photographs."[36]

From the standpoint of the press, however, collotype processes such as the Woodburytype, the Albertype (invented by Bavarian court photographer Josef Albert in 1868), and the heliotype (a modification of the Albertype patented in 1870 by Ernest

Edwards, an English photographer), were flawed in part by their inability to be reproduced with words in the same printing operation.[37] They were also extremely sensitive to changes in temperature and humidity, and thus they required special care and handling. While suited to the production of illustrations for use in art books or for exhibition purposes, collotypes were of little use to the periodical press, where words and pictures formed a natural alliance. Printing processes incapable of easily and cheaply marrying the two had little journalistic impact.

At the *New York Daily Graphic,* an illustrated newspaper established on March 4, 1873, work was underway to perfect a method of mechanically transferring photographs with text to the printed page. In June 1873, Edward L. Wilson of the *Philadelphia Photographer* informed his readers of the existence of the paper, adding that while he could "not give credit for much good quality" in the illustrations, there was "hope for improvement in that direction."[38]

An article in *Appleton's Journal* mirrored Wilson's tentative approval. "A daily illustrated newspaper is the latest novelty in journalism," wrote the editors. "The illustrations in the *Daily Graphic* . . . are coarse in execution, and often very poor in printing; but these defects can largely be remedied."[39] Advances in the printing of illustrations would indeed be achieved at the *Daily Graphic,* due in no small part to the tireless work of one man.

Stephen Henry Horgan, originally hired as a staff photographer in 1874, was placed in charge of graphic operations in 1877. He began experimenting with a method of photoengraving called the halftone process. It involved the use of a cross-lined screen to break the continuous tones of a photograph into series of tiny, imperceptible dots. Horgan's halftone process would revolutionize the printing industry.

In its seventh anniversary edition, published on March 4, 1880, the *Daily Graphic* printed a halftone as part of a display of illustrations showing the "fourteen varia-

Picture page showing various methods of illustration used in the *New York Daily Graphic,* March 4, 1880. American Antiquarian Society.

tions of the graphic process" used at the paper. This was an epochal event, though the size and placement of the halftone suggests otherwise. Captioned "A Scene in Shantytown, New York," the picture was uncredited (the photographer was Henry J. Newton, and the original print was an Albertype) and placed discreetly on the lower left-hand corner of the two-page spread. The picture depicts several ramshackle structures perched atop and amid some large boulders. In the right background is the beginning of what appears to be a row of brick tenement houses. Since Horgan used a halftone screen containing only fine vertical lines, this and the other halftone prints in the paper consisted, in this case, of lines instead of tiny dots, giving them the appearance of engravings. The editors admitted that this first effort to reproduce a photograph mechanically through the use of an intermediary screen was not wholly successful, but they were certain that the halftone would soon replace other, less mechanical processes. "We have dealt heretofore with pictures made from drawings or engravings. Here we have one direct from nature. . . . There has been no redrawing of the picture," the editors wrote. Although the process was not fully developed, the editors and Horgan were confident that further experiments would "result in success, and that pictures [would] eventually be regularly printed . . . direct from photographs without the intervention of drawing." [40]

In spite of Horgan's efforts to popularize the use of halftone plates, it would take almost two decades for the new process to be assimilated by the periodical press. Initially, several problems had to be overcome, not the least of which was the reluctance of some publishers to accept the notion that a mechanical process could successfully compete with the painstaking work of artists and engravers. In 1893, Horgan was fired from his position at James Gordon Bennett's *New York Herald* when he insisted that

halftone plates could be used on the *Herald's* high-speed presses. Bennett and his employees in the printing department thought Horgan incompetent for suggesting that halftone plates could be used on the curved surfaces of the *Herald's* presses. [41] In addition, there was considerable uncertainty concerning certain crucial details of the process. Pressmen wondered, for instance, exactly how to make the screens that were used to convert photographs into intricate patterns of dots and how much ink to use on the halftone plates. Finally, since there was a variety of competing methods of producing halftones (Horgan's was not the only process), publishers and editors were understandably reluctant to invest in a system that might soon be made obsolete by one that was more effective or less expensive. [42] In 1878, for instance, Frederick Eugene Ives, director of the photographic laboratories at Cornell University, had invented a halftone process that some believed would eventually take over the market. Though complicated, Ives's method produced intricately detailed printing blocks in stereotype that some thought were far superior to Horgan's mechanically engraved plates. [43]

Though the halftone was not immediately adopted, Horgan showed the way. "It may be noticed that the newspapers of the whole country are endeavoring to use illustrations," he wrote in 1886. "This demand is in the form of a revolution, and is bound to succeed." Actually, the revolution had occurred in 1880, when the first photograph was published in halftone by the *New York Daily Graphic*. It was only a matter of time before halftones would replace the work of engravers and draftsmen, for the press was more concerned with verisimilitude than creative license. John Fortune Nott, author of *Wild Animals Photographed and Described,* a tame but abundantly illustrated examination of animals in zoos, wrote in 1891, "It must be patent to those who give the matter any attention that the

A SCENE IN SHANTYTOWN, NEW YORK.
REPRODUCTION DIRECT FROM NATURE.

First halftone reproduction published in the *New York Daily Graphic* on March 4, 1880. The original photograph was made by Henry J. Newton and is captioned "A Scene in Shantytown." American Antiquarian Society.

Waterspout in Vineyard
Sound, near Oak Bluffs
on Martha's Vineyard,
Massachusetts, 1896.
Wisconsin Historical
Society.

public demand is for truth rather than for work which only shows this or that artist's treatment of the various scenes, highly artistic though they may be."[44]

By 1880 the pioneering days in American photography were ended. Photographic plates were now being mass-produced, and they were much more sensitive to light. Smaller and lighter cameras were being manufactured at the same time that fast shutters made it possible to freeze motion completely. Flash powder enabled photographers to make pictures when there was no light at all. And new methods of mechanically reproducing photographs on the printed page foretold the end of wood engravings. No one doubted anymore that photographs could be used to describe the world, to depict current events. The photograph had become a partner of the printed word.

Improvements in halftone technology during the 1880s and early 1890s dispelled whatever misgivings publishers had about photomechanical printing. "In no other country are pictures and illustrations so popular or so important a feature of everyday life as in America," wrote Edward Wilson at the turn of the century. "The daily and weekly papers, the periodicals, and printed matter of every sort with which we are literally deluged at every turn, depend largely for their interest upon illustration." And it was the photographer, according to Wilson, who bore the brunt of the "public demand for illustrations."[45]

However cumbersome their equipment or arcane their methods, many American photographers from 1839 to 1880 were committed to using photographs as reportage. They were not full-time photojournalists, perhaps, but when given the opportunity, photographers in the nineteenth century made and sold news pictures. "The camera for some years has been an adjunct to the journalist," wrote Wilson in 1901.[46] Indeed it had. The work of Plumbe, Barnard, Brady, the Langenheims in Philadelphia, Southworth and Hawes in Boston, and many others showed that even daguerreotypists could make pictures with news value. During the collodion, or wet-plate, era, news-minded photographers often made prints for reproduction and mass-produced others for sale to the public in the form of stereographs, cartes de visite, and cabinet photographs. Photographic coverage of the Civil War and of the postwar westward migration were further proof of the legitimate journalistic uses of photographs.

Professional news photography is a twentieth-century product with origins in the early history of the medium. Photojournalism did not appear in America as if by magic when Henry Luce started *Life* magazine in 1937; nor is it merely a by-product of Horgan's halftone process. Press photography evolved in America. The photojournalist of today is impelled by the same desire to make news pictures for public consumption as his or her nineteenth-century counterpart. What separates the two is neither impulse nor instinct but technology.

GLOSSARY
NOTES
SELECTED BIBLIOGRAPHY
INDEX

GLOSSARY

Albumen print. The most common form of paper print used in the nineteenth century. Invented by French photographer Louis Désiré Blanquart-Evrard in 1850. Made by coating ordinary paper with an emulsion composed of light-sensitive salts of silver suspended in albumen.

Ambrotype. A one-of-a-kind photographic image on glass. Made by backing a slighty underexposed glass plate negative produced by the collodion, or wet-plate, process, with a dark material such as black velvet or colored glass.

Calotype. The photographic process invented by William Henry Fox Talbot and made public in 1839. Involved the use of a paper negative to make paper prints. The chief competitor of the daguerreotype, though little used outside of England. Also called the talbotype.

Camera obscura. A light-tight wooden box with a tiny hole (often fitted with a lens) on one side that allowed light to enter. Images formed on a ground-glass plate placed opposite the lens. Used by artists as drawing aids and later by photographers as the first cameras.

Carte de visite. A paper print mounted on thin cardboard measuring approximately 2½ by 3¾ inches. Introduced in America in 1859, cartes de visite soon became popular collectors' items and a major source of revenue for photographers.

Collodion. A thin, viscous solution made by dissolving guncotton in alcohol and ether. Used while moist as a base for light-sensitive salts of silver, and thus called the wet-plate process.

Daguerreotype. The process invented by Louis-Jacques-Mandé Daguerre with help from Joseph-Nicéphore Niepce and made public in 1839. Thin sheets of copper were electroplated with silver, buffed and polished, and then made light-sensitive by exposure to bromine, chlorine, and/or iodine fumes. After being exposed, the image was developed over a solution of heated mercury, fixed in hyposulfite of soda (sodium thiosulfite), washed, dried, and sometimes hand colored.

Dry plates. Introduced by several practitioners in the 1870s and designed to replace the collodion, or wet-plate, process of making negatives.

In the dry-plate process, gelatin replaced collodion on glass plates as the base for the light-sensitive salts of silver.

Engraving. The intaglio process of preparing a metal or wood surface for printing by removing material in lines or dots. Ink is spread into the resulting indentations or furrows and the plate then used in a common press.

Fixer. The solution used by photographers to remove any unexposed, light-sensitive particles from the film or paper after the original exposure has been developed, thus making the image permanent. English chemist Sir John Herschel was the first to suggest the use of sodium thiosulfite in 1839.

Gutta-percha. A rubbery substance obtained from tropical trees and used in the manufacture of cases for daguerreotypes, ambroypes, and tintypes. Most cases casually identified as being made of gutta-percha, however, are actually plastic (the so-called Union cases).

Halftone. The process introduced by Frederick Ives and Stephen Horgan in the late 1870s that mechanically transfers photographs with text to the printed page. The original image is rephotographed through a screen that breaks the continuous lines of the image into a matrix of tiny dots.

Heliotype. The first photographic process, invented by Niepce in 1826 and involving the use of light-sensitive bitumen on a pewter plate. Later, the name given to one of the collotype (gelatin-relief) processes.

Melainotype. *See* Tintype.

Shutter. A mechanical device in modern cameras that opens and closes, allowing light to enter the camera for a specified amount of time. In the early days of photography, cameras had no shutters. The photographer determined exposure times by removing and then replacing the lens cap.

Stereograph. A photographic image consisting of two nearly identical views, made most often by a single camera with lenses placed approximately two and one-half inches apart. Introduced in England by Sir David Brewster in the late 1840s, based upon experiments by Sir Charles Wheatstone a decade earlier. When viewed in a device called a stereoscope, these twin views provided the illusion of depth.

Tintype. The process invented and patented by Hamilton Smith in 1855 and involving the use of a collodion emulsion on black, japanned tin plates. Like the ambrotype, a one-of-a-kind process, though one that remained popular for more than half a century because of its durability, ease of production, and comparatively low cost. Also called melainotype and ferrotype.

Wet-plate process. *See* Collodion.

Woodburytype. A photomechanical printing process developed in 1866 in England by Walter Woodbury. Like other collotype printing processes, the Woodburytype relied on the light-sensitive properties of gelatin mixed with potassium bichromate.

NOTES

Introduction

1. Wilson Hicks, *Words and Pictures: An Introduction to Photojournalism* (New York: Harper and Brothers Publishers, 1952).

2. *The Journals of Ralph Waldo Emerson, 1820–1872,* ed. Edward Waldo Emerson and Waldo Emerson Forbes (Cambridge, Mass.: Riverside Press, 1911), 6:87.

3. William Marder and Estelle Marder, *Anthony: The Man, the Company, the Cameras: An American Photographic Pioneer* (Plantation, Fla.: Pine Ridge Publishing Co., 1982), 15.

4. "Picture Pausings, No. II. Daguerreotypes," *Christian Watchman* 27, no. 20 (May 15, 1846): 77.

5. M. A. Root, *The Camera and the Pencil* (Philadelphia: J. B. Lippincott, 1864), 31.

6. This should not be confused with the stereopticon, or magic lantern, another popular nineteenth-century viewing device and precursor to the modern slide projector. See Edwin Emerson, "On the Perception of Relief," *Humphrey's Journal* 14, no. 16 (December 15, 1862): 197.

7. Oliver Wendell Holmes, "The Stereoscope and the Stereograph," *Atlantic Monthly* 3 (June 1859): 742, 748.

8. Clarence S. Jackson, *Picture Maker of the Old West; William H. Jackson* (New York: Charles Scribner's Sons, 1947): v.

9. Susan Sontag, *On Photography* (New York: Farrar, Strauss, Giroux, 1978): 3, 5.

10. See Andy Grundberg, "Ask It No Questions: The Camera Can Lie," *New York Times,* August 12, 1990, sec. 2, pp. 1, 29.

Chapter One

1. In this study I have elected to omit the acute accent over the first *e* in Niepce. I was persuaded to do so by Georges Potonniée, who explained that over time the Niepce family adopted this mode of writing the name. Georges Potonniée, *The History of the Discovery of Photography,* trans. Edward Epstean (New York: Tennant and Ward, 1936; New York: Arno Press, 1973), 75. See also René Colson, *Mémoires originaux des créaturs de la photographie* (Paris: Georges Carré et C. Naud, 1898).

2. Gaston Tissandier, *A History and Handbook of Photography,* 2d ed. (London: Sampson, Low, Marston, Searle, and Rivington, 1878), p. vii.

3. Helmut Gernsheim and Alison Gernsheim, *The History of Photography* (London: Oxford University Press, 1955), 143–50.

4. Mrs. D. T. Davis, "The Daguerreotype in America," *McClure's Magazine* 8, no. 1 (November 1896): 6–7.

5. Cited in Gernsheim and Gernsheim, *History of Photography,* 125.

6. Nathan G. Burgess, *The Photograph Manual: A Practical Treatise, Containing the Carte de Visite Process, and the Method of Taking Steroscopic Pictures* (New York: D. Appleton and Co., 1862), 25.

7. Robert Taft, *Photography and the American Scene* (New York: Dover Publications, 1964), 109–12. See also the obituary of William Langenheim, *Philadelphia Photographer* 11, no. 126 (June 1874): 190–91, and Delores Kilgo, "The Robyn Collection of Langenheim Calotypes: An Unexplored Chapter in the History of American Photography," *Gateway Heritage* 6 (1985): 28–37.

8. "Fox Talbot's Patents," *Humphrey's Journal* 4, no. 1 (April 15, 1852): 13.

9. Henry H. Snelling, *The History and Practice of the Art of Photography; or, the Production of Pictures through the Agency of Light* (New York: G. P. Putnam, 1849; facsimile ed., Introduction by Beaumont Newhall, Hastings-on-Hudson, N.Y.: Morgan and Morgan, 1970), 27.

10. Ben Maddow, "Rembrandt Perfected," in John Wood, ed., *The Daguerreotype* (Iowa City: University of Iowa Press, 1989), 36.

11. Rev. W. P. Strickland, "The Fine Arts—Photography," *Ladies' Repository* 19 (August 1859): 477.

12. John Werge, *The Evolution of Photography* (London: Piper and Carter, 1890), 201–2.

13. "On the Application of Science to the Fine and Useful Arts," *Daguerreian Journal* 1, no. 10 (April 1, 1851): 296; *Photographic Art-Journal* 3, (May 1852), cited by Charles Canfield, "American Bibliography of Photography," *Photographic Times and American Photographer* 18 (February 10, 1888): 65.

14. "The Daguerreotype Explained," *Journal of the Franklin Institute* 24, no. 3 (September 1839): 303–11. A second, more detailed version was published in the November issue.

15. Davis, "Daguerreotype in America," 10.

16. Robert V. Remini, *Andrew Jackson* (New York: Harper and Row, 1969), 181–88.

17. The A. Wisong Company in Baltimore advertised half- and quarter-plate Voigtländer cameras for sixty-five and thirty-eight dollars respectively in the late 1840s. Silvered copper plates sold for a dollar each in the whole plate size, and leather cases cost from $1.50 to $1.75. George Smith Cook, Account book, 1845–1850, Papers of George Smith Cook, Manuscript Division, Library of Congress, Washington, D.C.

18. Albert Sands Southworth, "Early History of Photography in the United States," *British Journal of Photography* 18 (December 1871): 582.

19. *Washington* (D.C.) *Daily National Intelligencer,* June 23, 1843, 3.

20. Nathaniel Hawthorne, *The House of the Seven Gables: A Romance* (New York: New American Library, 1961), 156–57.

21. Davis, "The Daguerreotype in America," 13.

22. "Photography in the United States," *New York Daily Tribune,* April 30, 1853, 6.

23. Beaumont Newhall, *Photography and the Book* (Boston: Trustees of the Library of the City of Boston, 1983), 26.

24. *Cosmopolitan Art Journal,* supplement to vol. 4, cited by Frank Luther Mott, *A History of American Magazines* (Cambridge: Harvard University Press, 1938), vol. 2, *1850–1865,* 191.

25. Tissandier, *History and Handbook of Photography,* 179–80.

26. [*Hartford*] *Connecticut Courant,* February 1849; cited by Wendy Wickes Reaves, "Portraits for Every Parlor," in Wendy Wickes Reaves, ed., *American Portrait Prints* (Charlottesville: University Press of Virginia, 1984), 84.

27. *Daguerreian Journal* 1, no. 2 (November 15, 1850): 63.

28. Newhall, *Photography and the Book,* 26.

29. Edward W. Earle, "The Stereograph in America: Pictorial Antecedents and Cultural Perspectives," in Edward W. Earle, ed., *Points of View: The Stereograph in America—A Cultural History* (Rochester, N.Y.: Visual Studies Workshop Press, 1979), 12.

30. Edgar Allan Poe, "The Daguerreotype," *Alexander's Weekly Messenger* (January 15, 1840), 2.

31. J. Fortune Nott, "Photography and Illustrated Journalism," *Wilson's Photographic Magazine* 28, no. 395 (June 6, 1891): 321.

32. Brady Ledger, 1879, International Mu-

seum of Photography at George Eastman House, Rochester, N.Y.

33. "Cultivation of Disrespect for the Daguerreotype," *Daguerreian Journal* 3, no. 2 (December 1, 1851): 52.

34. Root, *Camera and the Pencil*, 366.

35. *Daguerreian Journal* 1, no. 7 (February 15, 1851): 211; 1, no. 10 (April 1, 1851): 306.

36. "Our Illustrations: Victor Piard," *Photographic and Fine Art Journal* (December 1857): 357; see also Beaumont Newhall, *The Daguerreotype in America* (New York: Graphic Society, 1961), 80. All but a single daguerreotype of John Quincy Adams were destroyed in a fire in 1852.

37. "Political Portraits with Pen and Pencil," *United States Magazine and Democratic Review* 11, no. 53 (November 1842): 502–7.

38. *Photographic Art-Journal* 1, no. 1 (January 1851).

39. T. B. Thorpe, "Webster, Clay, Calhoun, and Jackson: How They Sat for Their Daguerreotypes," *Harper's New Monthly Magazine* 38 (May 1869): 788.

40. T. S. Arthur, "The Daguerreotypist," *Godey's Lady's Book* (May 1849): 352.

41. Bonnie G. Wilson, "Working the Light," *Minnesota History* 52, no. 2 (Summer 1990): 45.

42. Cited by Remini, *Andrew Jackson*, 187.

43. T. B. Thorpe, "Webster, Clay, Calhoun, and Jackson," 789.

44. "The Brothers Meade and the Daguerreian Art," *Photographic Art-Journal* 3, no. 5 (May 1852): 294.

45. *New York Morning News*, February 5, 1846, 2.

46. *New York Morning News*, February 21, 1846, 2.

47. John C. Plumbe, *Sketches of Iowa and Wisconsin* (St. Louis: Chambers, Harris, and Knapp, 1839; Iowa City: State Historical Society of Iowa, 1948).

48. Robert Taft, "John Plumbe, America's First Nationally Known Photographer," *American Photography* 30, no. 1 (January 1936): 1–12.

49. *United States Journal*, January 29, 1846, p. 2, cited by Alan Fern and Milton Kaplan in "John Plumbe, Jr., and the First Architectural Photographs of the Nation's Capital," in Renata V. Shaw, ed. *A Century of Photographs, 1846–1946, Selected from the Collections of the Library of Congress,* (Washington, D.C.: Library of Congress, 1980), 5.

50. Cited in Ruel Pardee Tolman, "Plumbeotype," *Antiques* 8 (July 1925): 27.

51. Ibid., 27–28.

52. Taft, "John Plumbe," 10. See also Susan E. Cohen, "John Plumbe, 1809–1857," Information Files, International Museum of Photography at George Eastman House. Many of Plumbe's images as well as his equipment and galleries were bought by his colleagues in the photography business. For example, Solomon Carvalho, who began his career in Charlestown, South Carolina, moved into Plumbe's Baltimore "depot" in 1849.

53. C. Edwards Lester, "M. B. Brady and the Photographic Art," *Photographic Art-Journal* 1, no. 1 (January 1850): 36–40.

54. William F. Stapp, "Daguerreotypes on Stone: The Life and Work of Francis D'Avignon," in Reaves, ed., *American Portrait Prints,* 200.

55. *London Illustrated News,* February 22, 1851, pp. 168, 203.

56. See Brady's portrait of Henry Clay, *London Ilustrated News,* July 17, 1852, 36; and of John C. Calhoun, April 20, 1853, 269.

57. *Frank Leslie's Illustrated Newspaper* 1, no. 14 (March 15, 1856): 214.

58. Ibid.

59. Carl Bode, "Introduction: Barnum Uncloaked," in P. T. Barnum, *Struggles and Triumphs* (New York: Penguin American Library, 1981), 15.

60. Irving Wallace, *The Fabulous Showman: The Life and Times of P. T. Barnum* (New York: Alfred A. Knopf, 1959), 139.

61. [George Alfred Townsend], "Still Taking Pictures: Brady, the Grand Old Man of American Photography," *New York World,* April 12, 1891, 26.

62. Joel Benton, *Life of Hon. Phineas T. Barnum* (Philadelphia: Edgewood Publishing Company, 1891), 213–15.

63. *Daguerreian Journal* 1, no. 2 (November 15, 1850): 51.

64. "Our Daguerreotypes," *Daguerreian Journal* 2, no. 7 (August 15, 1851): 211. Richards was not the only photographer to be singled out in Samuel Humphrey's magazine. In April 1851, the St. Louis daguerreotypist John H. Fitzgibbon "caged three fine counterfeits of the Swedish Nightingale, and suspended them on the walls of his extensive establishment, where they

served as food in satisfying the gazing public." *Daguerreian Journal* 1, no. 10 (April 1, 1851): 306.

65. *Daguerreian Journal* 2, no. 11 (October 15, 1851): 351.

66. [Townsend], "Still Taking Pictures: Brady," 26.

67. H. J. Rogers, *Twenty-three Years under a Skylight* (Hartford, Conn.: American Publishing Co., 1873), 42–43.

68. *Memoirs of John Quincy Adams,* ed. Charles Francis Adams (Philadelphia: J. B. Lippincott, 1876), 2:401; "The Portraits of Washington Irving," *Crayon* 7 (February 1860): 55–56; Emerson, "On the Perception of Relief," 111; Harold Francis Pfister, *Facing the Light: Historic American Portrait Daguerreotypes* (Washington, D.C.: Smithsonian Institution Press, 1978), 33–39; [George G. Rockwood], "Is Photography an Art?" *Anthony's Photographic Bulletin* 15, (June 1884): 287.

69. Rogers, *Twenty-three Years under a Skylight,* 78.

70. *Daguerreian Journal* 1, no. 4 (January 1, 1851): 117.

71. Beatrice Farwell, "Introduction," in Farwell, ed., *The Cult of Images: Baudelaire and the Nineteenth-Century Media Explosion* (Santa Barbara: University of California and Santa Barbara Art Museum, 1977), 8.

72. See, for example: *Photographic Art-Journal* 3, no. 2 (February 1852): 127, and *Humphrey's Journal* 4, no. 11 (September 15, 1852): 169, on photographic chemistry, and "Improvements in the Daguerreotype," *Burton's Gentlemen's Magazine and American Monthly Review* 6, no. 4 (May 1840): 246.

73. "The Chemical Power of the Sunbeam," *Ladies' Repository* 15, (April 1855): 237.

74. "Process of Daguerreotyping," *Dwight's American Magazine* 3, no. 3 (January 16, 1847): 61.

75. Horace Greeley, *Glances at Europe,* 3d ed. (New York: Dewitt and Davenport, 1852), 26.

76. Ingenious items for use by photographers were manufactured in the extensive factory owned by the Lewis brothers in Daguerreville, New York (originally named New Windsor), a small town about one mile south of Newburgh on the west bank of the Hudson River. Among other things, the Lewises made Jenny Lind head supporters and tables. *Daguerreian Journal* 1, no. 9 (March 15, 1851): 20.

77. James F. Ryder, *Voigtländer and I in Pursuit of Shadow Catching* (Cleveland: Cleveland Printing and Publishing Company, 1902), 19.

78. A. B. Fenton, "The Itinerant Artist," *Daguerreian Journal* 3, no. 3 (December 15, 1851): 82.

79. Don D. Nibbelink, "The Story of Edward Anthony," *PSA [Photographic Society of America] Journal* 8 (Summer 1942): 269–74.

80. *Anthony's Photographic Bulletin* 14 (October 1883): 335. See also U.S. Department of State, *Report of the Commissioners Appointed by the President of the United States for the Purpose of Exploring and Surveying the Boundary Line between the States of Maine and New Hampshire and the British Provinces,* January 27, 1843.

81. Solomon N. Carvalho, *Incidents of Travel and Adventure in the Far West* (New York: Derby and Jackson, 1857), 17, 26.

82. Charles Preuss, *Exploring with Frémont: The Private Diaries of Charles Preuss, Cartographer for John C. Frémont on His First, Second, and Fourth Expeditions to the Far West,* trans. and ed., Erwin G. Gudde and Elisabeth K. Gudde (Norman: University of Oklahoma Press, 1958), 35.

83. "Solomon Nunes Carvalho, Photographer," in *Solomon Nunes Carvalho: Painter, Photographer, and Prophet in Nineteenth-Century America* (Baltimore: Jewish Historical Society of Maryland, 1989), 28–29.

84. Carvalho, *Incidents of Travel and Adventure,* 20–21.

85. Jessie Benton Frémont, "Some Account of the Plates," in John Charles Frémont, *Memoirs of My Life* (Chicago: Belford, Clark and Co., 1887), 1:xv.

86. Ibid., xv–xvi.

87. Francis L. Hawks, *Narrative of the Expedition of the Exploration of an American Squadron to the China Seas and Japan performed in the Years 1852, 1853, and 1854, under the Command of Commodore M. C. Perry, United States Navy* (New York: D. Appleton, 1856), 99.

88. Joe D. Thomas, "Photographic Archives," *Journal of the Society of American Archivists* (October 1958): 420.

89. George C. Groce and David H. Wallace, *The New-York Historical Society's Dictionary of*

Artists in America, 1564–1860 (New Haven: Yale University Press, 1957), 85.

90. Ryder, *Voightländer and I,* 26–27.

91. Edward Vischer, "A Trip to the Mining Regions in the Spring of 1859," *Quarterly of the California Historical Society* 11, no. 3 (September 1932): 229.

92. "Daguerreotype Panoramic Views in California," *Daguerreian Journal* 2, no. 12 (November 1, 1851): 371.

93. "Panorama of San Francisco and the Gold Diggings," *Daguerreian Journal* 2, no. 4 (July 1, 1851): 115.

94. "Fair of the American Institute," *Daguerreian Journal* 2, no. 11 (October 15, 1851): 342.

95. Caption supplied by Kenneth Finkel, curator of Prints and Photographs, Library Company of Philadelphia.

96. William F. Robinson, *A Certain Slant of Light: The First Hundred Years of New England Photography* (Boston: New York Graphic Society, 1980), 61. See also Craig T. Norback and Melvin Gray, eds., *The World's Great News Photos, 1840–1980* (New York: Crown Publishers, 1980), 6.

97. *Photographic and Fine Art Journal* 8 (January 1854): 9–10.

98. "Terrible Conflagration: A Sad Day for Oswego," Syracuse *Daily Standard,* July 7, 1853.

99. "The Great Fire at Oswego," *New York Times,* July 9, 1853, 3.

100. Keith F. Davis, *George N. Barnard, Photographer of Sherman's Campaign* (Kansas City: Hallmark Cards, 1990), 29.

Chapter Two

1. Joseph-Nicéphore Niepce to the Royal Society, London, December 8, 1827, reprinted in the *Literary Gazette,* no. 1154 (March 2, 1839), 138.

2. Newhall, *Photography and the Book,* 111–15.

3. William Crawford, *The Keepers of Light: A History and Working Guide to Early Photographic Processes* (Dobbs Ferry, N.Y.: Morgan and Morgan, 1979), 41.

4. Charles Ehrmann, "Whipple's Crystallotypes," paper presented to the Photographic Section of the American Institute, April 7, 1885, printed in *Anthony's Photographic Bulletin* 16, no. 8 (April 25, 1885): 247–48.

5. "Crystolotype," *Humphrey's Journal* 4, no. 5 (June 15, 1852): 75. Humphrey, like many others, had trouble with the spelling of Whipple's process. In December 1852, Humphrey again praised Whipple's crystalotypes, this time correctly. *Humphrey's Journal* 4, no. 17 (December 15, 1852): 269.

6. *Photographic Art-Journal* 4, no. 5 (November 1852): 317.

7. "A New and Important Invention," *Photographic Art-Journal* 4, no. 6 (December 1852): 380.

8. "Photography in the United States," *New York Daily Graphic,* April 29, 1853, 7.

9. Cited by Robert Hunt, *Photography: A Treatise on the Chemical Changes . . . and Other Photographic Processes* (New York: S. D. Humphrey, 1852), 98.

10. B. Silliman, Jr., and C. R. Goodrich, eds., *The World of Science, Art, and Industry Illustrated from Examples in the New York Exhibition, 1853–1854* (New York: G. P. Putnam, 1854). Whittemore was well-known for his daguerreotype views of South America and the Caribbean. Shortly after producing the images for this book, he sold his New York City gallery. Nothing is known of his subsequent activities.

11. "The Crystalotype," *Putnam's Monthly* 5, no. 27 (March 1855): 335.

12. "Gun Cotton," *Dwight's American Magazine* 3, no. 7 (February 1847): 109. Many Americans, among them Fitzhugh Lee, the ambassador to Cuba, were convinced that the battleship *Maine* was blown up in 1898 by a crude mine consisting of a barrel of some sort stuffed with guncotton. See Joyce Milton, *The Yellow Kids* (New York: Harper Perennial, 1990), 231.

13. Josef Maria Eder, *History of Photography,* 4th ed., trans. Edward Epstean (New York: Columbia University Press, 1945; Dover Publications, 1972), 342–43. See also C. F. Chandler, "Photography: A History of Its Origins and Progress," *Anthony's Photographic Bulletin* 15, no. 3 (February 14, 1885): 65.

14. Frederick Scott Archer, "On the Use of Collodion in Photography," *Chemist* 2 (March 1851): 257.

15. John Towler, *The Silver Sunbeam* (New York: J. H. Ladd, 1864), 17.

16. S. Rush Seibert to Samuel C. Busey, October 19, 1896, cited in Samuel C. Busey, "Early

History of Photography in the City of Washington," *Columbia Historical Society Records,* 3 (1900): 93.

17. Gustave Le Gray, "Photography on Paper and Glass," *Humphrey's Journal* 4, no. 3 (May 15, 1852): 33.

18. Tissandier, *History and Handbook of Photography,* 22.

19. *Appleton's Cyclopaedia of American Biography* (New York: D. Appleton, 1888), 5:447.

20. Rev. George Mary Searle, "Every Man His Own Photographer; or, the Recent Invention of Gelatin Dry Plates," *Anthony's Photographic Bulletin* 13 (April 1882): 114.

21. I. B. Webster, "Photographic Mincemeat," *Philadelphia Photographer* 10, no. 3 (March 1873): 73.

22. New York photographer J. J. Clark's method of substituting chlorine for bromide in collodion was described in the *American Journal of Photography and the Allied Arts and Sciences* 8, no. 13 (January 1, 1866): 312.

23. "Letters on the Bromide Patents," *American Journal of Photography and the Allied Arts and Sciences* 1, no. 19 (March 1, 1859): 298; *Photographic and Fine Art Journal* 8 (August 1855): 255–56.

24. [Samuel Humphrey], "Resistance to Cutting Patents," *Humphrey's Journal* 11, no. 23 (April 1, 1860): 356.

25. "List of Patent Claims," *Scientific American* 11, no. 25 (March 1, 1856): 194.

26. Peter E. Palmquist, "A Portfolio: The Ubiquitous Western Tintype," *Journal of the West* 28, no. 1 (January 1989): 89–108.

27. "The Chemical Power of the Sunbeam," 237.

28. "3-D Daguerreotypes in America," *Image* 3, no. 1 (January 1954): 2–3.

29. "The Stereoscope," *Graham's Magazine* 43, no. 5 (November 1853): 538.

30. Peter Palmquist, *Lawrence and Houseworth / Thomas Houseworth and Co.: A Unique View of the West, 1860–1886* (Columbus, Ohio: National Stereographic Association, 1980), 6–7.

31. Oliver Wendell Holmes, "History of the 'American Stereoscope,'" *Philadelphia Photographer* 6, no. 61 (January 1869): 2.

32. "Kohl's Regulation Stereoscope," *Philadelphia Photographer* 3 (November 1866): 370.

33. Holmes, "The Stereoscope and the Stereograph," 748, 742.

34. *Anthony's Photographic Bulletin* 1 (November 1870): 208.

35. Werge, *Evolution of Photography,* 193.

36. "The State of the Art in the City of New York," *Humphrey's Journal* 12, no. 21 (March 1, 1861): 324.

37. Towler, *Silver Sunbeam,* 218.

38. William Culp Darrah, *Cartes de Visite in Nineteenth-Century Photography* (Gettysburg, Penn.: W. C. Darrah, 1981), 9, 81.

39. N.G. Burgess, *The Photograph Manual,* 19.

40. Darrah, *Cartes de Visite,* 10.

41. The Cooper Union portrait was published again in E. G. Squier, ed., *Frank Leslie's Pictorial History of the Civil War* (New York: Frank Leslie, 1862), 1:ix. In the book version, the background of the original is completely altered. The scene was transposed to an interior room of the White House and the caption reads, "Abraham Lincoln, President of the United States." No credit is given to the engraver or, for that matter, to Brady.

42. William Welling, *Photography in America: The Formative Years, 1839–1900* (New York: Thomas Y. Crowell, 1978), 143.

43. W. Fletcher Thompson, *The Image of War: The Political Reporting of the American Civil War* (New York: Thomas Yoseloff, 1960), 166. See also Frederick Hill Meserve and Carl Sandberg, *The Photographs of Abraham Lincoln* (New York: Harcourt, Brace and Co., 1944), 30–45.

44. Silas Hawley to George W. Nichols, October 30, 1860, cited by Harold Holzer, Gabor S. Boritt and Mark E. Neely, Jr., *The Lincoln Image: Abraham Lincoln and the Popular Print* (New York: Charles Scribner's Sons, 1984), 67. See also Earl Schenck Miers, ed., *Lincoln Day by Day: A Chronology, 1809–1865* (Washington, D.C.: Lincoln Sesquicentennial Commission, 1960), 2:283.

45. Werge, *Evolution of Photography,* 192.

46. Southworth, "Early History of Photography in the United States," 532.

47. Cited by Roy Meredith, *Mr. Lincoln's Camera Man: Mathew B. Brady,* 2d rev. ed. (New York: Dover Publications, 1974), 62.

48. Ryder, *Voightländer and I,* 112, 114.

Chapter Three

1. Martha A. Sandweiss, Rick Stewart, and Ben Huseman, *Eyewitness to War. Prints and Daguerreotypes of the Mexican War: 1846–1848* (Fort

Worth, Tex. and Washington, D.C.: Amon Carter Museum and Smithsonian Institution Press, 1989), 44.

2. "The Development of Illustration," *Wilson's Photographic Magazine* 37, no. 521 (May 1900): 231–32.

3. Barnum, *Struggles and Triumphs,* 169.

4. Benton, *Life of Hon. Phineas T. Barnum,* 318.

5. Thompson, *Image of War,* 20–21.

6. "The Arctic Explorers," *Frank Leslie's Illustrated Newspaper* 1, no. 1 (December 15, 1855): 1.

7. "J. Gurney, Photographist," *Frank Leslie's Illustrated Newspaper* 8, no. 199 (September 24, 1859): 266.

8. Frederick L. Allen, *"Harper's Magazine," 1850–1950: A Centenary Address* (New York: Newcomen Society, 1950), 14.

9. "Publisher's Notices," *Harper's Weekly* 1, no. 18 (May 2, 1857): 1.

10. Ibid.

11. "Notice to Photographers," *Frank Leslie's Illustrated Newspaper* 10, no. 259 (November 1860): 384.

12. "An Acknowledgment," *Harper's Weekly* 10, no. 511 (October 13, 1866): 643.

13. *Frank Leslie's Illustrated Newspaper* 8, no. 207 (November 19, 1859).

14. *Humphrey's Journal* 7 (March 1, 1861): 9. See also Taft, *Photography and the American Scene,* 478.

15. Hinton to George Cook, April 18, 1861, Cook Papers.

16. In George Cook's account book for the year 1863, nearly half the sittings listed were for "soldier portraits." From May 23 to November 7, Cook made $3,638, over $1,500 of which was profit. Cook Papers.

17. Ryder, *Voigtländer and I,* 208.

18. John T. Morgan, "Reminiscences of the Battle of Bull Run," in *Frank Leslie's Illustrations. The American Soldier in the Civil War* (New York: Bryan, Taylor and Co., 1895), xviii.

19. Holzer, Neely, and Boritt, *The Confederate Image: Prints of the Lost Cause* (Chapel Hill: University of North Carolina Press, 1987), 26.

20. As early as 1851, an article in the *Photographic Art-Journal* 1 (1851): 138 mentioned that Brady "was not a camera operator himself, his failing eyesight precluding the possibility of his using the camera himself with any certainty."

See also Josephine Cobb, "Mathew B. Brady's Photographic Gallery in Washington," *Records of the Columbia Historical Society* 53–56 (October 1955): 28–69.

21. Josephine Cobb, "Photographers of the Civil War," *Military Affairs* 26 (Fall 1962): 127–35; William Frassanito, *Grant and Lee: The Virginia Campaigns, 1864–1865* (New York: Charles Scribner's Sons, 1983), 28; Darrah, *Cartes de Visite,* 78; George F. Witham, *Catalogue of Civil War Photographers* (Portland, Ore.: George F. Witham, 1988).

22. William C. Davis, ed., *The Image of War, 1861–1865,* vol 6: *The End of an Era* (Garden City, N.Y.: Doubleday, 1984), 122–45.

23. Captain A. J. Russell, "Photographic Reminiscences of the Late War," *Anthony's Photographic Bulletin* 3 (July 1882): 212.

24. According to Josephine Cobb, both Gardner and Brady employed Gibson, though "he spent much of his time making photographs for Gardner" (Cobb to Lloyd Ostendorf, June 4, 1958, Photography-Photographers file, Still Pictures Branch, National Archives).

25. *Catalogue of Photographic Incidents of the War from the Gallery of Alexander Gardner, Photographer to the Army of the Potomac* (Washington, D.C.: H. Polkinghorn, 1863). Over four hundred stereo titles were listed in the catalogue, each selling for fifty cents. Fifty-five of the views had been made at Gettysburg some two months prior to publication.

26. Darrah, *Cartes de Visite,* 57.

27. Edmund Guilbert, *The Home of Washington Irving, Illustrated* (New York: D. Appleton, 1867).

28. William Culp Darrah, *Stereo Views. A History of Stereographs in America and a Guide to Their Collection* (Gettysburg, Penn.: Times and News Publishing Company, 1964), 63.

29. While Brady is generally given credit for conceiving the idea of documenting the war, there is evidence that the original idea was Gardner's. See Josephine Cobb, "Alexander Gardner," *Image* 7 (June 1958): 124–36; and Frassanito, *Grant and Lee,* 16–17.

30. [Townsend], "Still Taking Pictures." See also "War Time Pictures," *Chicago Evening Post,* February 11, 1893, 5.

31. Waud first covered the war for T. B. Leggett's *New York Illustrated News,* but he left in early 1862, persuaded by Fletcher Harper to join

his staff. Waud remained at *Harper's* until his death some thirty years later. See Thompson, *Image of War,* 50.

32. Cited by Taft, *Photography and the American Scene,* 228.

33. "Photographs of the War," *New York Times,* August 17, 1861, 4.

34. "Editorial Miscellany," *American Journal of Photography* 4, no. 6 (August 1861): 120.

35. Cited by Davis, *George N. Bernard,* 57.

36. "Editorial Miscellany," 120.

37. Henry Wysham Lanier, "Photographing the Civil War," in Francis Trevelyan Miller, ed., *The Photographic History of the Civil War* (New York: Review of Reviews Co., 1912), 1:38. See also Sargeant Noblet, "The Camera on the War-Path," *Wilson's Photographic Magazine* 36, no. 509 (May 1899): 231–32.

38. Stanley B. Burns, "Early Medical Photography in America (1839–1885): Civil War Medical Photography," *New York State Journal of Medicine* 80, no. 9 (August 1980): 1446.

39. "Photographic History," *Nation,* August 17, 1865, 219–20.

40. Cited in Benson J. Lossing, *A History of the Civil War* (New York: War Memorial Association, 1912), 4.

41. William A. Frassanito, *Gettysburg: A Journey in Time* (New York: Charles Scribner's Sons, 1975), 186–95.

42. Alexander Gardner, *Gardner's Photographic Sketch Book of the War,* 2 vols. (Washington, D.C.: Philip and Solomons, 1866; New York: Dover Publications, 1959).

43. *New York World,* September 15, 1862, 5.

44. Cobb, "Brady's Photographic Gallery," 47.

45. *Catalogue of Card Photographs Published and Sold by E. and H. T. Anthony* (New York: E. and H. T. Anthony, 1862).

46. "Day Breaking," *Humphrey's Journal* 13, no. 20 (February 15, 1862): 320.

47. Lanier, "Photographing the Civil War," 31, 41–42.

48. Thompson, *Image of War,* 23.

49. *Confederate Veteran* 8, no. 6 (June 1900): 274. See also Millard K. Bushong, *General Turner Ashby and Stonewall Jackson's Valley Campaign* (Verona, Va.: McClure Printing Company, 1980), 174–82.

50. Henry Kyd Douglas, *I Rode With Stone-wall* (Chapel Hill: University of North Carolina Press, 1940), 200.

51. Oliver Wendell Holmes, "My Hunt after 'The Captain,'" *Atlantic Monthly* 10, no. 62 (December 1862): 758–64.

52. Oliver Wendell Holmes, "Doings of the Sunbeam," *Atlantic Monthly* 12, no. 69 (July 1863), 11–12.

53. "Brady's Photographs: Pictures of the Dead at Antietam," *New York Times,* October 20, 1862, 5.

54. "Rebel Cruelties," *Harper's Weekly* 9, no. 442 (June 17, 1865): 379–80.

55. "An irrefragable proof of all that has been stated of the rebel cruelties towards our prisoners will be seen on our first page in the portraits of eight prisoners returned to us by exchange. They are from photographs, and without exaggeration. It is not a case where any is needed" ("The Diabolical Barbarities of the Rebels," *Frank Leslie's Illustrated Newspaper* 16, no. 455: cover page and 199).

56. Geoffrey C. Ward, Ric Burns, and Ken Burns, *The Civil War: An Illustrated History* (New York: Alfred A. Knopf, 1990), 404.

57. Russell, "Photographic Reminiscenses," 213.

58. A. W. Greely, "Introduction," in *Subject Catalogue No. 5. List of the Photographs and Photographic Negatives Relating to the War for the Union* (Washington, D.C.: Government Printing Office, 1897), 6. See also Christopher H. Bready, "Civil War Photography: A Collector's Guide," *A. B. Bookman's Weekly* 77, no. 26 (June 30, 1986), 3054.

59. Former generals James A. Garfield and Benjamin Butler persuaded the federal government to appropriate an additional $25,000 to Brady in 1875 (Edward B. Eaton, *Original Photographs Taken on the Battlefields during the Civil War of the United States by Mathew Brady and Alexander Gardner* [Hartford, Conn.: Edward B. Eaton, 1907], 9.

60. "In Memoriam," *Wilson's Photographic Magazine* 33, no. 471 (March 1896): 121–23.

61. Louis J. Weichman, *A True History of the Assassination of Abraham Lincoln and of the Conspiracy of 1865,* ed. Floyd E. Risvold (New York: Alfred A. Knopf, 1975), 283; *New York Times,* July 8, 1865, 1; Craig T. Norback and Melvin Gray, eds., *The World's Great News Photos, 1840–*

1980 (New York: Crown Publishers, 1980), 13; and D. Mark Katz, *Witness to an Era: The Life and Photographs of Alexander Gardner* (New York: Viking, 1991), 177–92.

Chapter Four

1. Frederick S. Dellenbaugh, *The Romance of the Colorado River,* 3d ed. (New York: G. P. Putnam's Sons, 1909), 184.

2. Ferdinand Vandeveer Hayden, *Sun Pictures of Rocky Mountain Scenery* (New York: Julius Bien, 1870), 77.

3. Edwards Roberts, *Shoshone and Other Western Wonders* (New York: Harper and Brothers, 1888), pp. 4, 7.

4. Cited in Mark H. Brown and William R. Felton, *The Frontier Years: L. A. Huffman, Photographer of the Plains* (New York: Henry Holt and Co., 1955), 26, 238; and Brown and Felton, *Before Barbed Wire: L. A. Huffman, Photographer on Horseback* (New York: Henry Holt, 1956), 12. This reminiscence was found in Huffman's desk shortly after he died, among what the authors call a "heterogeneous assortment of notes and short manuscripts in various stages of completion."

5. See, for example, G. R. Fardon, *San Francisco in the 1850s: Thirty-three Photographic Views by G. R. Fardon* (San Francisco: Herre and Bauer, 1856; New York: Dover Publications, 1977); and "Isaiah West Taber, 1830–1912," *Image* 3, no. 3 (March 1954): 19. Taber's collection of negatives was destroyed in the San Francisco earthquake and fire of 1906.

6. Frank Luther Mott, *American Magazines, 1865–1880* (Iowa City: Midland Press, 1928), 69–70.

7. Darrah, *Stereo Views,* 85, 87. Darrah notes that few stereos were made of Indians prior to 1885, perhaps no more than twenty-five hundred.

8. Fanny Kelly, "Narrative of My Captivity among the Sioux Indians," in Frederick Drimmer, ed., *Captured By Indians: Fifteen First-Hand Accounts, 1750–1870* (New York: Dover Publications, 1985), 336.

9. Wilson, "Working the Light," 42.

10. Richard J. Walsh and Milton S. Salisbury, *The Making of Buffalo Bill* (Indianapolis: Bobbs-Merrill, 1928), 154.

11. Tissandier, *History and Handbook of Photography,* 319.

12. John Wesley Powell, *The Exploration of the Colorado River and Its Tributaries* (Washington, D.C.: Government Printing Office, 1875; New York: Dover Publications, 1961), 389. In a series of articles for *Scribner's,* Powell hired Thomas Moran to make the engravings used as illustrations.

13. Clarence King, *Mountaineering in the Sierra Nevada* (Boston: James R. Osgood, 1872), 270.

14. "Photosculpture," *Philadelphia Photographer* 4 (1867): 105.

15. William A. Bell, *New Tracks in North America* (London: Chapman and Hall, 1870), xvi.

16. A railroad official complained that Bell's images "are too dim or not well finished." Charles B. Lamborn to General W. J. Palmer, July 31, 1867, William A. Bell Papers, State Historical Society of Colorado, Denver, cited by Karen Current and William Current, *Photography and the Old West* (New York: H. N. Abrams, 1978), 51.

17. Bell, *New Tracks in North America,* 95, 87–88.

18. W. J. Palmer and W. A. Bell, *The Development and Colonization of the "Great West"* (London: Chapman and Hall, 1874). See also Current and Current, *Photography and the Old West,* 48–52.

19. William Henry Jackson and Howard Driggs, *The Pioneer Photographer: Rocky Mountain Adventures with a Camera* (Yonkers, N.Y.: World Book Company, 1929), 58, 61.

20. William Henry Jackson, *Time Exposure: The Autobiography of William Henry Jackson* (New York: Van Rees Press, 1940; Albuquerque: University of New Mexico Press, 1986), 173, 174.

21. Ibid., 175.

22. John G. Cawelti, *The Six-Gun Mystique* (Bowling Green, Ohio: Bowling Green University Popular Press, 1975), 39.

23. Current and Current, *Photography and the Old West,* 146; and Ralph W. Andrews, *Picture Gallery Pioneers* (New York: Bonanza Books, 1964), 146–47.

24. *Rocky Mountain News,* December 2, 1868: Current and Current, *Photography and the Old West,* 146.

25. Rogers, *Twenty-three Years under a Sky-light,* 30–31.

26. Jackson, *Time Exposure,* 177.

27. Ibid., 177.

28. Ibid.

29. *F. Jay Haynes. Photographer* (Helena: Montana Historical Society Press, 1981), 11–14.

30. See Siegfried Mickelson, "Promotional Activities of the Northern Pacific's Land Department," *Journalism Quarterly* 17, no. 4 (December 1940): 325.

31. Freeman Tilden, *Following the Frontier with F. Jay Haynes, Pioneer Photographer of the Old West* (New York: Alfred A. Knopf, 1964), 73.

32. Cited by William Brey, *John Carbutt on the Frontiers of Photography* (Cherry Hill, N.J.: Willowdale, 1984), 49, 53.

33. Tilden, *Following the Frontier with F. Jay Haynes,* 80.

34. F. J. Haynes to C. M. Warren, October 1887, cited ibid., 14–15.

35. Robert Taft, "A Photographic History of Early Kansas," *Kansas Historical Quarterly* 3, no. 1 (February 1934): 12.

36. *Lawrence Daily Tribune,* September 21, 1869, 3, cited in Robert Taft, "Additional Notes on the Gardner Photographs of Kansas," *Kansas Historical Quarterly,* vol. 4, no. 2 (May 1937): 175.

37. Andrew J. Russell, *The Great West Illustrated in a Series of Photographic Views across the Continent: Taken Along the Line of the Union Pacific Railroad, West from Omaha, Nebraska* (New York: Union Pacific Railroad, 1869), 1:ii. Originally planned as the first in an extensive series, this was the only volume published.

38. Samuel Bowles, *Our New West* (Hartford, Conn.: Hartford Publishing Co., 1869), 73.

39. Russell's *East and West Shaking Hands* was used as the basis for Thomas Hill's painting, *The Last Spike,* commissioned by Leland Stanford in 1870. The painting, measuring eight by eleven feet, now hangs in the California State Capitol in Sacramento.

40. Current and Current, *Photography and the Old West,* 133–34.

41. A. J. Russell, "On the Mountains with the Tripod and Camera," *Anthony's Photographic Bulletin* 1, no. 3 (April 1870): 34.

42. Hayden, *Sun Pictures,* vii.

43. W. H. Hyslop, "Modern Methods of Illustration," *Wilson's Photographic Magazine* 28, no. 406 (November 21, 1891): 680.

44. [James Mason Hutchings], *Scenes of Wonder and Curiosity in California* (San Francisco: J. M. Hutchings and Co., 1862).

45. Ibid., 100.

46. "Editorial Topics: Concerning Newspaper Pictures," *Frank Leslie's Illustrated Newspaper* 39, no. 998 (November 14, 1874), 147.

47. Darrah, *Stereo Views,* 109–10. See also Donald Jackson, *Custer's Gold: The United States Cavalry Expedition of 1874* (New Haven: Yale University Press, 1966), 61.

48. William Culp Darrah, *The World of Stereographs* (Gettysburg, Penn.: W. C. Darrah, 1977), 6–9. The total number of cards produced in America may exceed twenty million, given the popularity and longevity of the process.

49. "Yosemite Valley in Literature and Art," *Daily Alta California,* (San Francisco) May 18, 1871, p. 2.

50. Werge, *Evolution of Photography,* 200.

51. Henry Hunt Snelling, "Photographic Prints for Books," *Philadelphia Photographer* 9, no. 97 (January 1872): 11.

52. Peter E. Palmquist, "Soule's California Stereographs," *Stereo World* 8, no. 1 (March–April 1981), 4.

53. Robinson, *A Certain Slant of Light,* 67.

54. Bierstadt Brothers, *Catalogue of Photographs* (New Bedford: Mercury Job Press, 1860), 10.

55. *Philadelphia Photographer* 10, no. 115 (July 1873): 201.

56. "Photography in the Great Exhibition," *Philadelphia Photographer* 13, no. 151 (July 1876): 200–201.

57. [Charles Savage], "A Photographic Tour of Nearly Nine Thousand Miles," *Philadelphia Photographer* 4, no. 45 (September 1867): 289.

58. J. D. Whitney, *Geological Survey of California: The Yosemite Book* (New York: Julius Bien, 1868), 9, 12–13.

59. C. A. Zimmerman, "On Landscape Photography," *Philadelphia Photographer* 10 (August 1873): 447.

60. See, for example, Richard A. Bartlett, *Great Surveys of the American West* (Norman: University of Oklahoma Press, 1962); Weston J. Naef and James N. Wood, *Era of Exploration: The Rise of Landscape Photography in the American*

West, 1860–1885 (Buffalo and New York: Albright-Knox Art Gallery and Metropolitan Museum of Art, 1975); and Wallace Stegner, *Beyond the Hundredth Meridian* (Boston: Houghton, Mifflin, 1954).

61. Jackson, *Time Exposure,* 196.

62. Jackson and Driggs, *Pioneer Photographer,* 73–74.

63. Jackson, *Time Exposure,* 196.

64. In October 1871, at the time of the great fire, Hine was employed in the Copelin and Sons studio on Lake Street (formerly the studio of John Carbutt). He lost his entire collection of negatives, valued at the time at more than seven thousand dollars (Brey, *John Carbutt,* 86).

65. Even light breezes were problematic for nineteenth-century landscape photographers. "A very large part of the beauty of most landscapes depends upon the foliage," wrote Cary Lea, "and it is necessary that this should remain quite still in order to be satisfactorily depicted" (M. Cary Lea, *A Manual of Photography* [Philadelphia: Benerman and Wilson, 1868], 170).

66. Jackson and Driggs, *Pioneer Photographer,* 111.

67. "Landscape Work," *Philadelphia Photographer* 9, no. 100 (April 1872): 128.

68. Jackson, *Time Exposure,* 251.

69. Senate bill 392, an "act to set apart a certain tract of land lying near the headwaters of the Yellowstone River as a public park" was signed into law by President Grant on March 2, 1872. (*Congressional Globe,* 42d Congress, 2d sess., pt. 2:1416).

70. "Yellowstone Lake: Wyoming Scenery," *Frank Leslie's Illustrated Newspaper* 37, no. 956 (January 24, 1874), 325. The story was accompanied by an unattributed engraving of Yellowstone Lake, probably made from a Jackson photograph.

71. William Goetzmann, "Foreword," in Frederick S. Dellenbaugh, *A Canyon Voyage* (New Haven: Yale University Press, 1962), xx—xxi.

72. Harper Brothers Records, Editorial Correspondence 1869–1892, Manuscript Division, Library of Congress.

73. "Publisher's Note," in George M. Wheeler, *Wheeler's Photographic Survey of the American West, 1871–1873* (Washington, D.C.:

War Department, 1975; New York: Dover Publications, 1983), vi.

74. Dr. Hermann Vogel, "On the Correctness of Photographs," *Popular Science Monthly* 6 (April 1875): 711.

75. Jackson, *Time Exposure,* 201.

76. Cuthbert Mills, writing for the *New York Times,* also stressed the hardships and difficulties of western exploration. "Those who believe [Hayden's] expedition to be one of pleasure, or a picnic party . . . labor under a very gross mistake," he wrote ("The Hayden Expedition," *New York Times,* November 22, 1874, p. 1).

77. John Samson, "Photographs from the High Rockies," *Harper's New Monthly Magazine* 39, no. 232 (September 1869): 465, 466.

78. Major J. W. Powell, "The Canyons of the Colorado," *Scribner's Monthly* 9, nos. 3, 4, 5 (January–March 1875), 293–310, 394–409, 523–37; Powell, "An Overland Trip to the Grand Canyon," *Scribner's Monthly* 10, no. 6 (October 1875): 659–78.

79. John K. Hillers, *"Photographed All the Best Scenery": Jack Hillers's Diary of the Powell Expeditions, 1871–1875,* ed. Don D. Fowler (Salt Lake City: University of Utah Press, 1972), 168.

80. Ibid., 7.

81. Dellenbaugh, *Romance of the Colorado River,* 383. See also RG 106, Records of the Smithsonian Institution Photographs, File 106, Still Pictures Branch, National Archives.

82. Jackson and Driggs, *Pioneer Photographer,* 198–99. The Utes described by Jackson were members of Ouray's band.

83. E. O. Beaman, "The Canyon of the Colorado, and the Moquis Pueblos," *Appleton's Journal* 11, no. 267 (May 2, 1874): 547. See also James D. Horan, *The Great West* (New York: Bonanza Books, 1959), 155.

84. *Philadelphia Photographer* 3 (November 1866): 339.

85. *Frank Leslie's Illustrated Newspaper* 23 (October 27, 1866): 94. See also Elmo Scott Watson, "Way Out West," *Coronet* 5, no. 6 (April 1, 1939): 152–53.

86. *Frank Leslie's Illustrated Newspaper* 23 (October 27, 1866): 94. See also Oliver Knight, *Following the Indian Wars* (Norman: University of Oklahoma Press, 1960), 31.

87. Thomas M. Heski, *"Icastinyanka Cikala Hanzi,"* the Little Shadow Catcher: D. F. Barry,

Celebrated Photographer of Famous Indians (Seattle: Superior Publishing Co., 1978), 61, 24.

88. John Gregory Bourke, *On the Border with Crook* (New York: Charles Scribner's Sons, 1892), 476.

89. Cited by Heski, "*Icastinyanka Cikala Hanzi*," 117.

90. Ibid., 43–44.

91. Elizabeth B. Custer to David Barry, January 14, 1927, cited by Heski, "*Icastinyanka Cikala Hanzi*," 45.

92. Usher Burdick, ed., *David F. Barry's Indian Notes on "The Custer Battle"* (Baltimore: Wirth Brothers, 1949), 33–35.

93. "Stereographic Views," *Yreka Journal* 20, no. 40 (May 1873): 3, cited by Peter Palmquist, *History of Photography* 2, no. 3 (July 1978): 193.

94. Anita Ventura Mozely, ed., *Eadweard Muybridge: The Stanford Years, 1872–1882* (San Francisco: Stanford Museum of Art, 1972), 46.

95. Custer to Mrs. Elizabeth Custer, August 15, 1874, in Elizabeth B. Custer, *The Custer Story: The Life and Intimate Letters of General George A. Custer and His Wife Elizabeth*, ed. Marguerite Merrington (New York: Devin-Adair, 1950; Lincoln: University of Nebraska Press, 1987), 274–75.

96. George Bill later worked for Chicago photographer John Carbutt, who expressed some dissatisfaction with his work habits. "Mr. Bill failed to fill his situation today caused I believe by his being out on a spree," Carbutt wrote in his journal on January 20, 1865. "It cannot occur very often without his losing his situation" (cited in Brey, *John Carbutt*, 21).

97. Ludlow to Chief of Engineers, January 12, 1875, RG 77, National Archives.

98. Paul L. Hedron, *With Crook in the Black Hills: Stanley J. Morrow's 1876 Photographic Legacy* (Boulder, Colo.: Pruett Publishing Co., 1985), 11.

99. Watson, "Way Out West," 152–53.

100. Jackson and Driggs, *Pioneer Photographer*, 73.

Chapter Five

1. "Magic Lantern Slides," *Magic Lantern* 1, no. 1 (September 1874): 4.

2. *New York Illustrated News*, January 1, 1853, 6.

3. "Topics of the Day: About Ourselves," *New York Daily Graphic*, March 4, 1853.

4. *American Annual of Photography, 1893*, 34–35.

5. Barnum, *Struggles and Triumphs*, 358.

6. Richard G. Case, "Puzzle Ends in Picture," *Syracuse Herald-Journal*, May 10, 1863; Dick Wright, "Last Years of a Pioneer Cameraman," *Syracuse Post-Standard*, May 24, 1964, magazine section, pp. 4–7; Davis, *George N. Barnard*, 182–83.

7. "Chicago Correspondence," *Philadelphia Photographer* 9, no. 17 (January 1872): 17.

8. *Philadelphia Photographer* 8, no. 96 (December 1871): 398.

9. "Editor's Table," *Philadelphia Photographer* 8, no. 95 (November 1871): 371. In the next edition, the editor mentioned additional views of the burnt-out district made by Henry Rocher and P. B. Green.

10. "George Eastman's Experiments with Dry Collodion," *Image* 4, no. 1 (January 1955): 3.

11. R. L. Maddox, "An Experiment with Gelatino-Bromide," *British Journal of Photography* 18 (September 8, 1871): 422–23. See also "The Invention of the Dry Plate," *Image* 3, no. 9 (December 1954): 60.

12. Brey, *John Carbutt*, 97–98.

13. "John Carbutt," *Camera* 9 (August 1905): 321–22.

14. F. Jay Haynes to John Carbutt, June 10, 1880, cited by Brey, *John Carbutt*, 112–13.

15. "Joshua Smith's Formula for Gelatino-Bromide Dry Plates," *Anthony's Photographic Bulletin* 13 (January 1882): 11–15; Welling, 270–71.

16. E. K. Hough, "Working Gelatino-Bromide Plates," *Philadelphia Photographer* 17, no. 193 (January 1880): 8–9.

17. G. Gentile, "Report on the Progress of Photography," *Anthony's Photographic Bulletin* 15 (August 1884): 349.

18. Searle, "Every Man His Own Photographer," 117.

19. "The Latest Step in Photography," *Anthony's Photographic Bulletin* 16, no. 7 (April 11, 1885): 221.

20. "A Wonderful Feat," *New York Daily Graphic*, April 26, 1873, 6.

21. Welling, *Photography in America*, 253.

22. Not everyone applauded Muybridge's in-

novation. William Herman Rulofson, a photographer and fellow San Franciscan, remarked that the pictures were little better than silhouettes, and he characterized the entire experiment as "bosh" ("The Horse in Motion," *Philadelphia Photographer* 16, no. 181 (January 1879): 22–23). See also "Mr. Muybridge's Photographs of Animals in Motion," *Anthony's Photographic Bulletin* 13 (January 1882): 6–7.

23. H. F. Talbot, "On the Production of Instantaneous Photographic Images," *Humphrey's Journal* 4, no. 1 (April 15, 1852): 1. See also "The Chemical Power of the Sunbeam," 235–38.

24. "Lightning Pictures: How Photographs Are to Be Taken at Night by Electronic Flash," *Anthony's Photographic Bulletin* 13 (February 1882): 44.

25. Advertisement, *American Journal of Photography and the Allied Arts and Sciences* 8, no. 13 (January 1, 1866).

26. Frances Stevens, "The Amateur's Camera," *New Peterson Magazine* 102, no. 6 (December 1892): 473.

27. "News and Notes," *Wilson's Photographic Magazine* 34, no. 488 (August 1897): 351.

28. Peter Neff and Charles Waldack, *Treatise of Photography on Collodion* (Cincinnati: Moore, Wilstach, Keys and Co., 1857).

29. Rick Dingus, *The Photographic Artifacts of Timothy O'Sullivan* (Albuquerque: University of New Mexico Press, 1982), 5–6.

30. Peter E. Palmquist, *Carleton E. Watkins, Photographer of the American West* (Albuquerque: University of New Mexico Press, 1983).

31. Arthur H. Elliot, "Report on the Progress of Photography," *Wilson's Photographic Magazine* 28, no. 399 (August 1, 1891): 475.

32. See Frederick Hart Wilson, "Where the Kodaks Come From," *Wilson's Photographic Magazine* 26, no. 356 (October 19, 1889): 609–10; "The Liliput Camera," *Wilson's Photographic Magazine* 26, no. 342 (March 16, 1889): 179–80.

33. Charles Ehrmann, "Technical Photography and Mechanical Printing," *Anthony's Photographic Bulletin* 4 (May 1884): 231.

34. "On the Various Methods of Engraving Photographic Pictures Obtained Upon Metal and Stone," *American Journal of Photography and the Allied Arts* 8, no. 13 (January 1, 1866): 300.

35. "The Late M. Poitevin," *Anthony's Photographic Bulletin* 13 (April 1882): 108–9.

36. Newhall, *Photography and the Book,* 33. See also Tissandier, 221–22; and "Obituary. Walter Bentley Woodbury," *Anthony's Photographic Bulletin* 16, no. 19 (October 10, 1885): 585–86.

37. Welling, *Photography in America,* 222–23; "Editor's Table," *Philadelphia Photographer* 8, no. 85 (January 1871): 32.

38. "Editor's Table," *Philadelphia Photographer* 10, no. 114 (June 1873): 184.

39. "Minor Mention," *Appleton's Journal* 9, no. 209 (March 22, 1873): 410.

40. *New York Daily Graphic,* March 4, 1880, pp. 36, 38–39.

41. Frank Luther Mott, *American Journalism: A History of Newspapers in the United States though 250 Years,* 501.

42. John William Tebbell, *A History of Book Publishing in the United States,* vol. 2, *The Expansion of an Industry, 1865–1919* (New York: R. R. Bowker, 1977), 665–66.

43. Welling, *Photography in America,* 274. See also Stephen H. Horgan, *Horgan's Half-Tone and Photomechanical Processes* (Chicago: Inland Printer Company, 1913).

44. J. Fortune Nott, *Wild Animals Photographed and Described* (London: S. Low, Marston, Searle and Rivington, 1886); Nott, "Photography and Illustrated Journalism," *Wilson's Photographic Magazine* 28, no. 395 (June 6, 1891): 321.

45. "Copyright and the American Photographer," *Wilson's Photographic Magazine* 37, no. 525 (September 1900): 385–86.

46. "The Journalistic Instinct," *Wilson's Photographic Magazine* 38, no. 532 (April 1901): 141.

SELECTED BIBLIOGRAPHY

Adams, Robert. *Beauty in Photography: Essays in Defense of Traditional Values.* New York: Aperture, 1981.

The American Image: Photographs from the National Archives. Introduction by Alan Trachtenberg. New York: Pantheon Books, 1979.

Andrews, Ralph G. *Picture Gallery Pioneers.* New York: Bonanza Books, 1964.

Arnheim, Rudolph. *Art and Visual Perception.* Berkeley: University of California Press, 1966.

Barthes, Roland. *Camera Lucida: Reflections on Photography.* Trans. by Richard Howard. New York: Hill and Wang, 1981.

Benton, Joel. *Life of Hon. Phineas T. Barnum.* Philadelphia: Edgewood Publishing Company, 1891.

Berger, John, and Jean Mohr. *Another Way of Seeing.* New York: Pantheon Books, 1982.

Bernard, Bruce. *Photodiscovery: Masterworks of Photography, 1840–1940.* New York: Harry N. Abrams, 1980.

Biographical Sketches of the Leading Men of Chicago. Chicago: Wilson and St. Clair, 1868.

Bisbee, A. *The History and Practice of Daguerreotyping.* Dayton, Ohio: L. F. Clafin, 1853; New York: Arno Press, 1973.

Boorstin, Daniel J. *The Image.* New York: Harper Colophon Books, 1964.

Brady, Mathew B. *The Civil War through the Camera.* New York: McKinlay, Stone and Mackenzie, 1912.

————. *National Photographic Collection of War Views, and Portraits of Representative Men.* New York: C. A. Alvord, Printer, 1869.

Brash, Edward, and Jay Brennan, eds. *Photojournalism.* New York: Time-Life Books, 1972.

Brewster, Sir David. *The Stereoscope: Its History, Theory, and Construction.* London: John Murray, 1856.

Brey, William. *John Carbutt on the Frontiers of Photography.* Cherry Hill, N.J.: Willowdale, 1984.

Brown, Joseph Epes, ed. *The North American Indians: A Selection of Photographs by Edward S. Curtis.* Millerton, N.Y.: Aperture, 1972.

Brown, Mark H., and William R. Felton. *The Frontier Years: L. A. Huffman, Photographer of the Plains.* New York: Henry Holt and Co., 1955.

Buberger, Joe, and Matthew Isenberg. *Russell's*

Civil War Photographs. New York: Dover Publications, 1982.

Buckland, Gail. *Fox Talbot and the Invention of Photography*. Boston: David R. Godine, 1980.

Burgess, Nathan G. *The Photograph Manual: A Practical Treatise, Containing the Carte de Visite Process, and the Method of Taking Stereoscopic Pictures*. New York: D. Appleton and Co., 1862.

Burns, Stanley B. *Early Medical Photography in America, 1839—1883*. New York: Burns Archive, 1983.

Carvalho, Solomon N. *Incidents of Travel and Adventure in the Far West*. New York: Derby and Jackson, 1857.

Cleveland, Past and Present: Its Representative Men. Cleveland: Maurice Joblin, Publ., 1869.

Crawford, William. *The Keepers of Light: A History and Working Guide to Early Photographic Processes*. Dobbs Ferry, N.Y.: Morgan and Morgan, 1979.

Curl, David H. *Photocommunication: A Guide to Creative Photography*. New York: Macmillan Publishing Company, 1979.

Current, Karen, and William R. Current. *Photography and the Old West*. New York: H. N. Abrams, 1978.

Darrah, William Culp. *Cartes de Visite in Nineteenth-Century Photography*. Gettysburg, Penn.: W. C. Darrah, 1981.

————. *Stereo Views: A History of Stereographs in America and a Guide to Their Collection*. Gettysburg, Penn.: Times and News Publishing Company, 1964.

————. *The World of Stereographs*. Gettysburg, Penn.: Wm. C. Darrah, 1977.

Davis, William C., ed. *The Image of War, 1861–1865*. 6 vols. Garden City, N.Y.: Doubleday and Co., 1982.

————, ed. *Touched by Fire: A Photographic Portrait of the Civil War*. 2 vols. Boston: Little, Brown, 1985.

Denison, Herbert. *A Treatise on Photogravure*. London: Iliffe and Son, 1892.

Dingus, Rick. *The Photographic Artifacts of Timothy O'Sullivan*. Albuquerque: University of New Mexico Press, 1982.

Doherty, R. J. *Social Documentary Photography in the USA*. Garden City, N.Y.: American Photographic Book Publishing Company, 1976.

Doty, Robert, ed. *Photography in America*. Introduction by Minor White. New York: Random House, 1974.

Earle, Edward W., ed. *Points of View: The Stereograph in America—A Cultural History*. Rochester, N.Y.: Visual Studies Workshop Press, 1979.

Eder, Josef Maria. *History of Photography*. 4th ed. Translated by Edward Epstean. New York: Columbia University Press, 1945; New York: Dover Publications, 1972.

Edmunds, A. C. *Pen Sketches of Nebraskans with Photographs*. Lincoln, Nebr.: R. and J. Wilbur, Stationers, 1871.

Edom, Clifton C. *Photojournalism: Principles and Practices*. Dubuque, Iowa: Wm. C. Brown Co., 1976.

Fardon, G. R. *San Francisco Album: Photographs of the Most Beautiful Views and Public Buildings of San Francisco*. San Francisco: Herre and Bauer, 1856; New York: Dover Publications, 1977.

Finkel, Kenneth. *Nineteenth Century Photography in Philadelphia*. New York: Dover Publications, 1980.

Fishwick, Marshall. *General Lee's Photographer: The Life and Work of Michael Miley*. Chapel Hill: University of North Carolina Press, 1954.

F. Jay Haynes, Photographer. Helena: Montana Historical Society Press, 1981.

Fleming, Paula Richardson, and Judith Luskey. *The North American Indians in Early Photographs*. New York: Dorset Press, 1986.

Fly, Mary Edith. *Geronimo, the Apache Chief*. Tombstone, Ariz.: Mrs. M. E. Fly, ca. 1905; Tucson: Adobe Corral of the Westerners, 1986.

Fouque, Victor. *The Truth Concerning the Invention of Photography: Nicéphore Niepce: His Life and Works*. Translated by Edward Epstean. New York: Tennant and Ward, 1935.

Frassanito, William A. *Antietam: The Photographic Legacy of America's Bloodiest Day*. New York: Charles Scribner's Sons, 1978.

————. *Gettysburg: A Journey in Time*. New York: Charles Scribner's Sons, 1975.

————. *Grant and Lee: The Virginia Campaigns, 1864–1865*. New York: Charles Scribner's Sons, 1983.

Frémont, John Charles. *Memoirs of My Life*. Vol. I. Chicago: Bedford, Clark and Co., 1887.

Freund, Gisele. *Photography and Society*. Boston: David R. Godine, 1982.

Gambee, Budd Leslie, Jr. *Frank Leslie and His Illustrated Newspaper, 1855–1860*. Ann Arbor: University of Michigan Department of Library Science, 1964.

Gardner, Alexander. *Gardner's Photographic Sketch Book of the War*. 2 vols. Washington, D.C.: Philip and Solomons, 1866. Reprint ed., New York: Dover Publications, 1959.

Geraci, Philip C. *Photojournalism: New Images in Visual Communication*. Dubuque, Iowa: Kendall/Hunt, 1984.

Gernsheim, Helmut, and Alison Gernsheim. *The History of Photography*. London: Oxford University Press, 1955.

———. *The History of Photography from the Camera Obscura to the Beginning of the Modern Era*. New York: McGraw-Hill Book Company, 1969.

———. *L. J. M. Daguerre: The History of the Diorama and the Daguerreotype*. New York: Dover Publications, 1964.

Gidal, Tim N. *Modern Photojournalism: Origin and Evolution, 1910—1933*. New York: Macmillan, 1972.

Glanz, Dawn. *How the West Was Drawn: American Art and the Settling of the Frontier*. Ann Arbor: UMI Research Press, 1978.

Goldsmith, Arthur. *The Camera and Its Images*. New York: Ridge, 1979.

Green, Jonathan. *A Critical History of American Photography*. New York: Harry N. Abrams, 1984.

Guilbert, Edmund. *The Home of Washington Irving, Illustrated*. New York: D. Appleton, 1867.

Hales, Peter. *William Henry Jackson*. London: Macdonald and Co., 1984.

Hall, Joseph. *Gems from Greenwood*. New York: Caldwell and Co., 1868.

Harber, Opal. *Photographers and the Colorado Scene, 1853 through 1900*. Denver: Denver Public Library, 1961.

Harrison, W. Jerome. *A History of Photography Written as a Practical Guide and an Introduction to Its Latest Developments*. New York: Scovill Manufacturing Company, 1887.

Hayden, Ferdinand Vandeveer. *Sun Pictures of Rocky Mountain Scenery*. New York: Julius Bien, 1870.

Haynes, F. Jay. *Yellowstone National Park in Photogravure*. St. Paul, Minn.: F. Jay Haynes, 1891.

Hearn, Charles W. *The Practical Printer: A Complete Manual of Photographic Printing*. Philadelphia: Bennerman and Wilson, 1874.

Hedron, Paul L. *With Crook in the Black Hills: Stanley J. Morrow's 1876 Photographic Legacy*. Boulder, Colo.: Pruett Publishing Co., 1985.

Heski, Thomas M. *"Icastinyanka Cikala Hanzi," the Little Shadow Catcher: D. F. Barry, Celebrated Photographer of Famous Indians*. Seattle: Superior Publishing Co., 1978.

Hicks, Wilson. *Words and Pictures: An Introduction to Photojournalism*. New York: Harper and Brothers Publishers, 1952.

Hill, Paul, and Thomas Cooper. *Dialogue with Photography*. New York: Farrar, Straus, Giroux, 1979.

Hillard, Rev. E. B. *The Last Men of the Revolution*. Hartford, Conn.: N. A. and R. A. Moore, 1864.

Hillers, John K. *"Photographed All the Best Scenery": Jack Hillers's Diary of the Powell Expedition, 1871–1875*. Edited by Don D. Fowler. Salt Lake City: University of Utah Press, 1972.

Holzer, Harold, Gabor S. Boritt, and Mark E. Neely, Jr. *The Confederate Image: Prints of the Lost Cause*. Chapel Hill: University of North Carolina Press, 1987.

———. *The Lincoln Image: Abraham Lincoln and the Popular Print*. New York: Charles Scribner's Sons, 1984.

Homes of American Statesmen with Anecdotal, Personal, and Descriptive Sketches by Various Writers. New York: G. P. Putnam and Co., 1854.

Horan, James D. *Mathew Brady, Historian with a Camera*. New York: Bonanza Books, 1955.

Horgan, Stephen H. *Horgan's Half-Tone and Photomechanical Processes*. Chicago: Inland Printer Company, 1913.

Hunt, Robert. *Photography: A Treatise on the Chemical Changes Produced by Solar Radiation, and the Production of Pictures from Nature, by the Daguerreotype, Calotype, and Other Photographic Processes*. New York: S. D. Humphrey, 1852.

[Hutchings, James Mason.] *Scenes of Wonder and Curiosity in California*. San Francisco: J. M. Hutchings and Co., 1862.

Image of America: Early Photography, 1839–1900: A

Catalog. Introduction by Beaumont Newhall. Washington, D.C.: Library of Congress, 1957.

Ivins, William. *Prints and Visual Communication.* Cambridge: Harvard University Press, 1953.

Jackson, Clarence S. *Picture Maker of the Old West: William H. Jackson.* New York: Charles Scribner's Sons, 1947.

Jackson, Mason. *The Pictorial Press: Its Origin and Progress.* London: Hurst and Blackett, Publishers, 1885.

Jackson, William Henry. *Time Exposure: The Autobiography of William Henry Jackson.* Albuquerque: University of New Mexico Press, 1986.

Jackson, William H., and Howard Driggs. *The Pioneer Photographer: Rocky Mountain Adventures with a Camera.* Yonkers, N.Y.: World Book Company, 1929.

Jammes, Andre. *William H. Fox Talbot.* New York: Macmillan Publishing Co., 1973.

Jareckie, Stephen. *American Photography, 1840–1900.* Worcester, Mass.: Worcester Art Museum, 1976.

Jenkins, H. *A Manual of Photo-Engraving.* Chicago: Inland Printer, 1896.

Jenkins, Harold F. *Two Points of View: The History of the Parlor Stereoscope.* Elmira, N.Y.: World in Color Productions, 1976.

Jussim, Estelle. *Visual Communication and the Graphic Arts: Photographic Technologies in the Nineteenth Century.* New York: R. R. Bowker, 1983.

Katz, D. Mark. *Witness to an Era: The Life and Photographs of Alexander Gardner.* New York: Viking, 1991.

Kerns, Robert L. *Photojournalism: Photography with a Purpose.* Englewood Cliffs, N.J.: Prentice-Hall, 1980.

Kismaric, Carole, and Ann Horan, eds. *Documentary Photography.* New York: Time-Life Books, 1972.

Kneeland, Samuel. *The Wonders of Yosemite Valley and of California.* Boston: Alexander Moore, 1871.

Knight, Oliver. *Following the Indian Wars.* Norman: University of Oklahoma Press, 1960.

Kobre, Kenneth. *Photojournalism: The Professionals' Approach.* Somerville, Mass.: Curtin and London, 1980.

Kolb, Gary P. *Photogravure: A Process Handbook.* Carbondale: Southern Illinois University Press, 1986.

Lea, M. Carey. *A Manual of Photography.* Philadelphia: Benerman and Wilson, 1868.

Lesy, Michael. *Bearing Witness: A Photographic Chronicle of American Life, 1860–1945.* New York: Pantheon Books, 1982.

Linton, W. J. *Wood Engraving: A Manual of Instruction.* London: George Bell and Sons, 1884.

Lorant, Stefan. *Lincoln: His Life in Photographs.* New York: Duell, Sloan and Pearce, 1941.

Lothrop, Eaton S. *A Century of Cameras.* Dobbs Ferry, N.Y.: Morgan and Morgan, 1973.

Lyons, Nathan, ed. *Photographers on Photography.* Englewood Cliffs, N.J.: Prentice-Hall, 1966.

McCabe, Lida Rose. *The Beginnings of Halftone.* Chicago: Inland Printer, 1924.

McLuhan, Marshall. *Understanding Media: The Extensions of Man.* New York: New American Library, 1964.

Malcolm, Janet. *Diana and Nikon.* Boston: David R. Godine, 1980.

Marder, William, and Estelle Marder. *Anthony: the Man, the Company, the Cameras: An American Photographic Pioneer.* Plantation, Fla.: Pine Ridge Publishing Co., 1982.

Meredith, Roy. *Mathew Brady's Portrait of an Era.* New York: Norton Publishers, 1982.

———. *Mr. Lincoln's Camera Man: Mathew B. Brady.* 2d rev. ed. New York: Dover Publications, 1974.

Meserve, Frederick Hill, and Carl Sandberg. *The Photographs of Abraham Lincoln.* New York: Harcourt, Brace and Co., 1944.

Miller, Alan Clark. *Photographer of a Frontier: The Photographs of Peter Britt.* Eureka, Calif.: Interface Corp., 1976.

Miller, Francis Trevelyan. *The Photographic History of the Civil War.* 10 vols. New York: Review of Reviews Co., 1911.

Mott, Frank Luther. *American Journalism: A History of Newspapers in the United States through 250 Years, 1690—1940.* New York: Macmillan Company, 1942.

Naef, Weston, and James N. Wood. *Era of Exploration: The Rise of Landscape Photography in the American West, 1860–1885.* Buffalo and New York: Albright-Knox Art Gallery and Metropolitan Museum of Art, 1975.

Neff, Peter, and Charles Waldack. *Treatise of Photography on Collodion.* Cincinnati: Moore, Wilstach, Keys and Co., 1857.

Newhall, Beaumont. *The Daguerreotype in America.* New York: Graphic Society, 1961.

———. *The History of Photography.* 5th ed. New York: Museum of Modern Art, 1964.

Newhall, Beaumont, and Nancy Newhall. *T. H. O'Sullivan, Photographer.* Rochester, N.Y.: George Eastman House, 1966.

Norback, Craig T., and Melvin Gray, eds. *The World's Great News Photos, 1840–1980.* New York: Crown Publishers, 1980.

Palmquist, Peter E. *Carleton Watkins, Photographer of the American West.* Albuquerque: University of New Mexico Press, 1983.

———. *Lawrence and Houseworth/Thomas Houseworth and Co.: A Unique View of the West, 1860–1886.* Columbus, Ohio: National Stereographic Association, 1980.

Pfister, Harold Francis. *Facing the Light: Historic American Portrait Daguerreotypes.* Washington, D.C.: Smithsonian Institution Press, 1978.

Prime, S. I. *Life of Samuel F. B. Morse.* New York: D. Appleton and Company, 1875.

Ranney, Victoria Post, ed. *An Open Land: Photographs of the Midwest, 1852–1982.* Chicago: Open Lands Project/Aperture, 1983.

Robinson, William F. *A Certain Slant of Light: The First Hundred Years of New England Photography.* Boston: New York Graphic Society, 1982.

Root, M. A. *The Camera and the Pencil.* Philadelphia: J. B. Lippincott, 1864.

Rothstein, Arthur. *Photojournalism.* 3d ed. Garden City, N.Y.: American Photographic Book Publishing Company, 1974.

———. *Words and Pictures.* Garden City, N.Y.: American Photographic Book Publishing Company, 1979.

Rudisill, Richard. *Photographers of the New Mexico Territory, 1854–1912.* Albuquerque: Museum of New Mexico, 1973.

Ryder, James F. *Voigtländer and I in Pursuit of Shadow Catching.* Cleveland: Cleveland Printing and Publishing Company, 1902.

Sandler, Martin W. *The Story of American Photography.* Boston: Little, Brown, 1979.

Schuneman, R. Smith. *Photographic Communication.* New York: Hastings House, 1972.

Shaw, Renata V., ed. *A Century of Photographs, 1846–1946, Selected from the Collections of the Library of Congress.* Washington, D.C.: Library of Congress, 1980.

Snelling, Henry H. *The History and Practice of the Art of Photography; or, the Production of Pictures through the Agency of Light.* New York: G. P. Putnam, 1853.

Snyder, Joel, and Doug Munson, eds. *The Documentary Photograph as a Work of Art: American Photographs, 1860–1876.* Chicago: David and Alfred Smart Gallery at the University of Chicago, 1976.

Sontag, Susan. *On Photography.* New York: Farrar, Straus, Giroux, 1978.

Squier, E. G., ed. *Frank Leslie's Pictorial History of the Civil War.* Vol. 1. New York: Frank Leslie, 1862.

Szarkowski, John. *American Landscapes: Photographs from the Collection of the Museum of Modern Art.* New York: Museum of Modern Art, 1981.

———. *Looking at Photographs.* New York: Museum of Modern Art, 1973.

Taft, Robert. *Photography and the American Scene.* New York: Dover Publications, 1964.

Tchen, John Kuo Wei, ed. *Genthe's Photographs of San Francisco's Old Chinatown.* New York: Dover Publications, 1984.

Thompson, W. Fletcher, Jr. *The Image of War: The Pictorial Reporting of the American Civil War.* New York: Thomas Yoseloff, 1960.

Tilden, Freeman. *Following the Frontier with F. Jay Haynes, Pioneer Photographer of the Old West.* New York: Alfred A. Knopf, 1964.

Tissandier, Gaston. *A History and Handbook of Photography.* 2d ed. (London: Sampson, Low, Marston, Searle, and Rivington, 1878).

Towler, John. *The Silver Sunbeam.* New York: J. H. Ladd, 1864.

Ward, Geoffrey C., Ric Burns, and Ken Burns. *The Civil War: An Illustrated History.* New York: Alfred A. Knopf, 1990.

Welling, William. *Photography in America: The Formative Years, 1839–1900.* New York: Thomas Y. Crowell, 1978.

Whitney, J. D. *Geological Survey of California: The Yosemite Book.* New York: Julius Bien, 1868.

Wickes, Wendy Reaves, ed. *American Portrait Prints.* Charlottesville: University Press of Virginia, 1984.

Wolf, Daniel, ed. *The American Space: Meaning in Nineteenth-Century Landscape Photography.* Middletown, Conn.: Wesleyan University Press, 1983.

Zakia, Richard D. *Perception and Photography.* Rochester, N.Y.: Light Impressions, 1979.